ARTS MANAGEMENT

ARTS MANAGEMENT

a practical guide

Jennifer Radbourne and
Margaret Fraser

ALLEN & UNWIN

For Kevin, Olivia, Ashley
and
Hugh, Lucy, Henry and Douglas

with thanks for their strength and
encouragement as this project developed.

Australia Council
for the Arts

This project has been assisted by the Australia Council, the Federal Government's arts funding and advisory body.

First published in 1996 by
Allen & Unwin Pty Ltd
9 Atchison Street, St Leonards, NSW 2065 Australia
Phone: (61 2) 9901 4088
Fax: (61 2) 9906 2218
E-mail: frontdesk@allen-unwin.com.au
URL: http://www.allen-unwin.com.au

National Library of Australia
Cataloguing-in-Publication entry:

Radbourne, Jennifer J.
 Arts management: a practical guide.

 Bibliography.
 Includes index.
 ISBN 1 86448 048 3.

 1. Arts—Australia—Management. 2. Federal aid to the arts—Australia. 3. Art and state—Australia.
 4. Australia—Cultural policy. I. Fraser, Margaret, 1958– .
 II. Title.

700.68

Set in 11/12.5 pt Baskerville by DOCUPRO, Sydney, Australia
Printed by South Wind Production, Singapore

10 9 8 7 6 5 4 3 2

Contents

Contents

Preface

Management of the arts and cultural industries is in a stage of transition. Cultural policy has broadened the definition of arts from its origins in particular artforms to a more general and all encompassing recognition of culture as the nourishment of the social imagination. The arts manager's role is to facilitate the cultural experience between artists and participants. Increasingly, contemporary economic, political and social influences necessitate a high degree of knowledge and professional management skill.

This book provides a reference point for students and practitioners of arts management. It is intended as a 'first work' in the area of arts management from an Australian perspective, and will be supported by texts and references in specific subject areas, and by other works dealing with advanced studies in strategic management in the arts, cultural policy, community cultural development, international arts marketing, cultural tourism and Aboriginal and Torres Strait Islander arts. Current debate in these areas will initiate further research and publications.

The content is divided into four sections: national, community, organisational and global environments. Each impacts on management practices and decisions. The book begins with a discussion on national identity and moves through various management techniques. It concludes by placing them in the global context. The recurring issues are planning, research, government subvention, entrepreneurship, internationalism, leadership and the importance of people as creators and participants in cultural experiences.

The three case studies illustrate the growing trend in joint ventures and cross-fertilisation between arts organisations, businesses, corporations or governments. Such models of co-operation illustrate an integrated cultural approach, and while existing in the non-profit sector, they are equally applicable in the profit sector. In this entrepreneurial environment management skills and knowledge outlined throughout the text apply in public administration of the arts and cultural industries, and to commercial arts entertainment management.

The examples used in this text originate in general from experiences in the Queensland and national cultural industries and environments. International research suggests that this regional evidence is replicated overseas much as it is in each state in Australia.

The authors wish to acknowledge the assistance of the following organisations and individuals: the Australia Council, the Queensland Performing Arts Trust, the Queensland Museum, Access Arts, the Queensland University of Technology, the Federal Department of Health and Human Services, the Cooloola Regional Development Bureau, the Northern Australian Performing Arts Centres Association, Bill Collyer, Cathy Hunt, Justin Macdonnell, Bryan Nason, Peter Skinner, Alice Stephens and Jane Watson-Brown.

In all arts management practice the value of the artist is paramount. A special feature of this text is the collection of photographs by artist Melanie Gray, who describes the creative process thus:

> As remarkable as the human brain is, it is not able to recreate every fleeting moment. For me, the camera is a tool I use to freeze those moments of magic that happen in life—an expression, light caressing an object, a human movement. I hope that my art is an uplifting experience and a reminder of the beauty around us.

<div align="right">

Jennifer Radbourne
Margaret Fraser

</div>

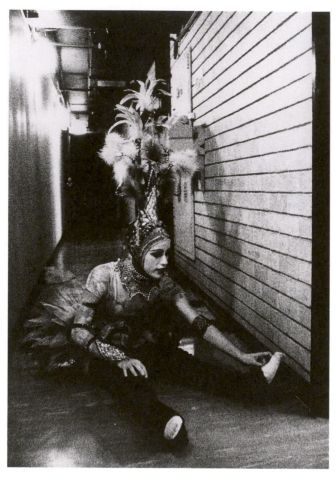

Dancer Larissa Wright rests between scenes in the Queensland Ballet Company's performance of The Tempest, 1993.

SECTION 1

Arts management and nationality

A nation's cultural products help construct its identity. Governments formulating arts and cultural policy and making decisions about funding and development are aware of the role cultural products play in displaying the nation to its people and the world.

The arts manager's role is to facilitate the exchange of the artistic experience between the artist and the consumer through innovative cultural leadership.

Changes in culture and society influence changes in management styles. Contemporary arts management embodies the spirit of a new nationalism in Australia.

— 1 —

Arts management and national identity

This chapter traces the history of cultural development and arts management in Australia since British settlement. Strong links between artistic output and peoples' images of self and nation are demonstrated. The arts manager, who may be a government bureaucrat, corporate entrepreneur or employee of a non-profit organisation, requires sensitivity to these interpretations, and the ability to relay them to the community. The main themes are:

- history and management
- national identity
- the nexus between government policy and national identity
- colonialism and the 'cultural cringe'
- reconstruction and centralisation
- the Australian Elizabethan Theatre Trust and postwar entrepreneurship
- the Australian Council for the Arts and the importance of leadership
- the Australia Council, commissions of inquiry and cultural debate
- separation and subvention
- colonialism and arts management in Asian countries.

Arts management

Arts management is concerned with monitoring and safe-guarding the efficient and sound delivery of artistic product

from artist to audience. In this book the term 'management' has been deliberately selected in favour of 'administration', which has task-specific inferences. 'Management' implies power to control and change, or to accomplish. In many cases individual artists will manage the delivery of their product to an audience or consumer. In other cases arts organisations such as museums, libraries, theatre companies or choirs have a more formal organisational structure which acts as an agent between product and public. The size and complexity of the organisation may vary from a large bureaucratic arts ministry or a national opera company attached to large corporations and to government through sponsorship and support, to a small co-operative of potters and weavers or a community writers' group. Non-profit organisations such as these compete for market share with for-profit organisations like international musical theatre entrepreneurships or cinema and sports entertainment.

Various definitions of the role of the arts manager are offered throughout this book and various personal qualities and codes of practice are discussed (see the section 'The role of the arts manager' in chapter 5, 'Management of people and place'). In providing a link or agency between artistic product and audience, the manager requires skills and knowledge in business practice combined with sensitivity towards creators and the creative process.

Formal recognition of the arts as an industry in Australia may be dated to 1976 when the arts were the subject of an Industries Assistance Commission report. In 1982 the Australia Council produced the first publication in a series of *The Artist in Australia Today*.[1] It outlined workplace conditions for artists and the value of arts in society, including employment characteristics (numbers of artists, artform distribution, age, gender, education and training, ethnic background, working hours, payment for work), taxation and legal guidelines, and data relating to visitor and audience attendances. By the mid 1990s the cultural industries, as they are termed, are included in census data, economic policy, industry development programs and industry training boards. The effects of receiving recognition as an industry are manifold and encompass from the management viewpoint:

- an increased need for professionally trained managers who are aware of competing industries and share similar skill levels and knowledge as managers in those industries
- a need to work with other businesses on a professional level, gaining acceptance and recognition for the cultural organisation
- conformity to legislation relating to employment, corporations and health and safety requiring knowledge and skill in those areas
- increased instances of working alongside competitors within the industry to achieve industry goals.

These skills help promote increased public recognition of the arts and increased integration of arts with public life.

The purpose of this chapter is to study the historical process by which the arts arrived at an industry status. From the manager's viewpoint, a historical view traces trends in social perceptions and governmental approaches to the arts and provides models for leadership, lobbying, policy formation and organisational structure. History also provides a pattern based on good and bad past practice into which current practice can be placed. For example, at times in the brief history provided in this chapter, cases are evident of too much or too little government intervention, of weak or overzealous leadership, of inadequate planning or of successful adhesion to missions through flexible strategic planning.

Federal, state and local governments participate in policy and funding decisions in the arts throughout Australia. Arguments for and against centralisation of control of arts funding and policy-making have been voiced many times. During the lobbying leading towards the formation of the Australian Elizabethan Theatre Trust in 1954, for example, Prime Minister John Curtin's views were remarked on in the newspaper the *Sydney Morning Herald*:

> The Prime Minister, Mr Curtin, is said to regard the formation of an official National Theatre as impossible. His personal view, it is believed, is that subsidisation of local conservatoriums, repertory theatres, and the like, would be the most effective

means of cultural advancement on national lines. His reason for this theory is thought to be that Australia has not one centre of art, and that the six State capitals provide whatever focal points there are for central direction of theatre and opera.[2]

Curtin's view has more recently been reflected in cultural policies in each state which advocate local identity and cultural practice in even the smallest of communities. At the time of Curtin's statement, however, the overriding push was for national theatre, opera and ballet companies which would showcase Australia to Australians and to people abroad. Arts commentators such as Tim Rowse branded such national institutions as elitist and wasteful of huge resources for the benefit of a privileged class.[3] Other lobbyists such as the economist H. C. Coombs have seen the establishment of national companies as a means of enriching the cultural life of the whole community. Gaining a historical perspective of such debates is important to the arts manager who is seeking a meaningful and profitable place for the arts organisation.

Through policy, governments create markets and supply. Through individual artists' grants, and operational or project funding of arts organisations, governments express cultural priorities. A self-sufficient artist working and selling from a private studio may not feel tied to government policy, but practises in an environment that is profoundly influenced by contemporary economic and cultural policy. Export and tourism policies, for example, can improve or diminish artists' ability to market their work. Prioritised funding to artists in the multimedia industries can affect artists not practising in that area by limiting their potential markets. Policies which encourage interest in particular art markets do not necessarily protect and provide for the producers of the artworks. The burgeoning interest in Aboriginal art has not enhanced the lifestyles of many popular indigenous artists. Arts managers can provide a sympathetic link between producer (the artist), product (the artwork) and consumer (the viewer, buyer, participator or audience). The manager can safeguard the product from corruption by monitoring publicity,

advertising, curatorial practice, contractual arrangements, marketing strategies and copyright. Providing an effective link requires knowledge of past and current policies and practices.

National identity

Many of the arguments surrounding funding and government strategies for the arts in Australia have centred around the image Australia projects as a nation. The history of the development of the arts and of government support for the arts reflects contemporary attitudes to the arts and culture in general. The terms national identity and cultural identity permeate such discussions and are commonly used to shape funding guidelines and government policy.

The Australia Council, the nation's chief federal arts funding body, specifies in policy documents objectives such as the promotion of awareness of Australian culture abroad and assistance in the establishment and expression of Australian identity.[4]

National awards for artistic achievement commonly have nationalistic criteria, either overtly stated in entry requirements or subtly constructed through the resulting creation of national canons of literature and art. The Miles Franklin Award for literature is unique in stipulating that competing works are to be written by Australians and have Australian content, although other award-winning literary works have largely been concerned with reflecting Australian life. The prime minister has awarded creative fellowships to Australian artists who have had distinguished careers in their field, and so honours them with a special form of citizenship in which they are recognised as national artistic representatives. Artists who win prizes such as the Archibald (for portraiture), the Blake (for religious art) and the Moet and Chandon (for an artist under thirty-five years) are provided with secure positions in national annals. Controversy over these awards is, from time to time, based on arguments about the suitability of the subject matter to the representation of national identity.

Artworks on display in Parliament House, Canberra, comprise not only a broad representation of styles and media but also a broad representation of artists from many regions and ethnic backgrounds. The collection consciously presents an image of unity in diversity and stands as a metaphor for national identity. Similarly the National Portrait Gallery in Canberra aims to present a narrative or portrait of Australia, with deference to democratic traditions in its wide choice of works and its charter to tour exhibitions frequently.[5]

Policy documents of the Australian Broadcasting Authority (ABA) recommend increased Australian content in television and radio programming and filmmaking.[6] Australian content requirements in filmmaking in particular specify the use of Australian employees. This type of nationalism acts as a protectionist device for the arts industry.

Recent federal government statements on the arts continue the postwar tradition of drawing heavily on definitions of who we are and how we interpret this identity artistically.

Culture, then, concerns identity—the identity of the nation, communities and individuals. We seek to preserve our culture because it is fundamental to our understanding of who we are . . . Culture, therefore, also concerns self-expression and creativity.[7]

The differences between anglophilia and nationalism and their reflections in our cultural identity have been dealt with overtly in government policy documents. The virtues of multiculturalism are emphasised as are the links between cultural identity and democratic ideals.[8] Government arts policy has in this way become inextricably linked with social policy which results in its implementation through more complex and diverse mechanisms than those of, say, the postwar arts bodies such as the Elizabethan Theatre Trust.

Arm's-length funding aims to separate the powers of funding source (the government) from decision-making executive (the Australia Council) and so prevent hegemonic control of arts by government. Because the arts are inextricably linked to social policy through the cultural component, however, this separation is sometimes difficult to maintain, and trends in social policy tend to be powerfully reflected

in trends in cultural policy. Prescriptive government policies can impede the power of the executive. State and local government policies provide a balance to federal policies with their more specific and localised interests.

Although some commentators find the term national identity inappropriate or irrelevant in our increasingly globalised culture, current debates about republicanism have in fact reinforced a desire to express our cultural distinctiveness from Britain and the rest of the world and to assert it through achievements in our culture.

Defining identity

National identity is difficult to define. It is a definition in flux, being inextricably bound to socio-cultural realities which also change, and one which is subject to individual interpretation. The definitions of national identity are of great importance to arts administrators as they represent the raw material on which management practices can be based to suit the community and its needs.

National identity is determined by the way in which a nation's people view their country and in turn attempt to promote this vision both within and beyond it. White Australia's origins in British colonialism engendered in its people a search for national identity which has involved artists and arts managers as its commentators, critics and propagandists.

Certain icons or symbols are from time to time perceived to be the suitable representations of national identity. Some television commercials, advertising slogans and vernacular expressions have in our past been seen to represent something quintessentially Australian. Vegemite, the Eureka Stockade, Phar Lap and Uluru are each jealously protected as the property of the nation and play a part in its popular culture.[9]

Art, architecture, literature, theatre, dance and music provide some of the most translatable and permanent media for the expression of national identity. The Ned Kelly story and the famous iron mask have reached an almost mythological status through their depiction in plays and stories and in Sidney Nolan's paintings. The distinctive landscapes of painters Hans Heysen and Albert Namatjira have come to be

seen as symbols of Australia. Art critic Robert Hughes commented in his book *The Art of Australia* that no Australian business was considered quite solid unless it had a Heysen in its boardroom.[10] The film *Crocodile Dundee* in 1986 became an export phenomenon by virtue of the portrayal of a character type with which many Australians wished to be identified. The Sydney Opera House provides an exportable image which is identifiably Australian.

The range of artistic and cultural symbols which a nation's people choose as a suitable representation of themselves is constantly changing. Fashionable ephemera become acceptable images for short periods, or exist for longer periods in subcultures. Other images are constant and survive in the annals of history where they help form a sense of historical national identity. Increased infusion of heritage issues into cultural policy documents and arts funding in recent years again exemplifies the marriage between national identity, culture and history.

The images of a society which survive in a historical sense may be quite remote from the identity felt by the people at the time of their making. The picture of classical civilisations built up from the architectural, artistic and literary works left behind may have little correlation to the culture as it was perceived at the time. Historical national identity results from selectivity enforced on the observer, and even quite recent historical periods tend to be selectively viewed from the bias of contemporary tastes. Technology and commercialism have ensured that symbols which would have once enjoyed a transitory status are recorded for posterity and so given importance beyond their original conceptions.

Donald Horne, a social historian and cultural commentator, has stated that there is not room in a public culture for all of society's realities. A public culture is rather the result of limiting and organising realities.[11] Seeking the means to express national identity is akin to finding order amongst the chaos of myriad viewpoints. A democratic society by definition takes pride in its diversity, but Horne notes that within that diversity there tend to be 'confident assertions about the nature of public life which have . . . a kind of bullying dominance'. Communist and totalitarian regimes

overtly control such assertions negating the opportunity for public debate about funding and policy issues. Arts managers in a democratic society must be aware of more subtle pressures operating to inform policy. 'Not only do we seek to preserve our heritage and tradition, we cultivate them. We preserve the things that make us what we are and cultivate the means of reaching what we can be.'[12]

History of arts policy, arts product and arts support

Arts policy came under official scrutiny in Australia during the reconstruction period after World War II. Public and political discussion about national identity was imperative in order to establish priorities in all facets of public life. The fact that Australians emerged from the war with a new confidence and sense of pride in their own rather than their mother country had a bearing on arts policy and artistic endeavour.

Colonialism

The conscious break from a colonialist state of mind had immense repercussions on artistic product. Early white settlers were self-conscious about both the convict origin of Australia and the stigma which derived from it, and their dislocation from the intellectual and social culture of Europe. Art emulated the European forms without often reaching their heights of sophistication. The rigid British class system was difficult to sustain in an environment devoid of inherited wealth, and the tradition of artistic patronage which went with it was nonexistent.

In the early nineteenth century, not long after British settlement in Australia, culture was defined as a refinement and training of minds, tastes and manners.[13] The scene of the landing of the First Fleet at Port Jackson in 1788 was by these terms a cultural desert. Here was a culture, in the broader sense of the word, pervaded by cruelty, sickness, rape, death, starvation and isolation. Until the 1960s convict history received perfunctory attention in favour of the heroic exploits of explorers, pioneers and politicians who 'opened up' the country. The shame felt by British expatriates at living as second-rate citizens in a country which was a poor

masquerade of the mother country took many years to abate. It is the source of the much discussed cultural cringe syndrome and a starting point for many artistic statements.[14]

Governor Macquarie (governor of New South Wales 1810–21) was quick to try to redress the perceived lack of culture in the colony, and employed a number of artists to assist him in this mission. Macquarie encouraged convict Joseph Lycett to paint landscapes which would promote Australia's beauty to free settlers. The result in *Views in Australia or New South Wales and Van Diemen's Land, Delineated* was a collection of landscapes quite English in their greenness and tameness although appreciative of the cornucopic exotica of the new land.[15] To Englishmen thinking of migrating these idealised views must have looked as inviting as a scene in a travel brochure looks today, and the accompanying descriptions offered much useful topographical information to potential farmers.

Macquarie had also suggested to John Lewin, a free settler and professional artist, that he accompany the Governor's expedition across the Blue Mountains in 1815 in order to illustrate the scenery. Two years earlier, the explorers Blaxland, Wentworth and Lawson had crossed the Blue Mountains and discovered the verdant pastoral land of the plains beyond. Lewin's watercolours gave potential settlers an idea of what the landscape offered. The ex-convict architect Francis Greenway was engaged by Macquarie to develop a city plan for Sydney. Greenway managed to create a unique architectural style not slavish to English traditions in his Hyde Park Barracks and several churches. Perhaps lack of skilled craftsmen and availability of particular materials helped his vision.[16]

Michael Massey Robinson, another ex-convict, was commissioned by Macquarie to write a series of birthday odes to the royal family and these were published in the *Sydney Gazette*. Robinson was given two cows for his trouble and somewhat mockingly named Poet Laureate.

For many years theatre also devoted itself to British templates. The first play produced in the colony was in 1789 when an all-convict cast performed George Farquhar's *The Recruiting Officer*. Commercial theatre empires expanded

during the gold rushes importing melodramas, operettas, and Shakespearian plays.

In 1880 journalists John Haynes and John Feltham Archibald founded *The Bulletin*, a political and literary weekly journal which soon become known for its strongly national-istic ideals. The slogan 'Australia for the Australians' appeared on its cover, to be replaced by 'Australia for the White Man' in 1908 and until 1960. By the 1890s *The Bulletin* was promoted as 'the premier literary journal', and editor J. F. Archibald encouraged contributors to write in a no-non-sense way using distinctively Australian subject matter. Bush ballads and poetry and stories of the pioneering life predom-inated. Banjo Paterson, Henry Lawson, Steele Rudd and Harry (Breaker) Morant were among the early published writers. They represented colonial life in realistic, romantic and comic modes through the characters of the drover, the horseman, the selector and the swagman. The famous Red Page of literary contributions was created by critic A. G. Stephens and was known for its fiery irreverence.

Australian painters were also developing a distinctively Australian school at the same time as *The Bulletin* writers were becoming popular. In 1889 Tom Roberts, Charles Conder, Arthur Streeton and Fred McCubbin exhibited a collection of their Impressionist works in Melbourne. These works, the result of painting outdoors from the base near Heidelberg, broke away from the derivative nineteenth-century landscape styles of Louis Buvelot and Eugène von Guérard. They cap-tured the distinctive Australian sunlight and fauna and used the subject matter of the bush, just as the bush balladists had done. Roberts's *Shearing the Rams* (1890), Streeton's *'Fire's On!' Lapstone Tunnel* (1891) and McCubbin's *The Pioneers* (1905) represent the harsh life of the manual labourer and eulogise this existence to folk-hero status. The Heidelberg School reflected a current nationalist sentiment, as Robert Hughes notes:

> Roberts's imagination runs parallel to the prevalent
> tone of Australian writing in the nineties. His virtues
> of mateship, courage, adaptability, hard work and
> resourcefulness are the very ones Lawson celebrated in

13

his short stories, and Joseph Furphy described in *Such is Life*. Their use indicated a growing sense of cultural identity. These virtues are thought distinctively—even uniquely—Australian.[17]

As a chiefly agricultural community, however, Australians experienced the arts as a separate addition to life, or something to be enjoyed or contemplated only after a day of back-breaking manual labour. There was no equivalent here to that class of English gentleman who could spend days at his club in intellectual discussion and games-playing. Nor were there strong local enclaves of people celebrating through ancient arts and crafts the culture of specific geographical areas with their distinctive forms of dance or craft or song as are found in an older country. Donald Horne notes that art came to be seen as separate from other facets of life only in modern industrial societies where work and leisure are irrevocably split.[18] In Australian history, geographic isolation and hard manual labour demanded by the harsh farming environment had played a major role in this separation of work and leisure somewhat before industrialisation. Participation in the arts was 'rare' because opportunities were rare, and 'self-conscious' because standards were perceived as inferior and because it was unseemly to leave toil for such frivolity.[19]

The life of high culture and participation in the arts was also not part of what social critics and historians have named the 'Australianist legend' or the 'democratic tradition'.[20] This male-oriented doctrine worshipped the values of mateship between working men and the virtues of life in the bush. The 'democratic tradition' and code of mateship were sympathetic to a strong unionist ethic in Australian history. The Eureka Stockade in 1853 was a brief but symbolic battle between gold miners and authorities over the miners' monthly licence. Peter Lalor led the battle. As brother of the famous Irish Nationalist James Finton Lalor, Peter typified a strain of Irish rebelliousness persistent in Australian working-class history.

Other strains of rebelliousness were present before those of the gold diggers. At the time of settlement, England prided

herself on her Protestantism, having defeated the great Catholic maritime and imperial powers of Spain and France. Part of Governor Phillip's commission on landing in 1788 was 'An Act for the Preventing of dangers which may arise from Popish recusants'.[21] Some of the Irish Catholic convicts were priests, but it was not until thirty years after settlement that Catholics were allowed priests of their own religion as confessors. The criminals developed fierce loyalties to one another and were naturally opposed to the authority of the Protestant militia. The Irish rogue who appeared as a hero in later poetry and stories was a convict descendant who revelled in his antipathy to English refinement. He found his spiritual home and freedom in this new untried land lacking in social niceties. His cheerful nature and larrikinism can still be found in many characters in Australian literature, film and popular culture.

The emergence of a strong labour union movement in Australia also moulded anti-elitist cultural values early in the nation's history. Métin, a French socialist who had travelled to Australia, made these observations in 1901:

> It is, therefore, an English society which we find again in the Antipodes, but with two very important innovations: democratic institutions and labour legislation which exist in embryo in the mother country, but which are fully developed only in Australasia. The former give rise to habits of independence and the instinct of equality, the latter afford leisure and material resources, the indispensable conditions for intellectual and moral development. But, the whole world over, intellect and morality progress more slowly than material prosperity.[22]

This early link recognised between strong unionism and affordable leisure time has more recently become embedded in Australian Labor Party cultural policy and in the funding of Art and Working Life programs supported by the Australia Council. Indeed the Labor Party in campaigns from 1975 onwards has deliberately aligned itself with artists and performers whose work exemplifies liberation from

oppression as an illustration of their own ideals. Bill Kelty, as President of the Australian Council of Trade Unions (ACTU), addressed an audience of unionists on the topic of the relationship between arts and working life in 1990:

> The ACTU has worked alongside the Australia Council over the past five years pursuing our shared commitment to greater cultural equity and involvement to Australian working people and their families . . . The recent growth in cultural involvement by unions is a reflection of the widening role of unions in social and quality of life issues and has been assisted and encouraged by this co-operation with the Australia Council.[23]

While Métin was inspired by the progress of the labour movement at the turn of the century, he was uninspired by the intellectual and moral fibre of the people. Horne defines the term cultural cringe as the depredations of a self-denigratory provincialism in academic, intellectual and artistic life.[24] Certainly in any definition of 'high culture' these three aspects are related. Academics were sparse in this land of convicts and pioneers. The new university in Sydney was initially staffed by English professors and it was some time before home-grown intellectuals were deemed suitable to take their places.

It is interesting that a distinctively Australian character was remarked on by visitors so early in the history of the colony. The traits noted have a bearing on the status of art and the colonists' attitudes towards culture in general. Charles Darwin, along with others, was particularly appalled by colonists' obsession with acquiring wealth, and their corresponding lack of intellectual pursuits. R. E. Twopenny, an Englishman, noted their rougher dress and manners complemented by their more liberal attitudes. He saw a levelling of the social classes and felt particularly sorry for the rich women who lacked an appreciative audience for their skills and wares. Their education in manners and finery was deemed to be pointless in such an environment. A distinctly Australian speech developed early and was the cause of further self-consciousness, being perceived as evidence of

social immaturity until well into the 1950s. Even then actors were sent to England to be trained to speak 'properly' and the ABC accent was decidedly BBC. In being more English than the English Australians developed an almost obsessional love of cricket which perplexed even their English rivals.[25]

The influx of non Anglo-Saxon immigrants after World War II has caused a new awareness of other cultures and changed earlier perceptions of national identity. This pluralism has made 'Australian' difficult to define as has the more recent official recognition of Aborigines as the first Australians. Besides the obvious artistic enrichment effected by a multicultural society, there remain large numbers of people adrift from their cultural heritage yet compelled to assimilate the dominant culture.

Reconstruction and the Australian Elizabethan Theatre Trust

H. C. 'Nugget' Coombs, an economist and governor of the Commonwealth (later Reserve) Bank, took charge of postwar reconstruction and founded the Australian Elizabethan Theatre Trust in 1954. Coombs said that 'Australians had discovered during the War that they could do a lot of things that previously they had looked abroad for'.[26] One of these was to provide a new national theatre 'of Australians by Australians for Australians'. By the 1920s large commercial enterprises such as J. C. Williamson's provided the Australian public with a rich array of overseas artists and shows. While it could be argued that tours such as these effectively deprived Australian playwrights and performers of an audience until the advent of the Australian Elizabethan Theatre Trust, credit must be given to these entrepreneurs for building up a strong theatre-going public. The 1930s and 1940s had seen the burgeoning of little theatre groups in the state capitals but the need now was for a showpiece theatre supported by federal and state subvention.

The concept of government support for performing arts was new. The Commonwealth Literary Fund had been established in 1908 to support writers, and then in 1912 the Commonwealth Art Advisory Board was set up as a means of collecting works of art for the Commonwealth. The Australian Broadcasting Commission, established in 1932,

was supported by the federal government. Private patronage existed in Victoria during the war years (1939–45) to support the opera, dance and drama of the National Theatre Movement. By 1948 the 25 per cent revenue tax on the entertainment industry was very harmful, especially alongside the postwar rise in actors' fees. Earlier, in 1946, theatre entrepreneur Nevin Tait of J. C. Williamson's had complained of the lack of government support for the performing arts, suggesting the need for government subsidy.[27] Tait estimated that the federal government was earning more than two hundred thousand pounds a year from the taxes on J. C. Williamson's productions alone, without sharing in any of the risk.

The interests of the Trust lay in the performing arts for a number of reasons. The performing arts had not received the kind of support offered to the visual and literary arts through the Art Advisory Board and Literary Fund referred to earlier. Museums and galleries had also been established in capital cities to serve similar audiences. The performing arts had been controlled to a degree by J.C. Williamson's and other commerical entrepreneurs on a professional basis, and by myriad amateur groups. The dependence of entrepreneurs on imported shows was not encouraging the industry to grow from the grass roots, and amateur organisations could not provide performers with qualified training courses. The labour-intensive and costly nature of the performing arts is broadly recognised as a factor in its struggle to survive in the open marketplace. Opera, ballet and theatre were also appropriate vehicles for Coombs's 'showpiece' platform. These arts are spectacles involving the visual and aural senses and are conducive to large audiences and large audiences of tourists. They are traditionally the marks of great past civilisations.

The debate about the virtues of a national theatre revolved largely around the idea of a theatre as a national monument to those who died in World War II, and as an expression of the coming of age of Australia. Coombs lobbied for a combination of government subvention, business investment and public support in the guise of the Australian Elizabethan Theatre Trust and timed his appeals to coincide

neatly with the Royal Tour of Queen Elizabeth II in March 1954. Most Australians were then in the grip of royal sympathy and commemorative articles and events were bound to succeed.

In an ABC broadcast on the Royal Tour Coombs described Australia as rich in natural resources but lacking in artistic aspects which are the mark of a civilised community. Prime Minister Menzies, an ardent royalist who had not until now succumbed to Coombs's logic, agreed to a subsidy from the government after wealthy patrons and businesses had made their contributions.

The aims of the Trust were to develop an audience in Australia for 'excellent' theatre, and to establish a native opera, ballet and drama company. The Trust wanted to

> assist organisations capable of presenting drama, opera and ballet of the highest standards and especially those which give promise of becoming self-supporting within a reasonable time . . . [and to] . . . encourage the establishment of training schools where new talent can be developed.[28]

It is interesting to note that most of the companies supported by the Trust did not become self-supporting, and it has become an accepted way of thinking by many groups that arts companies both small and large cannot exist without government subsidy.

The Trust was formed as a company limited by guarantee and registered as a body corporate in the Australian Capital Territory. Business corporations and wealthy citizens had provided half the targeted capital by the end of 1955, which was met on a one pound for three pound subsidy by the Menzies government.

Many references were made at the time to the importance of creating a truly Australian opera, drama and ballet, and to the need for a single national representative of each of the artforms. To these ends a large degree of centralisation was necessary. Many employees of the opera companies based in Victoria and Sydney (the Australian National Theatre Movement Ltd and the National Opera of Australia) helped form the new company, the Australian Opera. The Australian

Opera was granted free use of the ABC orchestras. The Borovansky Ballet, which had received international acclaim under the artistic directorship of Borovansky, was closed by J. C. Williamson's at the end of 1960. The new artistic director, Dame Peggy van Praagh, used the occasion of the final performance to announce the plans for the Australian Ballet Foundation and to encourage patronage. The Foundation was established in 1961 and subsequently supported by Prime Ministers Menzies, Holt and Gorton. The National Institute of Dramatic Art (NIDA) was established in Sydney in 1959. The Elizabethan Trust Theatre was established in Newtown providing the venue for the first of the Trust's presentations, Terrence Rattigan's *The Sleeping Prince*. It was important that overseas productions continued as a less risky venture alongside Australian drama, and the Trust co-operated with J. C. Williamson's to get a percentage of their profits on each production staged at the Elizabethan Theatre. The Trust also shared a percentage of the profits of the touring Tintookies marionette company, the Trust Players and The Young Elizabethan Players. The Australian Drama Company was established in Canberra. Its first production, *Medea*, starring Judith Anderson, toured for six months. Other successful tours entrepreneured by the Trust were those of Ray Lawler's *Summer of the Seventeenth Doll* (from the Union Theatre Repertory Company based at the Melbourne University) and Alan Seymour's *The One Day of the Year*, both of which were later presented overseas.

The Trust assisted repertory theatre in each state, recognising that a vital Australian theatre must originate from there and from educational institutions developing various art forms. There was always a strong undercurrent of resentment about the centrality of the national institutions, one which still causes much controversy in funding debates. Eventually permanent state theatre companies replaced the touring Trust Players, attesting to the immense vitality of the existing little theatre movement.

The Trust acted as a collection agency for the pluralistic funding from three tiers of government, corporations and private sources. In this way it differed from the Canada Council (formed in 1957), which encouraged artists and arts

organisations to look elsewhere for funding. It also differed from the National Endowment program in the United States (established in 1965) which implemented a partnership between government and private citizens to complement the already highly active role of private patronage. In 1962 the Trust Players disbanded and Trust productions were performed at the Old Tote Theatre as part of the NIDA training program. The promotion of Australian playwrights and actors remained a prime concern throughout the transition years from the Old Tote to the Jane Street Theatre to the Drama Theatre at the Sydney Opera House and eventually to the demise of the company and the corresponding birth of the Sydney Theatre Company in 1979. The Trust's policy of joining with existing commercial managements to finance and promote imported shows was met with some criticism, and did not seem to conform to the stated aim of promoting serious native drama. By 1961, however, the Trust had incurred serious financial losses and the policy of combined entrepreneurship was seen as a means to recoup losses.

The Australian Council for the Arts

By 1965 the Trust's control of performing arts was still felt to be too centralist, and Coombs began lobbying for a new organisation which would 'make recommendations for the support of the performing arts, and to administer the funds provided by the Government'. Following the models he had studied in the Canada Council, the United States National Endowment and the Arts Council of Great Britain (established in 1945), Coombs saw the advantages in support for innovative theatre instead of subsidising commercial enterprise. The Trust had by now faced considerable financial upheavals and a new statutory body was a sensible complement to the improvisational qualities of its management.

The belief that if the 'best' in the arts were to receive funding the effects would percolate down through society is, to many critics, misconceived anathema caused by middle class idealism. Clem Gorman recently argued that the profile of the arts-using public has not changed despite various initiatives towards democratic provision of access to artforms.[29] Only in communities where old cultures do exist,

claims Gorman, do the arts emerge out of the daily experience of the people. Tim Rowse had similar misgivings about the aims of postwar arts bodies, criticising their proponents as middle class.[30]

The idea that ordinary people will lead richer lives if the arts were somehow incorporated into their daily existence signified the change in direction at the formation of the Australian Council for the Arts. Whereas the Trust was concerned with showcasing Australia to Australians, and establishing traditions of an arts-minded public, the new Council was to actively encourage participation.

The Rockefeller Foundation in the United States espoused similar ideals, claiming that the ultimate test of a democracy lies in the quality of the artistic and intellectual life it creates and supports.[31]

In the 1960s and 70s changes in popular culture widened the gap between commercial and subsidised arts. The increasing role of the mass media, including television and advertising culture, changed the players' positions. Theatres like the Nimrod Theatre in Sydney and The Pram Factory in Melbourne sprang up as part of an anti-reactionary movement, often from a university campus base, and were venues for all sorts of social, literary and political experimentation. The great national monument or flagship companies lost popularity with this new protest group, who saw them as a means of widening the chasm between affordable community art and elitist, expensive and outmoded forms.

Harold Holt, in one of his last acts as prime minister before his disappearance off Cheviott Beach in 1968, announced the formation of the Australian Council for the Arts and plans for a National Gallery. Holt had been a great supporter of the arts and had actively assisted the formation of the Australian Ballet. The personal artistic interests of Holt and indeed all the postwar prime ministers in Australia have greatly influenced artistic policy and administrative procedure.

Prime Minister Gorton, who followed Holt in 1968–71, showed great enthusiasm for an Australian film industry. During Gorton's regime the Australian Council for the Arts was set up in Sydney away from the Canberra bureau-

cracy. Arts funding increased and experimentation and unorthodoxy were encouraged. This period of hopeful expectation was cut short by a successful leadership challenge from William McMahon, however, resulting in lack of direction or interest in arts management. McMahon (prime minister in 1971–72) managed to alienate both artists and arts administrators with his interventionist approach to funding decisions, his delaying of the establishment of the Film School, and his inability to develop a Charter for the Council for the Arts. The Council required strong prime ministerial support but at the same time was crippled by direct administrative interference.

The hiatus caused by McMahon provided a catalyst for two important movements: proposals for increased Council independence; and the Artist for Whitlam committees which were set up all around Australia. Coombs and Doctor Jean Battersby, then Chief Executive Officer of the Australian Council for the Arts, were now recommending policy changes to Whitlam which McMahon's arts minister, Howson, had not fulfilled. The arts component of the Labor Party policy speech delivered on 13 November 1972 reflected the priorities of a paper prepared by Battersby for Whitlam three months earlier.

The Australia Council

Battersby's paper listed the ingredients for what was to become the Australia Council in 1975. This new body was to promote excellence in the arts; to widen access; to help establish an Australian identity through the arts; and to help promote awareness of this identity abroad. The proposed Council was to be a statutory body attached to the prime minister's department consisting of a number of independent boards to advise on different artforms. So while the aims were remarkably similar to those set out by Coombs and others in the reconstruction era, and retained their strongly nationalistic impulses, the structure was new.

Whitlam implemented his proposed changes quickly on gaining the prime ministership (1972–75). These were halcyon days for the arts. Whitlam was generous with grants, and the general belief in native artistic capabilities was

strong. After Whitlam's dismissal in November 1975 Prime Minister Malcolm Fraser's call for accountability within the Council resulted in severe reduction in funding. Fraser was prime minister from 1975 to 1983. The inquiries and reports which characterise the period from 1976 to 1984 were in effect a catharsis designed to purge the Council after the excesses of the previous three years. Most of these focussed on practical means to streamline management procedures in the Council, but had their theoretical basis in economic rationalism. This new analysis of arts funding and policy formation brought with it much controversy and criticism. Applying economic analysis to the arts was a new technique. Finding appropriate scales for measuring such things as community benefits was bound to cause debate.

Commissions of inquiry and cultural debate

The Industries Assistance Commission Report delivered in 1976 caused dissatisfaction among the arts community and politicians, and its recommendations to phase out funding to the major performing arts companies on the basis that the wider public should not support the private pleasures of a minority group were rejected. Fraser in fact chose to support the Australian Opera, Australian Ballet, and the Trust Orchestras, or so-called flagships, through one-line appropriations from his Ministry.

Two years later Throsby and Withers found an apparently more acceptable method to quantify the public benefits issue using the logic of competitive market economics. Their arguments have been reflected in government documents and official reports since then and are worth summarising:

1. As a labour-intensive industry, excessive cost increases are experienced by the performing arts and so justify subsidy.
2. Support for the arts provides work for artists in their chosen profession, prevents loss of talent to other professions or to other countries and also attracts key non-artistic personnel to the country who require a cultural environment.
3. The performing arts stimulate associated business and consumer expenditures and encourage tourist expenditure.

4. The contribution of arts-associated activities to government revenue means that performing arts are not a net drain on the public purse.

5. People wish to retain the option of attending the performing arts even if they do not at present attend.

6. Economies of larger-scale operation will mean cheaper production costs for expanded artistic activity.

7. The performing arts make available skills and talents to a whole range of activities enjoyed by the whole population.

8. An important range of general community benefits are provided by the performing arts even to those who themselves do not attend the arts. These include: the provision of public creative ideas and aesthetic standards; the development of national feeling, pride and identity; the provision of social comment and criticism; and the social improvement of the participants in the arts.[32]

The so-called 'McLeay Report', completed in 1986, examined the issue of community benefits mentioned by Throsby and Withers.[33] The two main collective benefits derived from the arts were deemed to be those of 'National Feeling' and 'Social Criticism'. National Feeling refers to the pride felt by the people in the artistic achievement of a fellow citizen, especially if that person were recognised internationally, or their pride in the expression of something uniquely Australian. Social Criticism is the benefit gained from the process of critically evaluating artistic views of the human condition. A third benefit which was not dealt with in detail by the McLeay Report but which was part of the original Throsby and Withers thesis is that of 'Social Improvement', or the uplifting feelings and enlightenment gained from the arts.

The McLeay Report focussed on the question of direct grants via the Australia Council. Its first recommendation was to 'democratise culture' by ensuring wide access to a diversity of experiences. The shift in emphasis in the Australia Council to a community arts policy has been seen by some as an important shift in power from a leading cultural group to a more diverse range of workers in unions, institutions, and

ethnic and regional groups. While community arts were represented by a separate artform board within the Australia Council, its influence, according to Rowse, has a wider base in a philosophy of patronage across the artforms.[34]

Whether or not culture can really be 'democratised' by arts policy changes is highly debatable. Access to different artistic experiences is not based only on geographic and financial considerations, but is determined by the matrix of social background, education, opportunity and taste predilections of every individual. The solution to limited access has often been found in wider geographic access, or regionalism policies, but these can provide only a partial remedy.

Throsby and Withers likened the arts to 'a public good' in their examination of the economics of access. A public good is one that is non-rival in consumption, that is, the same unit of good can be consumed by many individuals and its availability to one individual does not diminish its availability to others. This cannot be the case with expensive opera seats, for example, which are unavailable to many people not only because of their price and location, but because enjoyment of the artform requires education and taste acquirement.

This line of thought is subject to uncertain developments: are events which have mass appeal the only acceptable contenders for government subvention? Are we to ignore all artforms which require some sort of educational background, training or prior knowledge to transform their enjoyment to a different level? Who is to decide what is 'expensive' and what is an acceptable price to pay?

It is clear that the very cultural diversity aimed at in access arguments can be lost if there is too much intervention in control of the arts. Perhaps the basic fallacy in the public good assumption lies in the likening of the highly individualistic activity which is art, to something as generic and basic in its requirement as a non-rival item of consumption. All cultures need government institutions, certain environmental standards and laws so that individuals can function well within them. Art is a facet of these needs, but cannot be judged solely by whether it is always accessible to all people. Individual artistic events cannot be summed up

against permanent facilities like laws, parks and buildings. Individual artistic events cannot be non-rival in consumption by the very fact that they exist in certain locations and at certain times.

By the end of Fraser's prime ministership community attitudes, participation and needs in the arts had changed as greatly as the style of arts administration. The Australia Council Annual Report of 1983/84 commented on the nexus between funding and policy and the flow-on effect of their strengths and weaknesses. The arm's-length principle had become sacred, and peer-group assessment highly favoured. Professor Di Yerbury, General Manager of the Australia Council 1984–86, outlined the advantages of arm's-length funding:

- support for the arts can be carried forward without fear of political censorship or pork barrelling
- arts policy formulation can be sustained and policy makers are protected from undue sensitivity to current political or short-term priorities
- goals are arts-oriented rather than politically motivated
- support for the innovative or risky or experimental is forthcoming
- rotational membership ensures against entrenched viewpoints
- appropriate advice can be channelled to government.[35]

Peer-group assessment, or judging of grant applications by fellow artists practising in that field, was considered the most logical and effective way to make informed funding decisions. Peer assessment has since come under review.

Bob Hawke's election speech for 1983 promised the restoration of flagship funding to the Australia Council, the strengthening of Australian content in film and television, and the encouragement of community participation, access and decision making in the arts. He also promised the return of funding to 1975 levels (1975 has been termed the period of the 'arts boom', when, under Prime Minister Whitlam, funding increased rapidly). Only the first promise was delivered. In fact little sensitivity to the arts was shown from Hawke or his arts minister Cohen, and many observers

have noted their predilection for using the tall poppies of the art world to their own political advantage.

Donald Horne chaired the Council in these years, making a recognisable contribution to the examination of national culture. His strong advocacy for innovation and experimentation was based on his belief that these create the embryo of future artistic excellence.

Separation and subvention

Government subvention has followed an interesting pattern in Australia. The inadequate private patronage of colonial times was replaced early this century by vibrant support from dedicated amateurs in community organisations and professional entrepreneurs who imported shows as well as providing work for locals. Both groups then became lobbyists for government support as the private economy could no longer support artistic growth, and as the general desire became apparent for showcase art indicative of the nation.

Government support increased from the postwar years on, as did the policy control over it. Flagship funding and centralisation of institutions helped develop the showcase pieces desired, but soon a call for a more democratic and less centralised funding arose, reflecting a desire for democratic institutions from society in general.

The main funding body responded by supporting diverse community arts at the grassroots level, as well as the major institutions, and by managing that support through the mechanisms of arm's-length funding and peer assessment. The resulting growth in myriad smaller arts organisations has now caused the Australia Council to encourage and support the industry and training of managers as well as providing grants for artists. State and local governments are increasingly taking up the call for this kind of individualistic funding. Separationist policy such as this will be important in creating the basis for self-funding and independence.

National identity and the arts in Asia

The correlation between national political independence

and government support for arts and culture industries has followed a similar pattern in Asian countries.

Concurrent with the republican movement in Australia is the push to increase trade links with Asian countries. The increasing Asian immigrant population and Asian cultural influences have also resulted in artistic trade with these countries. Arts companies are targeting the Asian market more as other kinds of trade and tourism exchanges become established. Asian trade ministers have noted the need for Australians to understand and appreciate Asian culture before embarking on in-depth negotiations.

Many Asian countries have, like Australia, experienced a search for national identity while changing from colonial rule to independence. In some cases this cultural rediscovery has followed political suppression.

At a 1995 conference of Asian and Australian arts managers, Tiongson claimed that 'if Asian nations are to survive and prevail, they need consciously and systematically to create a culture that will transform the ethnic into the national'.[36] In this way traditions are brought into the context of the modern nation. Tradition, race and religion are issues of overriding concern for artists and arts policy makers in Asian countries.

Science and industrialisation have impacted on Asian countries in the latter part of this century. Predominantly agrarian societies with strong religious and cultural traditions have come face to face with Western culture, urbanisation and capitalist economic structures. Many of these countries have also experienced the quest for independence from a colonial power or powers, and are inhabited by diverse racial groups. The need for an enduring set of values to provide a balance to the materialism and rapid physical development has been addressed by artists, arts managers, and socio-cultural policy makers in many Asian countries in the past two decades.

Malaysia gained independence in 1957 but racial and cultural unity did not automatically follow. The question of national identity was much debated during the 1970s and still is by the country's policy makers and artists. Race, tradition and religion are the three elements which policy

tries to unify in searching for a national identity. Racial integration has been a particularly important issue in Malaysian cultural policy owing to its volatile and diverse social profile.

As in Australia, artists are important figures in the interpretation and presentation of a cultural identity. Rajah Fuziah and Azizan Baharuddin report the recent development in the Malaysian art scene of the commitment of Muslim artists not only to the Nusantara/Malay art heritage but also to Islam.[37]

In Japan, improved standards of living have allowed people to take more notice of cultural aspects of their social lives. The Japanese have demanded more cultural activity and performing arts venues and art museums have tripled in number in the past decade. This huge expansion into the culture and leisure industry has been supported by governments at the national and local levels, and by the corporate sector. Corporate support for the arts accounts for the majority of funding in Japan. The problem remains that much of this culture expresses values and forms of economically and educationally dominant groups from big cities and has failed to affect the lives of many rural or uneducated citizens. The democratisation debate is as relevant in Japan as it has been in Australia.

Responding to this perceived unequal distribution of cultural goods, local governments in Japan have tripled their cultural budget over the last decade to assist in such projects as establishing community buildings and forming or reinvigorating arts groups. Local government support and promotion of rural culture has in fact taken precedence over the promotion of industries in many areas.[38]

In the Philippines World War II is seen as a dividing point in cultural history. Americanisation and the collapse of ancestral homes and magnificent churches had deteriorated cultural identity. After the war the survivalist ethos of a society ruled by money-hungry and corrupt politicians annihilated traditional values and icons. The Marcos regime promoted materialism and institutionalised corruption.

Rebuilding culture and cultural identity in the Philippines must incorporate a conservation movement to reclaim

and document traditional artforms. Tiongson claims that artists in the Philippines must go through a purification process to rid themselves of Western influences and rediscover their traditional artistic roots.

> They [the artists] must seriously reflect on traditional art forms to understand their philosophy and context and to appreciate the integrity as well as the integration of these arts within the communal societies that nourished them . . . As the artists open themselves up to the masterpieces of tradition, they must exorcise themselves of artistic criteria derived from the West, which made them disparage their own native traditions as backward or 'quaint'.[39]

Countries which have developed further in the international marketplace and have enjoyed more stable political situations are less concerned with using art as a mechanism for social engineering and recovery. Japan, like Australia, is concerned with access issues. Japanese business has become a major supporter of the arts alongside different levels of government. Culture has become a commodity with important societal functions. Singapore has also identified arts and culture as a major focus for development. A large arts centre in Singapore is seen as a means to attract tourists and place Singapore as a cultural destination for affluent regional Asians.[40]

Expressions of national identity in these countries will help reassert their differences to outsiders as well as to the people themselves. It is the responsibility of arts managers to keep informed about the dialogue of national identity and to prevent the distortion of images which can arise when market forces are unqualified by artistic integrity. With this safeguard, creators and consumers can benefit from discussions of national identity in arts policy and through art product.

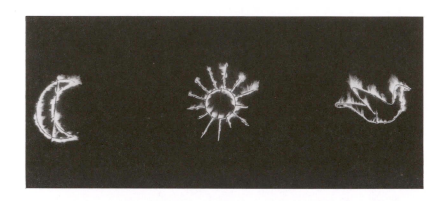

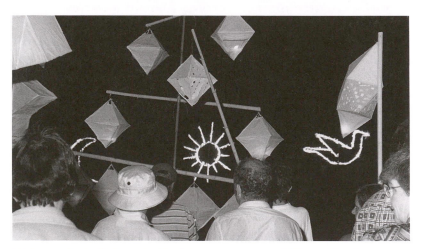

'Arts on fire', Artists in Residence Program, Prince Charles
Hospital, 1994.

SECTION 2

Arts management and the community

The issue of customer satisfaction is highlighted in the relationship the arts manager and the arts organisation develop with the particular demographic community. For market researchers the community can be customers, clients, publics, consumers or target segments. An arts community includes the artists, the patrons and the audiences, and those who participate in the artistic experience as managers and decision makers. The arts manager's role is to address the needs of each of these customer groups through media management, marketing strategies, and legal and ethical behaviour. This section of the book marks the social responsibility of the arts manager in fulfilling the mission of the organisation.

── Case study 1 ──

Arts on fire

A community arts project involving integration of people with a mental illness into the community through arts activity.

This case study has been selected because it addresses the issue of arts management and community cultural development within the complex framework of several professional management stakeholders exercising control and influence on participants and outcomes.

The goal of the project was to develop a national model for empowering people with psychiatric disabilities to integrate into their communities through community-based arts projects. Called the 'Mental Health Project', it was managed by Access Arts, a non-profit professional arts organisation supporting people with disabilities; co-ordinated by a project officer; and funded by the federal Department of Human Services and Health. It employed eight artists and a research consultant; responded to various community consultations; depended on local government human and financial support; and incorporated constant evaluation by health professionals. Planning and goal setting, reporting and information flow, and community relationships had to be balanced with the creative process of artistic activity and the well-being of the people experiencing a mental illness.

Though complex, the case typifies community arts activity and the critical role of arts managers in facilitating such projects in the contemporary environment of multi-government department funding for community cultural development.

The objectives of the project focussed clearly on mental health patients because those objectives fulfilled the mission of the managing arts organisation and the criteria for funding from the government department. While acknowledging these social justice

issues, the project was essentially a community arts project. The benefits for people with psychiatric disabilities were nominated as increased quality of life and community living skills and reduced dependency on health services, but there were also community benefits. In particular these involved new and strengthening relationships between people with mental illness, mental health services and community groups.

Two very different communities were chosen to provide sufficient data in developing a model for integration that could be implemented elsewhere in any community by an arts organisation, a local government or a community health service organisation. The first community, Kedron/Wooloowin, is an inner northern city suburban area of Brisbane comprising retired pensioner residents and a changing residency to professionals with young children who are renovating the popular old Queenslander homes in the area. Income level ranges from pensioners to two-income professional families. The area is well serviced by bus, train, shops and primary and secondary schools. Recent proposed road changes involving the construction of a freeway to the airport through this quiet suburban area provided a vital rallying point for the community through meetings, parliamentary delegations, doorknocks and increased festival and arts activity. Kedron/Wooloowin is close to the office of Access Arts and to day centres of the Winston Noble Psychiatric Unit of the Prince Charles Hospital.

The second community was the rural satellite town Caboolture, one hour by train or car north of Brisbane. The Caboolture Shire covers 1215 square kilometres and incorporates a range of lifestyles from medium density residential, rural residential, rural, to beach and island homesites. Housing is cheap and available and the area has experienced rapid population growth in recent years. Two thirds of the population have no further schooling past sixteen years; the annual income for nearly half the population is less than $12,000; and unemployment is higher than average. Caboolture embodies a climate of social and economic disadvantage with a high percentage of people with mental illness. Fifty per cent of people living near the Arboretum, where the art projects are now installed, have been identified as requiring the Caboolture Mental Health Service.

Art and cultural activity are recognised by governments around the world as 'public goods' having 'benefit' for the spiritual well-being of all people in the community. Access and participation are key issues in government funding for community cultural develop-

ment. Through art, community participants can explore the creative process and express emotional, intellectual, social and physical needs.

Community artists are skilled in creating an environment where each individual can participate, enjoy and thrive on the artistic experience, whether it be dance, storytelling, painting, clay modelling, wood carving or mask making. A community can find its 'sense of place' through the shared experiences in artistic activity.

People with mental illness often endure a restricted, isolated and marginalised life. They are perceived negatively by society, and through heavy reliance on formal human service organisations such as a mental health service centre or day centre at a psychiatric hospital their powerless and vulnerable position is reinforced. Evidence is available indicating that involvement in community arts projects leads to social interaction and friendships, communication and personal skill development, self discovery, empowerment and confidence, improved community relations, reduced reliance on mental health services, and increased supportive networks in communities for people with mental illness.

The managing organisation, Access Arts, together with the project research team (two health professionals, project co-ordinator, research consultant) met in early March 1994 to prepare and plan the project tasks, artist recruitment, selection of target groups, and documentation and evaluation methods. Having chosen the two communities because of access to health professionals and people with a mental illness, resource availability, community needs and a basis for comparative analysis, the criteria for selecting the artists focussed not necessarily on artform skill, but rather on strength of communication, quality and standard of art work, leadership skills and capacity to work with a community.

The artists were required to design the project as a team with installation of completed art work in a public park as the culminating event. A diary sheet of each session of arts activity was prepared for them to document the date, goals, outcomes and participant experiences. Further evaluation of the project's progress was planned through community consultation meetings, survey questionnaires, focus groups with health professionals, carers, the artists and with the 'core participants'. This was the name chosen for the people with mental illness in order to differentiate them from other community participants, many of whom were also disabled by hearing, age, sickness or adolescent behavioural disorders. For ethical reasons all core participants were invited to take part in the

project and agreed to the established procedures in psychological testing being used to measure any increases in community living skills, increases in severity of illness and increases in social networks. The documentation and evaluation was designed to employ the techniques of literature search, participant observation, in-depth interview, focus group interview, survey data analysis, psychological testing and qualitative anecdotal diary recordings. The arts were the process for achieving the technical goals of the project.

In responding to the media advertisement, artists were invited to 'express interest' in full-time contract work for two to eleven months 'on a project to develop a National Model for community cultural development projects involving people with psychiatric illness in arts projects with their local community'. Three artists were employed for the Kedron/Wooloowin community: a sandstone sculptor, a metal and stone construction artist and a community artist. All artists also worked in clay, mosaics, linocuts and print-making. These artists began work in April 1994 and stayed with the project until the installation and opening of the sculpture walk in Melrose Park in Wooloowin. Five artists were employed to work in Caboolture over the period September 1994 to March 1995. These artists possessed artform ability in storytelling, wood carving, painting, drawing, metal and wood sculpture, dance, movement and drama, puppet and mask making, ceramic tile making, linocuts and printing.

The artistic activity revolved around the skills of the artists, the needs and development of the core participants and the design of the culminating installation and event in each location. A workshop was conducted with the artists prior to commencement of activity. This comprised the project co-ordinator and the Access Arts manager discussing mental illness and disability and the goals of the project. Artists were given the option of attending regular research meetings held at each arts venue during the twelve months of the project.

In both communities, public meetings were held to gather community input into design and cultural outcomes, involve the Council in community decoration of the landscape, and inform the community of the goals for the core participants. In Kedron/ Wooloowin the Brisbane City Council was immediately involved and made available the services of designers from the Department of Parks, the community arts officer and later council workmen and equipment. Councillors were present at the first and final commu-

nity meetings. In Caboolture, the Council made an initial effort at support through the newly elected mayor at the first public meeting. Later as Council politics and staffing changes occurred, delays in decision making, lack of understanding of the values of the project and provision of substandard accommodation for the arts activity all caused problems within the project. Not until the last few weeks before the project concluded did the Council show interest, appreciation or support. And then it was very valuable, involving moving heavy sculptures to the site, laying cement slabs and tiles, erecting structures in the lake at the Arboretum, and finally a Councillor delivering an opening speech of congratulations and genuine warmth for the artistic achievements for the community.

The artistic activity proceeded with enthusiasm and reward in both communities. The Melrose Park project in Kedron/Wooloowin was conducted for children from nearby schools including a hearing-impaired group from the local secondary school, residents at the Mercy Centre Workshop and the Newstead Special School, parents and children living near the main workshop centre called the Art Surgery, and people experiencing mental illness from the Prince Charles Hospital.

The selected group of core participants worked predominantly at a halfway house which provided a safe, creative environment away from the day centre at the hospital. The artist-in-residence for this group has a background in psychiatric nursing and with hospital approval conducted the workshops for this project at these especially prepared venues away from but administered by the hospital. Linocut prints on handmade paper were proudly displayed at the Arts Surgery after one of the Melrose Park artists visited the group and discussed making frames for their prints. The most rewarding artistic outcome for this group was the local coffee shop proprietor offering to install special lighting and tracking to exhibit the works publicly. In addition these core participants contributed to the mosaic tiles, etched clay pavers and sandstone carving later installed at Melrose Park.

At a final meeting the core participants declared that their self-esteem and their friendship networks had increased; access to other community networks had expanded; they were less dependent on the day centre and their expectations of community arts were fulfilled with the pleasure of 'leaving something behind in the park'. The artists observed that this group were self-directed and worked as a cohesive unit, while other participants with mental illness who joined the project lacked spontaneous creativity. This

could be attributed to the stage of their illness and the amount of medication being taken. The benefits of the project were clearly observed in the changed community participation and relationships of the core participants. General community participation decreased markedly until local residents observed and participated in the final installation at Melrose Park. The community benefits longer term in such a project through the structures in the park and the stories that are told to visitors by those who witnessed the transformation and the installation of the sculptural artworks.

The Kedron/Wooloowin project was well organised, physically close to the management at Access Arts, and the artists worked independently but with clear goals for the structures to be created from an initial collaborative design.

Two ethical concerns arose, the first in media reporting and the second involving a hospital ethics committee.

Access Arts, like many organisations associated with people with disabilities, has a clearly defined media policy which aims to reinforce positive public images of people with disabilities. Each media opportunity is viewed as educational regarding the use of appropriate language and positive imagery. Participants in Access Arts' activities are people first. Language which demeans or marginalises a person's abilities, experiences or talents is avoided. Persons in photographs are referred to as community participants in an Access Arts project, never by their disability or by their institution. The organisation always prepares press releases in advance and follows up interviews with supporting information.

The local community newspaper gave excellent coverage of the Melrose Park project with photographs, a description of the Council support and the artists' creations, as well as a sensitive outline of the project's objectives:

> Many people with disabilities, including those with mental illness, live independently or with support in the community, but are too shy or lack opportunities to have contact with others around them. The Melrose Park Project is a focus for all people in the community to be involved and recognised as participants and contributors, without the labels of 'elderly' or 'disabled'.
>
> Access Arts invites all individuals and groups in our community to participate—either as a one-off visit, or seeing an idea through from initial design stages to completion—you don't have to be 'artistic'—everyone has a

creative streak which the Access Artists will help you discover!

Melrose Park is evolving into a rich melting pot where government grants, community ideas, sponsorship and creativity in many media have come together . . . [1]

However, the media policy safeguards were not sufficient for ethical media reporting by a particular university paper, *The Weekend Independent*, which contained the blatant headline 'Art paves the way for mentally ill'. Accompanying photographs taken at the time with permission consequently linked the persons in the photographs with mental illness.

The second major concern involved the Prince Charles Hospital Ethics Committee. The hospital administration has maintained support for an artist-in-residence program for some years providing funding, equipment and acceptance of the wider community involvement in the care of people with mental illness. While all research for this project was carried out in accordance with national research standards in ethics and the confidentiality of individuals was protected, the hospital Ethics Committee had reservations about the value of community arts research and about patients making these choices regarding their own rehabilitation. The project understandably did not comply with the hospital's view of biomedical research. The administration of clinical analysis and measurement tests, vital to the outcome of the project, was questioned. Rather than abandoning the planned clinical evaluation completely and as participants were voluntarily taking part in an open community activity the project team invited core participants individually to take part in the clinical evaluation. The problem was therefore resolved, but revealed that the issue of ethics in this case was a management and ownership issue. Who is responsible for the patient's well-being: the patient, the hospital, the health professional, the current carer, the artist, the project manager?

The artists' group at Caboolture faced a very different community, environment, workspace, target group of core participants, management style and Council relationship. The project was delivered in three phases, not actually identified until one month before the conclusion. The introductory phase involved investigating arts experiences and developing confidence through linocutting, paperwork, metal and wood construction, storytelling and ceramic tiles to be painted and fired. Essentially it connected artists, core participants and community workers such as the Blue Nurses,

schoolteachers, aged group carers, administrators and human and health service professionals. The second phase comprised finding a focus and direction for the arts activity through hatmaking, ceramic tiles, body painting, theatre and movement, lantern and puppet making. This culminated in an end of year celebratory fire event in December where health professionals, core participants, artists, Blue Nurses, Councillors, students and teachers, community family, friends and observers came together in a spirit of keen interest and excitement. The value of the project was heightened and an impetus created for its final phase in the New Year. Health professionals and mental health service consumers developed clearer understanding of each other's needs and roles through shared pleasure in the celebration. The third phase from January to March 1995 involved movement and dance workshops, carving the wooden seats and creating the metal and bamboo structures, all to be presented and installed at the final Fire Event on 24 March.

With the pressure of a concluding event to the project, problems emerged. The Caboolture project had begun hesitantly with artists spreading themselves geographically in pockets over the Shire attempting to give as many groups as possible access to the arts workshops. The corrugated iron store shed in the park provided by the Council as the arts workspace was exposed to wind and rain, inadequate as security for tools and equipment, substandard in terms of health and safety, too small for groups to work in and lacked the storage space for the wood carvings and metal sculptures which were constructed elsewhere or in the open park. Questions were now being asked by participants about future cultural activity: what action could be taken to ensure ongoing Council and community support? The artists expressed concern about the duality of their role and goals: were they involved in artistic production or in the personal development of people with mental illness or in community cultural development? Too many of their arts workshops were influenced by the external factors of Council attitudes, the community's lack of identity and the emotional tension of the core participants' behaviour. The research team spent much time in reassurance.

In the final weeks the artistic activity developed with intensity in preparation for the installation, event and opening at the Arboretum. With focus, action plans and dates for achievement, the group of artists and core participants worked in a teamlike manner. The project had become a two-way learning process: artists learn-

ing about the core participants and their learning about forms of art. The artists at Caboolture worked collaboratively through most of the project, sharing ideas and concerns with each other and with the research team. The community artists believed that their sensitivity, perception, and open and honest communication enabled them to know more about the core participants with whom they were working. The health professional claimed this unnecessary.

Nevertheless following a second impressive opening, installation and Fire Event at the Caboolture Arboretum, the project concluded with a post project debriefing for a very small group of core participants who joined the original storyteller and recounted the 'journey' that had taken place.

Conclusion

The stone, metal and wood structures remain in place in both parks and are a memorial to the artists and mental health patients who created them. They are valued highly by the local communities. Initial interest in filling the void left by the arts activity subsided. A change occurred, primarily in Caboolture, where the core participants in the community arts project disbanded their New Life group because networking and more important independent initiatives took over their lives. Clinical tests proved that the community arts project achieved its goals for the majority of the core participants in both communities. In Caboolture the Council is considering appointing a community arts officer and the Mental Health Service has prepared a proposal for funding a community development officer to eventually be self-funding through a local group.

Case study questions

The project in this case study was in many respects self-managed or managed by committee, and this caused problems. Consider the following issues and how the arts manager should address them:

1. What framework or processes should be designed to ensure community arts workers meet their social, ethical and legal responsibilities with the varying community participants in arts activities?
2. How could the role conflict of carer and artist have been avoided for the artists in the Caboolture Mental Health Project?
3. What strategies could be implemented to overcome lack of

interest by councils and community members in arts projects in their own communities?

4. How can community arts projects help communities develop a long-term 'sense of place'?

5. What guidelines should be established for communities in other parts of Australia to develop a similar community arts project aimed at integrating people with mental illness into their communities?

— 2 —

Marketing

Marketing in the arts is the strategic process that fulfils the mission of the organisation.

The purpose of this chapter is to construct a framework for planning the marketing activity for an arts organisation, whether that organisation is a performing arts company, a gallery, a museum, an arts centre, a community arts network, a writing group, a touring organisation or the arts program in an educational institution. For all of these the marketing principles are the same.

From the mission to implementation and evaluation, the product, price, promotion and place strategies of the marketing plan emphasise the need for customer orientation rather than product orientation. This is particularly so in the revenue-generating marketing strategies of fundraising, sponsorship and strategic alliances. The key areas of arts marketing in the chapter are:

- customer orientation
- the principles of marketing: price, product, place, promotion
- marketing planning
- market research
- fundraising
- sponsorship
- strategic alliances.

Marketing defined

Marketing the arts is the process of linking the art with an audience. The process involves action, communication, implementation, feedback. Marketing is not a static plan that once prepared becomes a book of rules, nor is it a set of tactics designed to coerce an audience into participating. It is an ongoing dynamic two-way process. The variables involved in the process are the artistic company or organisation, the product and communication, the audience, the response and money paid by the audience, and the environment.

While most arts managers are not marketing professionals, the size and budget of the organisation often determines that the manager assumes the marketing responsibility. However, every person in the organisation, from board member, government representative, general manager, artistic director, curator, to box-office operator, information officer, shop manager, all must have a marketing orientation for the organisation to survive. The organisation should consider itself in crisis if the board, or the general manager, or the artistic director is heard to say, 'Oh that's the marketing department's problem, they have to find the audience'.

When used well, marketing can play a major role in achieving the objectives of the organisation. In arts organisations, those objectives are complex and usually involve a combination of artistic, financial and social goals.

Commercial organisations generally aim to promote and distribute a product or service effectively so that the organisation makes a profit. The product can be discontinued if demand is not forthcoming, but in the arts the product is the motivation for the activity of the organisation. Those who engage in arts and cultural experiences believe in the value of art and culture and that it nourishes the soul, helps people understand others, expresses the society's aesthetic and spiritual values, and creates an identity for the nation. Artistic and cultural activity is at the core of the vision or mission of the organisation. Marketing in the arts is the strategic process that fulfils that mission.

It is accepted that the arts product motivates the

organisation's activity, but the most important aspect of all marketing is thinking about people, looking at the organisation from the point of view of its customers—audiences, visitors, readers, government departments, sponsors, members. Marketing means thinking about what kind of audiences the organisation has, and what it wants to have, learning as much as possible about them, and finding ways to reach and motivate them to become first interested, then involved with the organisation. All of this is in order to achieve the organisation's objectives.

Marketing is not the same thing as publicity and public relations. It is not all about making money. It does not seek to dictate the programming of the product. Public relations, advertising and promotion are tools of marketing, forming part of the 'marketing mix'. Whereas in profit-motivated organisations, sales are the key measure of success, in the arts, marketing serves multiple and complex objectives—making money is a means to other ends. The relationship between the artistic program and the marketing program is crucial and must be based on artistic integrity—good programming in the arts is the best marketing tool in the world. Used in the most proactive way, marketing is a long-term planning tool which asks 'where do we want to be?' and gives the answer to 'how do we get there?'

The first comprehensive overview of marketing the arts appeared in the 1970s in the United States. North America had been strongly influenced by Danny Newman and his subscription promotion scheme to build audiences for the arts. In Australia, a subscription selling package was produced for the Australian Ballet in 1967, and in 1968 the Ballet's marketing manager visited the United States to study the latest developments in arts marketing. By 1979 Timothy Pascoe, director of the government and privately funded consultancy Arts Research, Training and Support Ltd (ARTS Ltd), brought Keith Diggles, a marketing consultant from England, to run seminars on marketing the arts. Diggles' marketing strategies were designed to achieve artistic goals for secondary financial rewards. In 1980 Pascoe produced a 'how to' booklet in Australia, 'Marketing the Arts'.[1] Books specialising in arts marketing were not published until 1979

(Reiss),[2] 1980 (Mokwa),[3] 1983 (Melillo)[4] and 1986 (Diggles).[5]

This specialised view of arts marketing was prompted by the realisation that resources had been taken for granted. Competition for earned revenue and external funding had increased significantly, and rarely were arts organisations using marketing skills. Since that time increasing attention has been devoted to finding out what motivates arts consumers. It is generally recognised that advertising coming events is not enough. It is now understood that the consumer determines whether a transaction is to occur and that a wide variety of factors enters into that determination. When supply exceeds demand, the consumer determines when and at what price the transaction will be made: currently the supply of arts products far exceeds the demand, although this is being addressed in cultural industry development strategies.

Marketing planning must start with customer perceptions, needs and wants. In the past product determination and the means of communication in the arts have been driven largely by the egocentric desires of the arts organisation and by a theorised image of who the consumer is. Product selection, whether the season's repertoire or calendar of events, is too often based on the desires of an artistic director who has little concern for or understanding of the needs of a presumed audience. Communication is usually addressed to a faceless mass. Most arts organisations tend to be product and sales oriented, focussed on satisfying their own needs, rather than being market oriented or focussed on satisfying the needs of the customer. There is a fear of sacrificing one's artistic integrity if the thrust of programming is consumer oriented. To alleviate this fear, a balance needs to be established between what the consumer wants and what the organisation wants. It is not a matter of either/or, it is a matter of market analysis and using creative judgement in both program selection and communication.

Many arts organisations have conducted demographic surveys in an effort to identify their current consumers. The results have provided a rather flat profile of such factors as education, age, gender, income and occupation. Demographics tell who is there, but not why. Lacking in dimension, these studies have rarely revealed descriptive information about

the values and lifestyles of consumers and the factors that motivate their purchase and consumption of the arts product. Little information has been gathered that identifies the role or roles that the arts play in the consumer's life.

Media coverage of the Australian Opera in 1993 included the general manager's announcement that the company was expecting an operating deficit of between half a million and $1 million. Box office was reported as considerably down. The general manager stated that the recession had meant that consumer caution was much greater than the previous year. Opera goers who might in the past have bought tickets for new productions with mixed reviews were now inclined to save their money for the 'safer' productions later in the season.[6] Artistic programming has usually been based on product (repertoire, artist and orchestra) and venue availability together with budget information. Had the Opera been customer oriented rather than product oriented, market research and ongoing economic forecasting for ticket pricing may have prepared it for customer rejection.

At about the same time *The Australian* reported acclaim for the contemporary Australian opera based on the topic of black deaths in custody which had won the prestigious Grand Prix Opera Screen 93 Prize in Europe. The writer and director of the opera, Kevin Lucas, was quoted as saying: 'Being awarded the Grand Prix Prize signifies that Australian contemporary music has suddenly been embraced by European classical music lovers and critics, and also the future direction of opera is to create new and challenging works relevant to the issues we all face today.'[7]

The two media reports conflict. In one, the general manager claims audiences are waiting for 'safer' opera productions. The second makes a declaration of audience demand for new challenging contemporary opera. Neither assumption had any basis in consumer research, and the Australian Opera commentator even stated that 'there is no way of predicting accurately how successfully a company's program for a season will be'.

Non-profit arts organisations can no longer afford to operate without planning, controls, market research and marketing strategies. Commercial arts organisations and

entrepreneurs utilise market research extensively: research carried out to predict sales of tickets and the full season return for *Les Miserables* at a Sydney theatre in 1993 proved to be accurate within 1000 seats.

Similarly, governments making arts policy that results from a general goal of regional development and access and participation for those geographically disadvantaged, may decide to fund an opera company for regional touring. Such decisions are not always based on market or consumer research which would inform decision makers which communities would pay what ticket price to see which productions. Market planning that begins with the organisation and what it wants to offer assumes that consumers will settle for anything the market tries to persuade them to buy. Those marketers try to change consumers to fit the product the organisation has to offer. Customer orientation requires that the organisation regularly studies both the internal and external customers' needs and wants, perceptions and attitudes, preferences and satisfactions. This audience feedback together with market information (market research) is an important resource enabling the decision makers within the organisation to improve the offerings to better meet customers' needs.

Market research

The value of market research to arts organisations must be equated with the cost, the benefits and the relevance of the information collected. Simple research can be conducted at the point of sale by collecting names and addresses. This postcode database can then be analysed through the Australian Bureau of Statistics (ABS) census data or similar statistical data gathering agencies to locate clusters of comparable potential audience groups of similar education, income, age and gender. These demographics are part of the basic marketing data system and all arts managers would accumulate such information regularly to identify audience and visitor segments. 'Front door', 'ticket sale' and 'subscription' entry into the arts venue or event should provide sufficient information to list segments such as tourists

(domestic and international), families, students, single ticket purchasers, repeat buyers or attendees, group buyers or 'package' purchasers. However, far more information is required for market planning.

Market research may be qualitative or quantitative and is often a combination of both. Qualitative research includes focus groups, observation and interviews where the emphasis is on understanding the underlying motivation and behaviour of audiences and potential audiences. Quantitative research includes all forms of survey sampling and analysis. Marketing research is conducted in order to understand and resolve a marketing problem. Typically the six steps involve defining the problem; conducting preliminary research through a focus group; designing, piloting and adjusting the questionnaire; administering the questionnaire to the selected sample; analysing the results; and presenting and implementing the report.

A focus group consists of six to ten people who participate in a relaxed, semi-structured group discussion on the research problem facilitated by the market researcher. The resulting notes may be compared to other focus group results and used to design a wider sample survey questionnaire.[8]

A survey questionnaire must be delivered to a random sample of the population in the knowledge that all members of that population could have been involved. The data can then be adjusted against the population size. The following points should be considered in questionnaire design:

- use simple conversational language
- ask difficult or sensitive questions last
- seek demographic information last (do not hesitate to ask for income, family and employment details)
- avoid open-ended, ambiguous, hypothetical or leading questions
- ask only for information required
- organise questions in a logical manner to reduce errors
- design the questionnaire so that responses can be presented as numerical data for computer data entry and analysis

- pretest the questionnaire with respondents similar to those for the final survey
- consider privacy and ethics, and decide whether to ask respondents to identify themselves (name, address).

The systematic organisation and collection of data on markets, customers, competitors and the environment provide the basis for a Marketing Information System (MIS). All market research methods contribute to the data base of the arts organisation.

Figure 2.1 Marketing information system

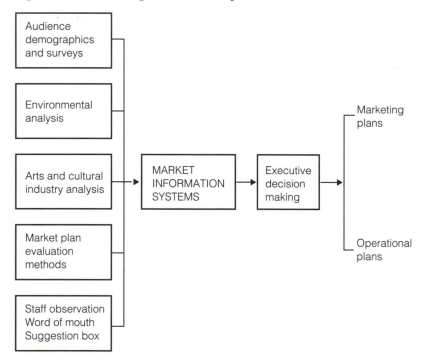

Two market research projects, one on subscribers and non-subscribers of the Melbourne Theatre Company,[9] and the other on the characteristics, attitudes and behaviour of shop customers at the Queensland Museum,[10] provide valuable informative methodology and outcomes of market research. It should be noted that in any market research the selection of data collection methods may be determined by

the available funding. Cost effectiveness is a major consideration for many arts and cultural organisations.

Melbourne Theatre Company market research studies
Both qualitative and quantitative research was carried out to gain a better understanding of the audiences and to use the data to develop optimum marketing and promotion strategies in order to maximise audiences. The qualitative research involved focus groups of subscribers and lapsed subscribers who provided a valuable list of reasons for subscribing and for non-renewals. The Melbourne Theatre Company audience, rather than being an homogenous demographic and attitudinal group, represented many customer segments: different age groups, varying levels of affluence and available leisure time, contrasting levels of interest in theatre, and degrees of gregariousness, that is, size of companionable groups attending the theatre. Each of these audience segments requires the development of individual marketing strategies. The reasons given for subscribing included the enjoyment of watching plays, a fun night out, joining friends in a party booking, studying the play, support for the arts centre (venue), and because theatre was a stimulating experience. Lapsed subscribers gave their reasons as expense, lack of time, subscribing elsewhere, pressure of work, apathy, children in family or the group of friends no longer attending. There was no criticism of the repertoire, standard of production, acting or venues.

The quantitative study was designed on the information collected from the focus groups. Questionnaires were placed on theatre seats at performances on different days of the week. Lapsed subscribers were contacted by telephone or via mailed self completion questionnaires. Members of the general public were surveyed by telephone, door to door interviews and shopping centre interviews. An incentive scheme for completion of surveys with respondents winning theatre tickets boosted response rates. The areas of questioning focussed on attendance behaviour, transport, type of chosen production, customer service, subscription influences, and opinion of productions, venues, season, booking facilities.

The market research offered the company a series of

opportunities for marketing initiatives: school involvement, subscription schemes, social events, venue tours, radio advertising, patron on-selling, more comedy in repertoire, and a more fully used booking system.

This and the following Museum Shop market research study emphasise how audience/visitor feedback provides valuable information to the organisation in establishing strategies to meet customer needs.

The Queensland Museum shop survey
The objectives of this survey were to determine the characteristics, attitudes and behaviour of shop customers. This was achieved by identifying who frequented the shop, what was purchased, and what were the unmet expectations of the shop customer. This data helped to identify existing and potential target markets for the shop and thereby assisted in developing shop policy and direction.

A questionnaire was developed in November 1993 based on a literature review and through informal discussions with museum personnel. It was decided that any profile of target customers should contain not only a demographic description but also a psychographic analysis. This involved obtaining an insight into the activities, interests and opinions of the group with questions including opinions on education and the environment, and details of preferred hobbies. The questionnaire was piloted for two weeks in November and a number of changes were made before administering the formal survey process.

A random sampling technique was used to select a sample of museum visitors leaving the museum. Four of the museum's interpretation officers were trained in the data collection which took place throughout the day from Monday to Sunday during the months of December 1993 and January 1994. The participants were directed to comfortable chairs in the museum foyer and any children in the group were provided with a colouring-in sheet to keep them occupied. The respondents completed and returned the questionnaire to the interpretation officer at the information desk. Completion time was between five and twenty minutes. A total of 226 people were approached to participate in the survey with

149 agreeing to be involved, a response rate of 66 per cent. The reason most commonly stated for refusal was the lack of time.

The fact that the survey was conducted during summer may have had some seasonal effect not allowed for in the study. Being school holidays, a number of school age children attended the museum with their parents, possibly spending pocket money on novelty items. In addition, a higher percentage than usual of tourists may have attended. The random sampling and data collection technique used can be subject to human error; the low representation of organised parties in the sample may be indicative of this potential error. The survey was provided in only the English language and this precluded the participation of people who do not speak and/or write English, especially international visitors. In particular, the surveying procedure was aimed at museum visitors only and did not attempt to survey non-museum visitors. However, target marketing suggests a penetration strategy into existing markets and improvements to better meet the needs of non-shopping and low spending museum visitors.

The museum visitor profile comprised 62 per cent females and 38 per cent males with 55 per cent between the ages of 30 to 49 years. A large proportion (44 per cent) of those surveyed lived in the Brisbane area with the remainder (56 per cent) being tourists from intrastate, interstate or overseas. The main reasons for visiting the museum were 'general interest and curiosity' and 'to bring the children'. Slightly less than half of the museum visitors entered the shop. The most common reason stated for not entering the shop was 'did not want to spend any money'. Although only 17 per cent of visitors said they did not see the shop, there is a need for the shop to make a stronger visual impression. Of those who entered the shop, 68 per cent made a purchase. Most people made purchases under $10, $49 being the highest purchase. Tourists and Brisbane residents were equally as likely to enter the shop.

The museum visitors were well educated, over half with university education. The occupations of museum shoppers were most commonly homemakers, managerial/business

owners and professionals. Retirement aged visitors were found not to enter the shop, thus requiring further research to identify the specific needs and wants of this group. Tourists were slightly more likely to purchase once in the shop.

A psychographic analysis which derives information on the respondent's behaviour, lifestyle, beliefs and attitudes, revealed that museum visitors hold education, educational activities and environmental issues in high regard and pursue hobbies such as bushwalking, camping, reading, travel, gardening, classical music, care of native animals, photography and collecting items.

Considering the level of customer education, the purchase of books in the museum shop seemed quite low. The high percentage of dinosaur items and novelties reflected the high number of groups who entered the shop with children and is symptomatic of the main reason people come to the museum in the first place, that is, to bring the children. It also highlighted the number and effect of children who are influencing the purchase decision despite the fact that survey respondents nominated 'value for money' and 'quality of products' as the most important criteria when shopping.

The potential of the children's market cannot be ignored given that 56 per cent of groups who visit the museum comprise at least one child. Groups with children were also more likely to enter the shop and purchase. The fact that the museum audience placed a high value on education and displayed a high education and income level presents opportunities to provide high quality educational products for children, for example, microscopes, nature kits and quality books. Overall, the survey highlighted the opportunities that existed for the museum management to 'adventure into more sophisticated and expensive items' in the shop, and to place a higher profile on the merchandising aspect of the museum's product and service.

These conclusions from market research do not imply that the customer is always right, nor that the arts product should be designed for the prime purpose of securing the patrons' money. The customer-focussed organisation tends to target audiences and develop a total package for the arts

product or service that influences audience or patron purchase and use decisions. The organisation is then in a position to determine who that audience or patron will be and how to maximise the volume of the exchange.

Product, price, place, promotion

The total marketing package includes the four key areas of product, price, place and promotion. These are variables which can be controlled by the arts manager, and a strategy formed for each to satisfy a target group of customers. Combined, the four p's are referred to as the 'marketing mix'. The diagram in Figure 2.2 shows how the customer perceives the organisation.

Figure 2.2 The marketing mix

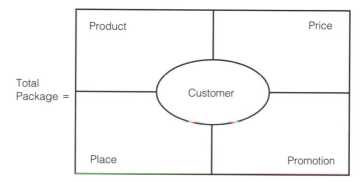

Marketing in the arts is the process whereby the organisation's goals for its arts and cultural products and services are strategically developed and implemented to meet carefully researched price, product, place and promotion preferences of targeted customer groups.

The arts *product* is based on an experience. The organisation is not selling tickets, it is selling an experience. A product consists of three parts. The core is the essential needs satisfying offering. The tangible is the physical form that can be seen, touched or heard. The augmented product comprises the additional items in the product package ranging from guarantees, parking, complimentary program, refreshments, information talks, to a supplementary arts product.

The arts offer to the customer is tangible. It is the intrinsic value of art such as joy, beauty, colour, action that provides a process of self-analysis and translation. This is the arts experience. In a marketing sense, the arts do not have to be glorified, as in 'buy this car' by linking the product to a lifestyle image. The arts have an attractive product already linked to lifestyle choices. The arts experience is image based and arises from self-determination. This is the intangible core. Even when the arts product is tangible, such as a painting, drawing, ceramic pot, piece of clothing or tapestry woven rug, its attributes to the market place lie in intangible benefits for the individual customer. The utilitarian quality of an artistic creation redefines the product.

Each arts organisation is usually involved in one product, for example: contemporary dance, classical ballet, servicing the needs of a membership network of craft workers or visual artists, an exhibition space, theatre, opera, a festival or event, writing, cultural heritage, or multicultural art. However, marketing strategies will be developed to extend the features and range of this product to satisfy wider customer preferences.

The *pricing* strategy for the product should also be customer focussed. The price should be set at what the customer thinks the product is worth. Unfortunately most art sells for less than what it costs to produce. In a relatively small market, government subsidy reduces the price and increases participation. However, other strategies to increase demand should be explored rather than the pricing variable. Artists and arts organisations who underprice their product in the belief that access and participation should be available for all, devalue the product and art in general. Economic studies such as *But what do you do for a living?* present statistics showing that the mean gross income of Australian artists in 1992–93 was A\$24,700 compared to the mean gross income across all occupational groups of A\$30,500.[11] However, as significant numbers of artists are unable to work full-time in their principal creative field, the mean income from this creative work was only A\$11,800.[12]

Artists and arts organisations deserve as much as they can get for their product. While government policy maintains a 'public good' approach to subvention and to particular art

and cultural institutions such as galleries and museums, pricing and marketing strategies are generally nonexistent. Public admission to these institutions may be free, but the lack of revenue generation adversely affects the marketing and development of the cultural institution. Free access does not always mean a larger audience. The price should be what the market will bear. This is a demand orientation focussed on the customer.

Common pricing strategies involve profit maximisation, revenue maximisation, target profit and price discrimination. Even profit maximising pricing is not contrary to the customers' interests. Customers are prepared to pay what they see as a fair price if the product meets their needs. This fair price may well include what the arts manager considers to be an excessive profit. Customer satisfaction will not necessarily increase by decreasing the profit content.

Price discrimination is the most popular pricing strategy in the arts. The concept involves discriminating between customers on the basis of some characteristic, either of the customer or the product. For example, discount prices may be offered for students, families or the unemployed. Premium prices should be charged for special event exhibitions, presentations or performances. Market research of customer groups will enable the manager to determine the price for the product.

Promotion is the most visible element of the marketing mix. Promotion is the use of information to influence the attitude and behaviour of customers and potential customers. It comprises advertising (newspaper, magazine, radio, television, posters), personal selling (direct mail, telephone, ticket counter), public relations (publicity, press conferences) and sales promotion (special offers and incentives). Promotional strategies must be formulated as an extension of the marketing objectives for the arts organisation or venue and the marketing objectives for the particular product or production. The strategies reflect market research carried out on current and potential audiences and distribution channels which service those customers. The major decisions on promotional strategy will answer the questions:

- Which form of promotion should be used for each customer group?
- What is the message or communication about the product or organisation?
- Which media should be used, and how often and at what time?

Audience promotion involves promotional strategies devised for target audiences. A well-planned advertising or public relations campaign will have audience development as its objective.

The final element in the marketing mix is *place*, or distribution. Even if the product is appealing, well priced and carefully advertised, the arts manager still has to bring the product and the customer together. This is the distribution strategy, the place where the transaction occurs. Craft work, paintings, books and music on CD and tape are distributed like commercial products from the wholesaler or producer via the supplier to the customer. However, most art involves the customer going to the product. The arts manager must select distribution channels that facilitate customer access. If a customer has to visit your venue twice, once to purchase the ticket, and then to see the performance, and negotiate parking, box-office opening hours and a long queue before receiving attention, the customer may not complete the transaction. The arts manager should research customer needs and wants in booking, ticket purchase, venue comfort, parking, refreshments, merchandising and service. Make tickets available through agents, utilise phone and credit card bookings, computer databases for return customer seating preferences and swift seating service. Evaluate the layout and resources of the venue and ensure that signage, shelter, seating, parking and disabled access are provided to a level of customer satisfaction.

Market planning

The market planning process involves more than assembling the four parts of the marketing mix. It entails creating or re-examining policy, conducting research and an organisational audit, formulating marketing objectives, preparing

strategic and operational marketing plans, and establishing controls and methods of evaluation.

The marketing policy of an organisation is a blend of the vision, mission and goal of the organisation which are embodied in the corporate plan. It is obvious from this chapter that a marketing policy would include a focus on customers and a marketing orientation throughout the organisation. Essentially the marketing plan defines the mission and goals of the arts organisation. It is one of the goals of the organisation and is part of the organisation's corporate plan. Whatever overall marketing strategy the arts organisation selects, it must fit with the organisation's mission. For example, museums are not in the merchandising business, but because these operations comprise significant revenue and support valuable curatorial work, it is tempting to place too much importance on merchandising in marketing the organisation. The mission of a non-profit arts and cultural organisation is usually defined in terms of activity to maximise artistic and cultural achievement by producing innovative products that will generate sufficient consumer support to sustain the organisation.

In order to develop marketing objectives it is essential to conduct external and internal research or an investigation of the environmental and organisational factors which may influence the organisation's development. For example, an environmental analysis will show the changing demographics of the population (age, education, two-income families, suburban profiles, leisure activities), the economic and political influences (unemployment, government policies, social justice legislation), the demands of technological advances (customer sophistication), cultural and social factors (values, ethics, heritage and environmental concerns) and how cultural industry competitors are performing in terms of market share and size. From such an investigation a solo puppeteer may find that education policy has changed and a touring organisation such as the Arts Council has had to reduce its touring program. This artist needs to investigate enterprises such as a regional puppetry festival, or a strategic alliance with a suburban shopping centre or family hotel/resort complex. This external analysis provides information on

opportunities and threats that exist in the current environment.

It is also essential to analyse the strengths and weaknesses of the organisation, beginning with its mission and objectives. Make an assessment of resources (human, financial and physical), customer relationships, audiences, the programming policy, the information system, the pricing policy, the communication (internal and external), the marketing style (aggressive, passive, integrated), touring pattern or network extension and core strategies (export, growth, diversification of product or revenue).

This information provides a base for formulating marketing objectives. These are leading or directing statements, positioning the organisation and declaring what is to be achieved. For example, if the organisation has a marketing objective to expand its audience beyond the typical demographic blend of current subscribers or patrons, it must develop a growth strategy.

The key to the strategic marketing process is to establish target markets and marketing mixes. The targets should be realistic and achievable and the plan creative and dynamic, that is, while the plan is chronologically developed, each strategy involves a creative blending of the marketing mix designed for the target audience. For example, if a theatre company wants to develop a market with multicultural audiences, the marketing strategy should focus on an aggressive promotion or advertising campaign using specific media publications and radio and television stations of minority ethnic customers. Or if the company has an objective to develop a regular touring program, the marketing strategy would involve a target audience of venue managers for repeat bookings to a logical outcome in three years of all venues as regular bookers.

The final component of the marketing plan is evaluation. Budget controls and performance indicators should be built into each marketing project's action plan. Regular reporting will realise such items as over-expenditure, fewer patrons, poorly planned booking schedules or insufficient human resources to carry out the task. If the costs of implementing the strategy exceed the budget and the number of new

Figure 2.3 Market planning

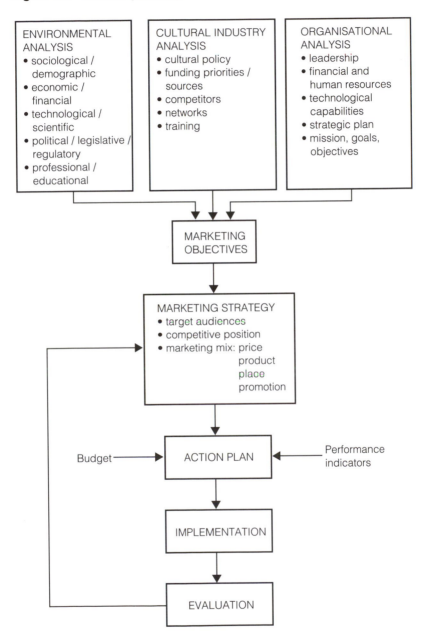

subscribers (in the multicultural audience example) is below the level of success, the organisation should revise the strategy as soon as possible. The marketing manager should set in place an overall evaluation of the marketing plan, as well as controls on all marketing strategies. This forms part of the organisation's strategic plan and monthly or yearly reporting to the board, statutory authority or government agency. Establish measuring devices for marketing objectives, for example, audience or visitor numbers; increased revenue from sponsorship, donations, merchandising; product acceptance (touring, schools presentation, conference, artist-in-residence, festival) by peers, critics or communities; or output of work over time by a certain number of people.

Figure 2.3 illustrates the marketing planning process.

The marketing strategy at the centre of this plan is customer focussed. It involves research to determine who is the audience, what competitors are in the marketplace, and the development of a marketing mix for the targeted audience. The customer relationship continuum moves thus:

single ticket purchaser → subscriber → member → donor.
The marketing relationship with a customer is rewarded in fundraising.

Fundraising

For most non-profit organisations (schools, universities, hospitals, welfare agencies, service groups, medical research associations) fundraising has become a critical strategic activity. For the arts and cultural industry, fundraising and development is a new and under-researched area of revenue generation. More than any other sector of the non-profit industry, the arts and cultural sector needs in-depth analysis and preparedness in the fundraising process if it is to succeed. The creative business of raising funds requires clarity of mission and objectives, organisational analysis and readiness, board member commitment, well-researched audience/consumer/constituency targets, audience and product matching, market planning, detailed project design, recognised effective management, healthy and stable government relations, and strategic fundraising plans. Other

non-profit organisations may succeed with one or two of these criteria missing because they have a 'cause' which strongly influences donor behaviour. People are more likely to give to a 'cause' rather than the organisation.

The arts' 'cause' may be defined as 'to enrich the quality of life through a cultural experience'. Patrons of the arts, members, friends and volunteers of an arts or cultural organisation would probably donate on that basis, but that is a very small percentage of the population. The benefits of giving to an arts or cultural organisation are easily defined for a sponsor whose product is linked to the arts product and the audience. It is very simply a marketing exercise. Philanthropy is currently practised by some corporate donors, and by governments who fund the arts for the 'public good'. The marketing skills of arts managers will be well tested in the preparation and promotion of the 'cause' to individual donors, who though practising philanthropy may want to see outcomes from the donation. The values associated with giving to welfare, education, medical research or political refugees embrace saving lives, providing shelter and food, enriching education, improving health. These are basic human needs. The arts fulfil the needs of preserving cultural heritage, spiritual development and compassion, but to attract donors these must be translated into benefits and outcomes.

A corporate donor, or donor of a major gift, is satisfied in seeing a new building or art space created, or championing an artist-in-residence for a community, or providing an award or prize for artists. However, to attract annual giving or bequests, the arts organisation must provide quality product and ongoing customer relationship.

Consider the following fundraising programs and campaigns as strategies to achieve a marketing objective of additional revenue sources:

- donations from volunteers, members and friends during an event or given with membership fees, or following a direct mail approach
- annual giving invitations to members, patrons, and targeted customers committed to this arts organisation or

artform who are requested to give a particular amount and may benefit from the tax deductibility of their gift

- bequests arranged before the death of a member, sub-scriber or patron, who will find satisfaction in perpetu-ating the arts for society
- capital campaigns where a gift range chart aimed at a few donors for large gifts and many donors for lesser gifts enables the organisation to purchase equipment or build a venue for a particular budget target.

Fundraising and sponsorship in the arts are strategies to achieve financial and artistic goals that allow the mission of the organisation to be achieved. Financial independence lets an arts organisation deliver the quality product demanded by customers. Any strategic vision for audience development must include strategic and action plans for fundraising and corporate sponsorship. The process is closely linked to mar-keting as it is based on meeting customer needs and values so that the transaction can take place in order to fulfil the organisation's mission.

Corporate sponsorship

Corporate sponsorship has developed during the last ten to fifteen years as the catchcry for the survival of arts organisations as accountable, effectively managed institutions in a growth industry. In Australia, arts organisations histori-cally were developed to form an administrative structure around cultural programs which the government chose to subsidise as part of the nation's welfare. Despite protracted uncertainty over funding levels, the arts have continued to aspire to principles of excellence, innovation, access and participation. The contemporary focus is not so much that the government is restricting subvention, but that an arts organisation is abdicating its responsibility if it is not actively and successfully seeking corporate sponsorship.

In today's competitive environment, corporations usually expect their sponsorships to enhance their corporate image or marketing aims. While the arts aspire to be non-compet-itive, their 'mass marketing' manner and the direct associ-ation with the world of ideas and creativity provide

Figure 2.4 Fundraising and sponsorship process

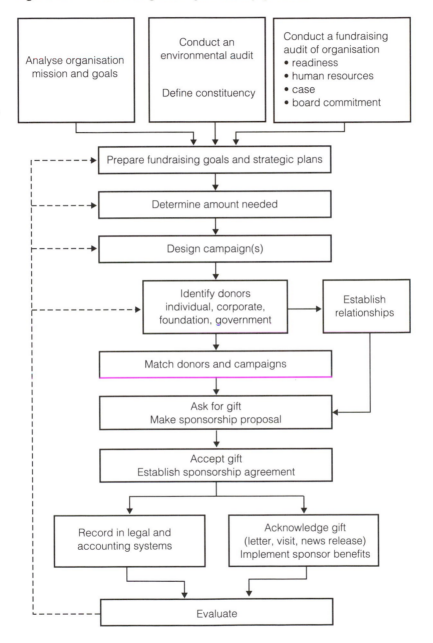

corporations with unique measurable benefits for entertaining clients and spreading an image. This marketing relationship has been described as 'Marriages made in Heaven'.[13] Arts and cultural organisations no longer expect corporate philanthropy. Considerably more money is available in the advertising and marketing budgets of corporations.

The case of the Citicorp/Citibank sponsorship of the New York Philharmonic Orchestra demonstrates the potential marketing relationship between a sponsor and arts organisation. The Orchestra's fifteen-concert tour of Asia in 1989 was sponsored for one third of the cost of the trip, running into millions of dollars, by the Citicorp/Citibank New York-based financial institution. The partnership began in 1980 and evolved into five year agreements, the second one expiring at the end of 1991. In addition, Citicorp/Citibank had first right of refusal in sponsoring the Philharmonic on any major tour outside the USA. The sponsorship relationship developed from membership on the Philharmonic's Board of a senior Citicorp official. He brought the two together and according to the Philharmonic's managing director: 'He challenged us to make it work as a marketing and public relations experience'. The first tour to Europe matched Citicorp's client base and appealed to the company in terms of its expanding base and the government contacts. Praise was high from clients and customers. Citicorp had 'bought an identification with the Philharmonic' in general terms of the environment in which both operated and 'That reputation includes the good that you do, the service that you provide, the impact you have in a community, the care you take to cultivate relationships with clients'.[14]

For example, in some countries important government officials were pleased that a corporation enabled such a world-class orchestra to visit the country and enrich the population. This resulted in important contacts and contracts.

The key to the partnership was Philharmonic's ability to come up with events and services that filled Citicorp's entertainment and public relations needs. These included master classes for promising students, an outdoor concert in an underprivileged area or country (in San Paolo 100,000

people attended such a televised concert), special chamber recitals for client groups and guest talks by the conductor or artistic director.

When the orchestra planned its tours, Citibank appointed a co-ordinator well in advance to arrange tickets, meetings, receptions and press material. Objectives for both groups were discussed and matched. The Orchestra decided where and what it played, and Citicorp did not pick up the option to sponsor the route unless it had sensible potential for business. 'It wouldn't be proper to spend our shareholders' money on a tour that went to ten countries and we were only operating in three of them,' said Koplowitz, Citicorp's head of International Public Affairs. 'We must respect the orchestra's artistic responsibilities.' However, the Philharmonic general manager admitted that there was the tendency to try to accommodate where Citicorp would like to visit—funding, business and audiences usually go together.[15]

The Academy of St Martin-in-the-Fields, a chamber orchestra established in the UK with a world-wide reputation and touring responsibilities, recently increased its management structure to include a director of development (fundraising) as well as a marketing manager, both involved in sponsorship. The group had never received government subvention and only recently moved into sponsorship. Since 1990 the Academy's marketing manager observed the many changes in the attitude of businesses to the arts. Companies are learning to make the most of sponsorship, not only for corporate entertaining, but as a way of reaching carefully targeted audiences often neglected by more traditional marketing methods. A corporate database was established by the Academy by researching companies and their sponsorship requirements. A sponsorship CD with information about the Academy and opportunities available was an important promotional tool.

The following article by the director of development for the Academy of St Martin-in-the-Fields outlines the importance of planning in preparing a fundraising program or campaign.

To some extent, problems with funding a project can

be seen as a symptom, not a cause, of problems with the project. 'Get the project right, and funding will stick to it'.

Accordingly, the first task has been to catalyse the elements of project development across an apparently diverse spectrum of component parts: marshalling the investment potential of the project's resources, both extant and projected. The Academy's heritage and reputation, its capacity for publicity, its profitability and its existing personnel—all these elements had to be interpreted in a strategic plan which would marry-up with the potential inherent in the development—its contribution to musicians and public, the new staff involved, its benefactors, its income. The outcome, a development strategy in which the fundraising campaign utilises the broad spectrum of potential which the Academy and its project represent.[16]

Sponsorship and fundraising are integral components of every arts organisation's strategic plan. Whether the organisation is a theatre venue, a theatre company, a touring network, an orchestra, a gallery, a museum or a ballet company, the goals, objectives and plans for development can only be achieved with financial security. The greatest advantage of financial independence is the freedom it provides to make choices about the future.

The most recent trends in sponsorship suggest that middle-sized corporations and businesses are now more active in sponsorship agreements with the arts than large corporations. Small business perceives sponsorship of the arts as a high priority for marketing and promotional opportunities. Most successful sponsorships result from one to one discussions between the arts organisation and the small business, often initiated by board members. Key reasons for corporate support are community service, improving company image, association with activities of excellence, entertainment of staff and clients, participation in arts activities at all levels and the personal interests of executive management.

Sponsorship is a definite communications and marketing strategy and as such creates a supportive environment within which a company can conduct its business.

Planning is essential. The arts manager's research in identifying appropriate companies to approach for sponsorship must include an analysis of each company's target audience, any risk involved, how the arts project will increase awareness of the company, exclusivity (naming rights), lead time and quantity and quality of publicity, competing events and the company's budget timetable. In addition, institutional readiness is paramount. In order to formulate the marketing strategy, in this case the sponsorship proposal, it is essential to conduct a SWOT analysis (strengths, weaknesses, opportunities and threats) of the arts organisation and the environment. Is the organisation ready? Has it prepared the case for sponsorship? Does it have the human resources to prepare the proposal, make the approaches and follow each through? Is the board of the organisation committed to the mission, goals and objectives and to this sponsorship strategy.

The sponsorship proposal should contain an appealing description of the event in the context of the organisation's history, mission, achievements, goals and future plans. Even details of personnel involved, how, where and when the event will occur, who will benefit and costs of production give the sponsor an idea of the organisation's planning skills, audience and capacity to achieve the project successfully. The estimation of the amount of money requested should relate to the value of the expected benefits to the sponsor. Always state the amount expected. It is more appealing to the sponsor if it relates to a particular cost, for example, transporting valuable works of art in a touring exhibition, or the employment of an artist-in-residence for a specific period to work with a community on a heritage project, or the materials for an installation project or purchase of a kiln, or 'in-kind' media coverage and public relations events. An amount not tied to a budget item cannot be related to an outcome or a plan. Place quantifiable value on the benefits offered to the sponsor: naming rights; advertising on all posters, invitations, banners; increase in market share of a

target audience; guest speaking; display space; media interviews; news articles; client entertainment; association with government and other businesses and corporations.

Make a personal approach first, then send the well-presented proposal document. Follow up the proposal. If invited to discuss the proposal, maintain a customer (sponsor) focus and a relationship attitude. It may be necessary to compromise financial needs, but do not compromise the art. When a verbal agreement has been reached, together draft a written agreement. It is essential to have a written sponsorship agreement where all the details, rights and responsibilities are clearly outlined: who is to do what, and who is to pay for what. The agreement formalises the partnership as a legal contract and should address the following key points:

1. A clear description of the sponsorship including its duration and any special features or contingencies to which the parties have agreed.
2. The terms of the sponsorship, including the fees, and the method and timing of payment.
3. The rights of the sponsor, outlining what the sponsor expects from the partnership.
4. The rights of the arts organisation, outlining what the arts manager or board expects from the partnership.
5. Intellectual property—the agreement should detail the provisions relating to the use of the arts organisation's name, product names, logos and any other copyrighted material or intellectual property linked to the partnership. Additional details concerning the use of the company's name throughout the sponsorship should be incorporated into the agreement.
6. The workload to be allocated to one or both organisations. This will include areas such as project management, media liaison, hospitality and publicity materials.
7. Other matters such as warranties, confidentiality and non-disclosure of the terms of the agreement.
8. The grounds for and the manner in which the contract may be terminated.

A grant application to a government or semi-government agency by an individual artist or an arts organisation follows the same principles as a sponsorship proposal, that is: establish a broad relationship with a project officer to obtain all the necessary information, performance criteria and expectations of the granting agency; detail the project and benefits to the artist and the community, the costs and outcomes; and ensure that all components of the reporting and acquittal process are understood. Every funding application, whether to a corporation, a local business, local government or state government department, requires the artist or organisation to plan the detail of the project or event and to envision the outcomes in terms of cultural development. Regular workshops are conducted by each government agency to guide applicants in the process. Attention should be paid to state, local or national requirements and to the relationship and communication developed with an officer in the granting organisation in order to enhance the result. Chapter 6 of this text details the financial implications of investing time and energy in grant applications.

Funding agencies are now inclined to view grants as a partnership or investment in the developing cultural industry. In this way the agreement reached with a recipient artist or organisation is a strategic alliance of state and artist sharing a common goal for the cultural industry.

Strategic alliances

The sponsorship agreement between an arts organisation and a business or corporate sponsor can be viewed as a strategic alliance. This is one of several ideas for innovation in marketing practice for the arts. A strategic alliance in the arts is the synergy of two or more organisations contributing their strengths and resources to the alliance in order to accomplish a 'win-win' outcome in achieving the relative strategic goals. Strategic alliances are more than joint ventures which are usually short-term efforts to gain a commercial edge in manufacturing or marketing. In long-term strategic alliances, the relationship between the contributing organisations is reciprocal. The partners share

strengths to achieve positive outcomes for all involved. They also share the risks.

The links between the arts and cultural industry and the corporate world are growing. Not only are new partnerships being forged, but arts organisations are increasingly promoting the non arts companies whose marketing projects assist in financing the artistic program. As part of an overall corporate strategy, arts organisations are forging new strategic alliances of two to five years to supplement decreasing government subvention. A museum, a restaurant and a bookshop may form an alliance to increase the number of patrons by targeting new markets. Various theatre companies may share marketing and ticket facilities for cost effectiveness, while corporate sponsors may form alliances with orchestras to improve their corporate image usage in the community by 'giving back' what is taken in retailing, mining, banking or insurance. Some of the advantages of forming strategic alliances are the shared costs of new ventures as in market development of new target audiences, access to distribution networks, increased financial base, access to local resources (human, physical, financial, technological) in management information systems, shared expertise for mutual gain and risk reduction through shared ownership of the operation.

The areas of concern in the strategic planning process are artistic, organisational and financial. Artistic personnel may perceive a compromise of the organisation's artistic integrity. Management structures may not be properly established, weakening decision-making and reporting procedures and thus jeopardising success of the projects. Organisational control of the various functions of the alliance must be designed and allocated. The distribution of financial gains and losses within the alliance must be negotiated and agreed. Some profit sector organisations are only interested in projects that attract a large audience. Performance indicators for aspects of the alliance and projects will maintain a constant monitor of progress and activity.

At the core of any alliance is networking. This allows for vigorous growth through mutual support, stability of pseudo businesses such as those in the arts and cultural industry, opportunities for small innovative organisations to join forces

with large organisation distribution channels, and regional activity to test global encounters.

Strategic alliances in the arts go beyond sponsorship. The sponsor as philanthropist is obsolete and the arts organisations are under pressure to 'perform' for the mutual benefit of all partners. A strategic alliance with big business means that arts organisations must produce quantifiable results for the benefit of the business that is allocating the capital. These measurements may take the form of market image, value for dollar, advertising returns. The public relations image of the corporation or company as a 'culturally aware company contributing to the artistic life of the community' is at stake if the arts organisation does not produce a measure of quality. There is a fine line between reduction of artistic integrity and balancing a corporation's public image and product demands. If these concerns are addressed in a written agreement, similar to a sponsorship agreement, then the goals of the strategic alliance will overcome individual desires.

The following example sets out background information and a strategic alliance agreement for three fictitious organisations whose goals in the alliance concern:

- quality of artistic/performance standards
- financial returns
- audience reaction (and means of measurement)
- audience development and growth (and means of measurement)
- organisational profile in the community
- marketing success
- control mechanisms (performance indicators in the alliance)
- options to renew.

It is assumed that all organisations have the capacity to engage in the alliance and maintain their autonomy. None of the organisations wishes to revise their missions, nor alter their organisational structures to reduce or increase staff to fulfil the terms and conditions of the alliance. The input and expertise of the employees of each organisation is of central importance to the alliance. Even though all three

organisations have strategic goals and tactical plans, the following agreement was constructed whereby individual organisational goals as well as alliance goals were able to be reached.

The unholy alliance[17]

BACKGROUND INFORMATION

Superhighway Inc.

Superhighway Inc. is a multinational corporation that has secured the contract to provide specialised Internet access in Australia. As part of its $500 million contract, the Australian government has decreed that Superhighway Inc. must give 1 per cent of its award to the arts and education in all states and territories in Australia. After careful consideration the company has chosen to allocate $1 million of this to the strategic alliance with the Limelight Arts Centre and the Boom Crash Orchestra.

Mission statement
A world without communication barriers is the beginning of world wisdom, shared experiences and, above all, peace.

Strategic goals
1. To connect all countries of the world via telecommunications by 2025.
2. To strengthen Superhighway Inc.'s leadership in the global telecommunications market.
3. To provide 15 per cent return to investors for at least ten years.
4. To promote communication as the beginning of global understanding.

Tactical plans
1. Secure tenders in developed countries to provide Internet access.
2. Expand options for customer positioning.
3. Gain support of local communities by contributing to the performing arts thus localising Superhighway Inc.
4. Design and implement an advertising campaign focussing on the multicultural diversity of Australia.

Superhighway Inc.'s resource contribution to the alliance

- $1,000,000 over a three year period
- Marketing expertise
- Access to the international recording industry
- Royalty income through sale of recording of events under the alliance
- Production of merchandise
- International telecommunications network i.e. orchestral performances to be seen on cable/satellite television world wide.

The Limelight Arts Centre

The Limelight Arts Centre is the major performing arts venue in the state. It includes in its operations its own programming department. This department produces events which complement productions presented by the hirers of the venue. Despite efforts to increase occupancy the venue has not managed to maximise the use of its stages and other facilities over the last three years. The Centre has joint ventured (one-off projects) with the Boom Crash Orchestra in the past. Despite being of a high artistic standard these projects have only covered costs. The Limelight Arts Centre hopes to broaden the scope of its product without having to take the sole responsibility of underwriting the projects.

Mission statement
To enhance the quality of life in the community by promoting, producing and presenting productions of the highest artistic standard.

Strategic goals
1. To provide the community with access to the best performing arts activities available.
2. To commit the Centre to artistic excellence, integrity, responsibility and reliability.
3. To achieve optimum occupancy of the Centre's venues and ancillary spaces.
4. To develop a secure financial base through joint presentation of commercial and entrepreneurial activities to decrease dependency on government subvention.
5. To develop the Centre's infrastructure so that its status as a major Australian performing arts venue is maintained.

Tactical plans

1. Develop relationships with other performing arts organisations in order to develop networks that facilitate the sharing of resources.
2. Actively seek alliances with the corporate community.
3. Formulate and implement an effective marketing plan that will access potential hirers.
4. Develop and implement information systems and specialist technology that will ensure the Centre is aligned with international standards and practices.

The Limelight Arts Centre's resource contribution to the alliance

- venue for rehearsals and performances
- production and technical expertise and equipment
- marketing services
- programming staff
- box office facilities and staff
- financial services
- extensive database for mailing lists
- catering facilities
- access to popular commercial artists and conductors
- contra arrangements with hotels and travel organisations.

The Boom Crash Orchestra

The Boom Crash Orchestra has reached a critical stage in its artistic and financial development. While subscriptions and government subvention keep the orchestra afloat, it does not have the organisational resources to expand its current operations or to increase its financial base. At this time the orchestra is beginning to develop an international reputation for its presentation of contemporary works with their highly acclaimed young Australian soloists and conductors. A strategic alliance with Superhighway Inc. and the Limelight Arts Centre will give the orchestra greater financial security and access to marketing expertise.

Mission statement

Music speaks all languages. The Boom Crash Orchestra strives to provide and develop the highest possible artistic service and enhance the artistic life of the community.

Strategic goals
1. To become financially independent of government funding bodies.
2. To develop and maintain an efficient and effective management structure.
3. To achieve a standard of excellence with the existing repertoire and to develop new works for the international audience.
4. To develop new audiences in Australia.

Tactical plans
1. Increase revenue via box office, subscriptions and corporate support by 30 per cent over the next three years.
2. Increase the orchestra's subscriber base by 15 per cent over the next three years.
3. Commission new works by Australian composers.
4. Allocate more funds to the marketing of the orchestra.
5. Engage popular artists with an international reputation.

The Boom Crash Orchestra's resource contribution to the alliance
- full-time orchestra
- music library and librarian
- orchestral management
- knowledge of and access to conductors and soloists
- high profile Australian reputation
- growing international reputation

THE AGREEMENT

This AGREEMENT dated this day of January 1995
BETWEEN: The BOOM CRASH ORCHESTRA, a company incorporated in the State of Queensland and having its registered office at 77 Strike Street, Smitherfield, Brisbane, 4333 Queensland (hereinafter referred to as 'the Orchestra');
AND: The LIMELIGHT ARTS CENTRE, of 33–50 Fresnel Road, Strand, Brisbane 4287 Queensland (hereinafter referred to as 'the Venue');

AND: SUPERHIGHWAY Inc., a multinational company with its Australian incorporated subsidiary situated at 789 Future Boulevard, Westmore, Brisbane 4511 Queensland (hereinafter referred to as 'the Sponsor')

WHEREAS: A: The Orchestra is a full time professional orchestra performing throughout Queensland and overseas;

B: The Venue operates the Limelight Arts Centre both as landlord of the Venue and producer of performing arts activities;

C: Hirers of the Venue present concerts, drama and drama seasons and the like as well as seminars and special events;

D: The Orchestra performs at the Venue for its own subscription series and for various presentations in conjunction with the Venue;

E: The Orchestra, the Venue and the Sponsor have agreed to form a cooperative, strategic alliance (hereinafter referred to as the 'Alliance').

IT IS PROPOSED THAT:

1. An Alliance be formed, commencing January 1995 to which the three (3) parties actively contribute;

2. That the Alliance be for an initial period of three (3) years, with an option for an additional three (3) year period thereafter;

3. In respect of any circumstances which arise from the Alliance and which are not specifically covered under the terms of this Agreement, such circumstances shall be agreed in writing between the parties hereto and such written agreement shall become integral to this Agreement;

4. In respect of any and all joint venture presentations pursuant to this Agreement, should any of the clauses hereinafter require amendment, such amendment(s) shall be documented, endorsed by all parties and appended hereto and shall form part of this Agreement;

5. This Agreement and therefore the Alliance, may be terminated by the withdrawal of one or more of the parties provided:

 (a) any desire to withdraw from the Alliance shall first be discussed between the parties with a view to remedy;

(b) should a mutually satisfactory remedy not be determined, three months notice is to be submitted in writing to all parties to the Alliance.

6. Notwithstanding Point 5 above, the Alliance shall be subject to review on or before 31 December each year.

IT IS AGREED THAT:

Responsibilities of the Orchestra

1. The Orchestra shall provide the base orchestra of fifty-eight (58) full time players for joint presentations pursuant to this Agreement.

2. The Orchestra shall provide any additional musicians necessary to augment the base orchestra for joint presentations pursuant to this Agreement.

Responsibilities of the Venue

3. The Venue shall provide its premises for each presentation under the Alliance.

4. All technical equipment and expertise, including the lighting design, shall be provided by the Venue.

5. Production and technical labour, front of house labour, box office and financial services shall be provided by the Venue within its existing infrastructure.

6. The preparation and administration of all artists' contracts and the individual project budget, including the setting of ticket prices, shall be the responsibility of the Venue.

Responsibilities of the Sponsor

7. The Sponsor shall contribute an amount of one million dollars ($1,000,000) for the production of joint ventures pursuant to this Agreement.

8. In accordance with Clause 7 above, the Sponsor shall be credited as a major sponsor for all presentations under the Alliance and as such have first right of refusal relating to minor sponsorships for the purpose of presentations under the Alliance.

9. The Sponsor shall be responsible for catering arrangements required in respect of entertaining its own clients, and/or receptions deemed appropriate by the parties jointly. Such arrangements shall be made utilising the catering business which operates within the Venue.

10. The preparation of a formal agreement covering the alliance and all amendments thereto, shall be the responsibility of the Sponsor.

Collective Responsibilities

11. In conjunction with the Venue, the Orchestra shall share the responsibility for the programming of each presentation under the Alliance. The final content of each concert shall be agreed with the sponsor.

12. In conjunction with the Venue, the Orchestra shall share responsibility for the choice of guest artists and conductors for each presentation under the Alliance. The final choice of guest artists shall be agreed with the Sponsor.

13. The negotiation of artists' fees shall be the shared responsibility of the Venue and the Orchestra. The specific responsibilities shall be agreed and assigned at the commencement of planning the concert program for each presentation.

14. Each party to the Alliance shall contribute its expertise in establishing and carrying out a marketing and promotions campaign for the purpose of each presentation under the Alliance.

15. The production of a printed program for the purpose of each presentation shall be acquired by means of the most attractive terms available through the resources of each of the parties.

16. Travel, accommodation and ground transport required for guest artists shall be acquired by means of the most attractive terms available through the resources of each of the parties.

Financial Distribution

17. For the purpose of each presentation under the Alliance, a project budget shall be prepared and shall reflect all estimated income and expenditure. Where appropriate and agreed between the parties, services such as marketing and certain labour shall be provided at cost for the financial benefit of each presentation.

18. Immediately following each presentation, a financial settlement of that presentation shall be prepared and issued to each party.

 The distribution of profit/loss for each presentation shall be *one* of the following and shall be determined at the time of agreement of each production budget:

 (a) In the event of a profit, distribution of the surplus funds shall be commensurate with the level of risk taken by each party;

(b) In the event of a loss, distribution of the deficit shall be in equal one-third shares;

(c) In any circumstances, distribution of profit or loss shall be in equal one-third shares, irrespective of the level of risk taken by any and all parties.

Project and Alliance Control

19. In addition to the practical issues in respect of each concert production, each party to the Alliance shall nominate two (2) members of its organisation who shall form a working party for the purpose of project management of each production.

20. Each organisation shall appoint two nominees for the sole purpose of monitoring the overall progress of the Alliance to ensure the achievement of its objectives.

21. This Agreement shall be judicial under the laws of the State.

Signed by and on behalf of

THE BOOM CRASH ORCHESTRA
by its authorised officer .
in the presence of .

Signed by and on behalf of

THE LIMELIGHT ARTS CENTRE
by its authorised officer .
in the presence of .

Signed by and on behalf of

SUPERHIGHWAY INC.
by its authorised officer .
in the presence of .

An alliance between arts organisations and business makes sense for several reasons:

- cultural excellence suggests corporate excellence
- support for the arts strengthens relationships in those countries where large corporations do business
- concern for cultural heritage of a country enhances business images with key audiences.

Conclusion

Marketing in the arts embraces the recurring themes in this book: leadership, planning, people and entrepreneurship. The key to successful marketing is the endeavour spent on research so that the marketing plan is built on customer needs and entrepreneurial leadership strategies. Marketing is a long-term investment that creates an environment for the organisation to keep growing and evolving. In an effort to develop entrepreneurial marketing strategies, arts managers should consider:

* the formation of alliances or networks by several smaller organisations (linked by art form or geography) to maximise resources for the employment of a marketing person or consultant, utilisation of market research, purchase of an information system, shared advertising budget or promotional literature
* the development of an alliance with a university or business to access human and technical resources
* the use of volunteers (the new age arts participants) for market research, fundraising and promotion
* the establishment of a marketing consortium with several arts organisations in a formal organisational network, not just an alliance
* increased board participation in fundraising, sponsorship and other marketing strategies
* seeking the support of a government agency for common market research, gathering information on audience demographics as an investment in audience development for the arts and cultural industries.

Effective marketing practice in the arts will facilitate the gradual release of organisational, financial and philosophical ties with government as arts managers learn more about the needs and wants of their audiences and the value of audience commitment to the organisation and its success.

3

Public relations and the media

This chapter outlines aspects of arts publicity and ways in which arts managers work with media representatives to achieve recognition for their organisations. A manager can actively seek opportunities to link the arts organisation with the community. In order to create the best publicity opportunities for their organisations, arts managers need to be well read in a broad range of publications within and beyond the arts industry. They can then develop skills in determining and emulating favoured writing styles, content, story length and illustration style of each publication.

The main areas dealt with are

- media and culture
- the role of the public relations manager
- public relations and the media—the customer-supplier relationship
- public relations and the community—the partnership role
- the press release, press kit, fact sheet and media conference
- an analysis of arts journalism in newspapers, television, journals and on radio
- newsletters, brochures and reports
- ethics and social responsibility.

Media and culture

The media influence a country's culture by the selection process which occurs before consumers receive the product. Media workers decide firstly what to offer consumers in terms of content, reviews, discussions and interviews. More importantly, once this selection has taken place, certain perspectives of presentation are adopted by journalists and editors which have a powerful influence on the consumers' judgement of the artistic product under review. The product offered by the media, then, is in a sense converted or transformed into a different artistic form of representation. 'Media' is an apt word, suggesting a medium through which change occurs.

Control of the change is part of the arts or public relations manager's brief. Good working relationships with relevant journalists and detailed knowledge of publications' styles and audiences are critical to positive control. 'Media' has become a well-used generic term to encompass a broad range of industries including film, television, radio, advertising, journals, newspapers, books and Internet communications. Each of these industries creates products which review, present or develop art. Arts managers are influenced by budget restraints, the artforms they deal with and audience profiles when deciding which media will best publicise the organisation.

The role of the public relations manager

Arts managers of smaller organisations often assume the role of publicity or public relations managers. Larger organisations with separate marketing or public relations departments delegate separate management duties. In this chapter the public relations manager referred to is a person within a marketing or publicity department, or the head of that department or the single arts manager who takes on all tasks.

In chapter 1 the arts manager is described as the monitor of the delivery of artistic product from artist to audience. In chapter 2 marketing is described as the process which links art with an audience. Public relations is part of the marketing

of the organisation or the delivery of the artistic product from artist to audience. In their book *The Australian Public Relations Manual*,[1] Tymson and Sherman cite the following definitions of the role of public relations:

> The deliberate, planned and sustained effort to establish and maintain mutual understanding between an organisation and its publics. *The Public Relations Institute of Australia*

> Public relations practice is the art of social science in analysing important trends, predicting their consequences, counselling organisation leaders, and implementing planned programs of action which will serve both the organisation and the public. *World Assembly of Public Relations Associations*

> [public relations is] the practice of promoting goodwill among the public for a government body, individual or the like, and the practice of working to present a favourable image. *Macquarie Dictionary*

Each definition is concerned with establishing sustained, effective communication between an organisation and its publics. The public relations manager communicates within the organisation with

- members and employees
- board members and
- general manager and/or chief executive officer.

The public relations manager communicates externally with

- particular audience segments through targeted marketing campaigns
- individual members of the audience in addressing their personal needs
- workers in the media for coverage of events or campaigns
- untargeted publics through general advertising and marketing strategies and
- sponsors, patrons, funding bodies or government departments.

Tools of communication include

- reports
- press kits, press releases, fact sheets, profiles, backgrounders
- newsletters
- suggestion boxes and noticeboards
- brochures
- media conferences
- meetings
- letters
- posters
- advertisements
- radio and television interviews
- appearances at functions related to the arts industry
- personal communication with and lobbying of important community, business and government figureheads.

Although communication is possible in an extremely diverse range of outlets, it is important that the organisation is regularly and objectively considered as a whole by the public relations manager. Objectivity is the key to judging public perception. Public relations strategies develop from and complement the objectives and mission of the organisation. Constant consultation with all levels of the organisation is required when planning strategies and publicity campaigns.

Communication with audience segments through targeted marketing campaigns and with untargeted publics through general advertising and marketing strategies have been dealt with in chapter 2. This chapter focusses on the communication between the public relations manager and individual audience members and media workers.

Public relations and the media

The customer–supplier relationship
The media provides arts coverage through advertising, interviews, reviews, issue-based discussion and promotional campaigns. Coverage of the arts on television and radio and in newspapers and journals exhibits varying degrees of

expertise and specialisation. Except in the case of advertising, which is paid for, the coverage given is not always requested. The arts organisation, usually seen to be a *producer* of goods, is in this scenario a *customer* or *consumer* who has minimal control over what is being broadcast to the public. The journalist, or publishing network, is the *supplier* who retains ultimate power over the finished product.

Separate media departments or publicity managers are commonly appointed to deal with the communication flow between their organisation and the community. Apart from word-of-mouth reportage from individual patrons, media reports are often the sole link between an organisation and the community. The success of an event, festival or exhibition can be almost entirely dependent on the type of media coverage it receives.

Operational efficiency and the development of good working relationships with appropriate journalists is sometimes enhanced by separating the duties of publicity managers from others within the organisation. While large organisations require separate publicity departments to deal with the magnitude of the work, smaller organisations which allocate publicity work to one or two people benefit from the more direct contact those managers have with the rest of the company. Managers who develop ways to keep separate departments co-ordinated with the rest of the organisation benefit from the information flow which develops between them and the increased opportunities for networking within the community.

Developing good working relationships with appropriate journalists is essential to the public relations manager's role. Thorough reading in a broad variety of journals, newsletters and newspapers assists the manager is deciding which outlets will best suit the publicity needs of the organisation or of a particular event held by it. Different journalistic styles and interests in particular topics should be noted along with readership levels and interests, and distribution figures and patterns. The manager can then cultivate a working relationship with the journalists who are most likely to publicise the organisation. Approaches to journalists should be kept on a

professional level, avoiding requests of favours or offers of privileges in return for publicity.

Once a relationship is established with a particular journalist, the public relations manager will know whether it is best to communicate through fax, telephone, e-mail or letters, what deadlines should be met, and what setting out or format is required for press releases or photographs.

Invitations to openings and media conferences provide journalists with opportunities to cover events which the public relations manager selects for publicity. It is the role of the public relations manager on such occasions to acknowledge the presence of journalists, either publicly or privately, and provide them with informative media kits. Guidelines on how to compile media kits and press releases and organise press conferences are provided later in the chapter.

Public relations and the community

The partnership role
The journalistic link should not be the only lifeline between an organisation and its publics. Valuable links can be made between the organisation and the community, whether that community is a geographically localised sector or a more broadly defined group. Membership organisations and the publications and meetings which result from them are obvious ways to enhance an organisation's profile at the same time as providing positive social, educational and business opportunities to a wide cross-section of the community, offering employment possibilities, empowerment, or simply helping to shape a more diverse culture within the organisation.

Membership or society organisations offer structured links between an arts organisation and the community. Less structured and less permanent links are also appropriate public relations vehicles. Lobby groups which advocate a particular cause in which the arts company shares an interest, or subcommittees or action groups set up to achieve a particular task, can heighten awareness of a company and encourage new patrons through the process of community involvement.

Awareness of the organisation within the community is an important step to broader recognition. Integration with the community is affected through membership offers, participation in local events and clubs, appearances at local meetings, work with local schools and educational institutions, open house days or regular events which invite outsiders onto the premises of the organisation. Once integration with the community has been achieved, the organisation works at displaying the virtues of its differences, and what makes it special.

The gay community has, for example, gained increased community recognition and support through campaigns which initially sought to tone down the sense of marginalisation from the general community. Once a degree of acceptance has been gained, the group then benefits from using their difference as a strength in their campaign and thus capitalises on their marginalisation. The campaign for funding for AIDS research has successfully followed the integration–segregation pattern. The Arts Law Council of Australia pioneered a program to help HIV positive artists make their wills. The Australia Council supported the program and enhanced it by arranging for quick processing of HIV positive artists' grant applications.[2] In an article in the graphic art journal *Art and Australia*, Martin Terry comments on the importance of gay artists being recognised as such because of the influence it has on their work.

> Until the National Gallery in Canberra began collecting David Hockney prints and Robert Mapplethorpe photographs, there had been little enthusiasm for acknowledging the notion of being gay was as critical to the appreciation of gay artists' art as being exuberantly heterosexual is so obviously part of Picasso's, for example.[3]

Publicity is often forthcoming if a lobby group uses a well-known spokesperson or one with appropriate connections with government and business. Australian poet Les Murray and fellow poet and journalist Mark O'Connor have attracted media attention through their spokesmanship for the Australia Council Reform Association. Murray and

O'Connor have received media attention because of their status in the arts community, the controversial nature of their criticisms and their access to the print media.

A high profile which goes beyond the immediate organisation and its loyal supporters and the artistic community is achieved through contacts with other clubs, businesses, festivals, schools and activities. Involvement with community offers an arts company increased public awareness of their organisation, more promotional opportunities through their peripheral involvement in community activities, an enhanced image as an integral part of the lifestyle of the community, an increased awareness of community needs and tastes, and the possibility of increased support from sponsors and volunteers. The community benefits from an increased sense of empowerment that the arts company provides, and the sense that their culture is enriched.

In this way the arts organisation becomes its own publicity-making machine instead of depending on the selection policies of editors and journalists for coverage. The benefits are likely to be more permanent. If, on the other hand, the arts company is at loggerheads with the community, perhaps through problems caused by noise or air pollution, parking or traffic congestion, or controversial content of exhibitions/events, media support is a good means to make amends.

The ability to match the needs of the organisation to those of the community and to use this knowledge constructively is part of the public relations manager's brief. Considerations such as price of tickets or goods, the timing of an event or exhibition on the community calendar, the audience segments it will appeal to, and the style and content of the product on offer all have a bearing on what sort of media coverage is to be favoured and who and when to approach for it.

Press releases, fact sheets and press kits

The press or media release is an essential publicity document for any arts organisation. It is inexpensive by comparison

with other forms of publicity and can be copied in great numbers.

A press release should both inform and tantalise. The who, what, where, when and why answers about the particular event should be given, preferably in the first paragraph. The first paragraph is sometimes adopted by editors as given, and so should provide the necessary basic information clearly. The following several paragraphs contain facts in descending order of importance, with attention to accuracy. Appropriate names and phone numbers through which to pursue the story are given at the end of the release.

Journalists need a lure to pursue the story or an entice-ment to go to a particular launch or conference. This will be easier to provide if the person writing the release has developed an acquaintanceship with the journalist. As press releases are sometimes published verbatim, they provide the publicity manager with the opportunity to decide which aspects of the event should receive emphasis.

Points to remember:

- information—clarity, precision, answer the who, what, when, where, why
- a lure entice the journalist with an angle which is seduc-tive, that is, what makes this one different from all the others
- a motivator to reply, attend, interview or cover the story (an invitation to an opening night, preview or press conference, or a wonderful photograph may suffice)
- tone—enthusiastic but not commercial
- meet requirements of editor in terms of deadlines, cor-rect paper size and margins if appropriate
- date the release and number pages clearly and finish sentences on each page in case they become separated.

The timing of a press release is important. The different deadlines of various publications should be observed, along with considerations of when coverage for an event will be most beneficial. Considerations such as other activities within the community around the same time will need to be taken into account.

Some journalists prefer their information in the form of a fact sheet, which simply gives all the facts contained in the press release, but excludes the lure and the adopted stylistic tone. The fact sheet is written either as a list of facts or as a narrative. It is then sent to a number of appropriate journal editors or broadcasters who decide which angle they prefer to follow. Once again, established working relations with the relevant journalists and first-hand knowledge of their publications assist in deciding in what form to send the information.

Narrative fact sheet
FACT SHEET—NEWSTEAD GALLERY

2 April 1995
Attention: Marcus Reading, Arts Editor, Newstead Times
Sender: Rachel Thallon, Publicity Officer, Newstead Gallery
Contents: One page

The opening of the first Australian exhibition of Jamaican artist, Pastiche, will be held in the Newstead Gallery on 16 May 1995.

The official opening will take place in the gallery courtyard, 123 Percival Street, at 1 pm. The Mayor of Newstead, Mr Les Daley, and the artist will be present. A display of Jamaican street games will take place after their speeches, while coffee is served.

Pastiche is a world-renowned painter who lives and paints in her hometown of Kingston. She has received several awards for her work, the most prestigious being the British Academy of Fine Arts annual Turner prize.

Pastiche's paintings are mostly large canvases (2m x 3m) depicting the streets and people of her country. The style has been classified as naive by many critics.

Pastiche's exhibition has been funded by a joint agreement between the Australia Council, the Newstead Gallery Friends Society, and the Newstead Cultural Exchange Association. It will be open until 30 July 1995.

LISTED FACT SHEET
FACT SHEET—NEWSTEAD GALLERY

Sender: Rachel Thallon, Publicity Officer
2 April 1995

* Exhibition of contemporary Jamaican artist, Pastiche, at Newstead Gallery.
* Opening on 16 May at 1 pm.
* Opening events include—Pastiche's presence, speech by Lord Mayor, Mr Daley, afternoon tea of West Indian foods and coffee, street games and performances.

- Paintings are brightly coloured, naive style. Street scenes in large canvases.
- Pastiche is world-renowned winner of 1994 Turner Prize (England).
- This is Pastiche's first Australian exhibition.
- Exhibition funded by Newstead Gallery Friends Society, Australia Council, and Newstead Cultural Exchange Association. Curated by gallery director, Ms Phillipa Jones.
- Newly renovated heritage garden area will be venue for opening ceremonies.
- Pastiche will be accompanied by film-director husband, Connor Evans.
- Exhibition closes 30 June.

CONTACTS
Gallery Publicity Officer Ms Rachel Thallon phone . . .
Gallery Director Ms Phillipa Jones phone . . .
Gallery Friends Association President phone . . .
Cultural Exchange President phone . . .

PRESS RELEASE—Newstead Gallery
2 April 1995 (2 pages)

The first Australian exhibition of world-renowned Jamaican artist, Pastiche, will be held in Newstead Gallery from 16 May to 30 July 1995.

Pastiche lives and works in Jamaica. She has exhibited widely in Europe and America, and has received numerous awards. In September 1994 Pastiche received one of the most prestigious and coveted international awards, the Turner Prize from the British Academy of Fine Arts.

Pastiche's work has been classified as naive by many critics, following in the tradition of Henri Rousseau. The paintings are large canvases (2m x 3m) which depict scenes of street life through vibrant colours and energetic brushstrokes. Around the perimeters lurks a sombre and sinuous jungle which threatens to take over the scenes of happiness.

The opening will take place in the beautifully renovated Heritage Garden Courtyard, at 1 pm, and will include a display of Jamaican street games. Jamaican coffee and delicacies will be served. The Mayor, Mr Les Daley, and Pastiche, will officiate at the opening.

Gallery Director, Ms Phillipa Jones, claims this is a coup for the city of Newstead. Ms Jones said, 'It is exciting that an artist of this calibre should choose our superb gallery space for her first exhibition in the country. The people of Newstead have worked hard to establish the gallery as a recognised cultural exchange centre and this exhibition will be the jewel in the crown of their achievements'.

The exhibition has been jointly funded by the Newstead Gallery Friends Society, the Newstead Cultural Exchange Association and the Australia Council.

Pastiche is married to the flamboyant film director Connor Evans,

whom she often accompanies on location. Some of her artistic visions have been attributed to the exotic sights experienced on these tours.

For further information do not hesitate to contact myself or any of the following people. I have enclosed an invitation to the opening, and a photograph of Pastiche's painting which won the Turner Prize. I will be contacting you regarding a suitable preview time.

Regards,
Rachel Thallon
Publicity Officer, Newstead Gallery

CONTACTS:
- Ms Phillipa Jones, Director, Newstead Art Gallery, phone . . . fax . . .
- Mr Geoffrey Simmons, President, Newstead Cultural Exchange Association, phone (w) . . . (h) . . .
- Mrs Ann Armstrong, President, Newstead Gallery Friends Society, phone (w) . . . (h) . . .

A press release serves a number of different types of publication. The example given, of the Jamaican artist's exhibition, could be taken up by the following journals and groups:

- a women's magazine interested in the angle of the artist–filmmaker relationship, or in a biography of the artist
- a serious art magazine interested in her paintings, her influences and her philosophy
- an arts column in a newspaper might have a more factual copy, rather like the release itself, whereas the social pages of the same paper would probably take up the story of the festivities at the opening
- general news sections or ethnic groups interested in the story about Jamaican culture
- the Cultural Exchange Association may interest readers from similar associations or those who would like to participate in or use such an organisation, so the release could go to publicity officers of those organisations
- artists who see an opportunity for their work to be displayed in a similar way overseas, and visual arts publications
- marketing or business journals with readers interested in the exchange aspect
- radio interviews with the artist, the gallery director, or any of the groups associated with its execution

- film journals interested in the husband and his works and how they relate to those of his wife
- heritage and/or garden society publications interested in the venue
- food columns or food journals interested in it as a food event
- interior design or architectural magazines seeking appropriate photograph opportunities, and
- a lifestyle television show interested in the event or the personalities involved.

All these themes can be drawn out of the short release. The arts or publicity officer would have to decide whether it is worth approaching these publishers, and when the most appropriate time is to do so. Among the publications there is much contrast, and the manager will have to opt for the type of coverage which best attracts the desired audience.

A press kit is a handy tool for publicity managers to develop. An all-purpose kit can be developed for the organisation, as well as a kit for particular events or activities. A clear, well-presented kit will provide accessible and reliable information on the organisation and coming events. Inclusions for a press kit are:

- an information sheet about the aims and history of the organisation
- an outline of the management structure and list of staff
- a current timetable of events
- highlights of past events, prizes and awards
- photographs of previous exhibitions/events/venues, each well documented with names and dates
- a 'profile' or biographical information sheet about a particular artist/performer
- a 'backgrounder' or information sheet which lists detailed facts behind a controversy or topical issue.

The press kit can be used as an introductory handout to new journalists, with appropriate releases added to it for a particular event. It is also useful when liaising with community organisations, sponsors or local government figures. In situations where venue hire is an important part of the

organisation's activities, a separate kit can be developed on the venue itself, although much of the general information will also remain useful.

An editor using such a kit should be impressed by the instant data it supplies and the corresponding minimal time needed on research.

A press kit for the Newstead Gallery example should contain:

- name and contact number of publicity officer
- table of contents
- photographs of internal and external gallery spaces
- brief history of the gallery (this might include original premises, development of collection, patrons and other influential past figures. Photographs should be included where possible)
- how the gallery operates on management level, including list of board members, patrons, sponsors, and all staff and volunteers (photographs may be included with permission of subjects)
- a mission statement
- description of services offered and hours of opening (including venue hire, cafe facilities, retail merchandise, public lectures, Friends Society, volunteers, tours, educational and library services)
- annual report
- curator's statement about the collection and acquisition policy
- press reports of recent exhibitions.

Neatly and aesthetically presented press kits gain attention and provide easy reference. Permission should be obtained from each person mentioned for their inclusion in it.

A press kit for the Pastiche opening at Newstead Gallery should contain:

- artist's curriculum vitae
- transparencies of some of the paintings on exhibit (of a suitable quality to reproduce black and white for newspapers, colour for other journals)

- invitation to the opening, addressed personally to the journalist
- timetable of events and speakers at opening
- copies of previous publicity about artist (preferably recent articles)
- press releases which deal with different aspects of the exhibition (for example the festivities, the collaboration between the organisers, the entrepreneurship of the gallery management and a critique of the work) and
- contact names and phone numbers for follow-up stories.

Media conferences

In some circumstances a media conference is the most appropriate means of communication. If there is a great deal of media interest in an event, a media conference can provide a large group of journalists with a single interview time. If a crisis has occurred within the organisation, a media conference can publicly set the record straight. They are good arenas for announcements of great importance to the organisation such as the launch of a new program or the completion of a building. They are also suitable vehicles of communication for artists who have created intense public interest for particular prizes, works or statements.

Individual or special interviews can be arranged before or after the official group conference. Media conferences are suitable when the interviewee is capable of responding in an articulate way to a range of questions, some of which may be critical in tone, in front of a large number of people.

When organising a media conference, a public relations officer should decide which journalists to invite and check on their availability. If possible, a time will be set to cater for all journalists, or at least for representatives from all the appropriate publications and television and radio programs. The room in which the conference takes place should be set up with a suitable arrangement of tables and chairs, power outlets, water jugs, catering equipment, and food and drink when appropriate. Media releases provided to all the journalists present decrease their workload and the possibility of dissemination of incorrect information.

The public relations officer will chair the conference, or arrange for a suitable person to do so. The chair's role includes welcoming journalists, outlining the program of the meeting, referring to any restrictions on questions and introducing the interviewees. The chair will also control hostile questioning and high noise levels, or dominance by particular journalists, and close the conference at the prearranged time.

Arts journalism and the media

Newspapers

Specific arts programs on television and radio or in specialist publications identify with certain attitudes and audience segments in a deliberate way, and are desirable advertising and information outlets for arts companies and artists because of their market differentiation. Newspapers, especially daily ones, are a basic source of information available to the whole literate population and pose as the standard bearers for social attitudes, appealing to 'middle' Australia. Newspapers have transformed over the last century from small party-line publications aiming to convert more people to their cause, to supposedly objective non-partisan documents with enormous circulation. The objectivity and apoliticism that newspapers assume needs to be considered critically, especially in the light of the monopolistic ownership patterns in Australia.[4]

Newspapers are still the primary source of information for our population, despite the fact that more immediate news is available from radio and television. Newspapers provide more detail than the radio, which concentrates on brief and frequent updating of news. Newspapers also place the stories and subject areas within a more intricately devised hierarchy of importance through their physical placement on the page and the angle from which the stories are approached. The different emphases a newspaper adopts might assert to the reader, for example, that politics are more important than health or that natural disasters are important only for a certain number of days or that sport is an important part of our culture or that art is particularly important when it impinges on our reputation overseas. The press is,

as a result of these subtle messages, perhaps the most influential of our information sources.

Massive circulation figures of daily newspapers mean that they cater to a heterogeneous audience. Accordingly, editors select items of broad appeal. This influences the types of arts articles which are selected for publication. Fringe or ethnic arts are often viewed from the viewpoint of their deviation from the norm rather than for their stylistics or subjects. Events which attract huge audiences or artists who are widely known are of interest to a greater number of readers than obscure artists who may be pioneers in their field.

Arts journalism varies greatly in quality while editorial selection policies between the various Australian daily newspapers show remarkable similarities. It is common, for example, to find a large arts section at the weekend complemented by a smaller one on one week day. These pages are usually towards the end of the paper, and are replaced by television show revues on the other week days. It is also common to find a page three or page five arts article consisting of a good photograph and very little copy. These page three and five articles are often about overseas artists visiting Australia, or Australian artists doing well overseas, or Australian artists receiving national awards or recognition in their artform, or meeting important figures from other spheres of activity such as politics.

It is not common to find any in-depth analysis of the arts industry, although such articles do occur sporadically in the better quality papers, usually in the commentary style articles by high profile journalists. Controversial issues receive more attention if a well-known artist is involved, and lobby groups also gain coverage by having a well-known artist as a spokesperson. Often this spokesperson will better communicate the message through a letter to the editor, as articles written by journalists tend to concentrate on personalities rather than issues. A fascination for famous people is evident in all arts reportage, with the emphasis in interviews on personality and personal foibles rather than deep analysis of craft.

While some arts journalists are extremely well informed and knowledgeable, others have no experience in the area, and are sometimes not sympathetic towards certain artforms

or their 'round' as arts reporters in general. Much of this can be countered by well-prepared and informative material in press releases. In fact the initial communications with the journalists should provide them with the stimulus to want to pursue the story. Journalists rarely cover the same story twice so it is better to provide highly motivating material in the first communication. Once a rapport is developed on a more personal basis between journalist and arts/publicity manager, these motivating points will be easier to predict and provide.

Photography is an important part of arts journalism. Public relations managers should provide journalists with the information to inspire them to take photographs and provide convenient access to good photographic opportunities.

Often it is the photograph rather than the story which will convince an editor to select the article for publication, and it is the photograph which will also attract the reader's attention. Sometimes photographs taken by someone within the arts organisation are used for publication, or provide an editor with the stimulus to want to use photography in the article. Colour photography is rapidly taking over from black and white in newspapers. Publicity managers must be sensitive to the different sorts of appeal different settings can provide for colour photos.

Some arts articles are shelved for a time and printed at a later date, so all stories do not have to be topical. The editor's decision to run an article on a particular day is often more dependent on considerations of length than quality, and on how well it will fit in with other stories on the page. Any big story of the day immediately takes precedence over whatever was prepared earlier, no matter how important it seemed at the time. This also makes it difficult for journalists to write a series of articles following through a topic, unless space has been previously allocated for something like coverage of a festival or conference.

The influence of the review varies from small to big operations and between artforms. Larger theatre companies which have the capacity to presell a high proportion of seats before a show opens are sometimes less concerned with bad reviews than smaller theatre companies without the means to presell and advertise on a large scale, and which therefore

rely on sales resulting from reviews and word-of-mouth rec-
ommendations. Commercial art galleries rely on large open-
ing night and preview sales and see the review as a means
of establishing a reputation of consistency for them as much
as for an enticement for particular sales. Arts/publicity man-
agers who have a good knowledge of the artistic preferences
of different reviewers are at an advantage when deciding who
to contact for coverage.

Radio

Radio operates well on a number of levels for arts coverage.
Detailed interviews with artists suit the medium, short aware-
ness advertisements for shows/events can be frequent and
inexpensive, specialist analysis programs can cover any
number of topics and enliven general debate and awareness
of issues without having to be 'newsworthy', short reviews can
reach audiences who may not deliberately tune in to hear
them but obtain the information coincidentally. And radio
is of course an excellent medium for music.

Radio audiences are more haphazard in their choices
than television audiences. Most people listen to radios in cars
or when they can at work places and during leisure hours
rather than deliberately selecting particular programs and
ordering their lives around those timeslots. Radio stations
have more defined market segmentation than television sta-
tions, which categorise their viewers for each program and
time of day rather than the general station positioning. This
has been influenced to date by the greater choice of radio
stations than television stations.

The Australian Broadcasting Commission (ABC, now Cor-
poration) was established in 1932 with a bifold purpose of
broadcasting parliament and 'promulgating the finer things
in life' to its audience through fine music and drama.[5] It
became a touchstone for 'good taste', helping mould creative
works as well as being a major participant in them. Proposed
changes to the ABC format, particularly in television, have
caused much controversy because they challenge not only
particular programs but entire cultural traditions. These tra-
ditions do not always blend with the demands of viability in
the commercial world.

Commercial stations established later were able to differentiate themselves via more popularist programs and aims. FM stations in their turn appealed to a more defined segment whose needs were not met by the popularist commercial networks, although recent monopolistic ownership patterns of FM stations has heightened their similarities rather than their differences.

Radio remains a cheaper publicity medium than television, and is well served by community announcement segments. Radio has the ability to serve the community and allow community members to keep in touch with one another more than other media and in a more immediate way.

Television
Television is prohibitively expensive as a publicity outlet for most small to medium size arts companies. However, some stories that evolve from an art event may be of interest to programs centred around art, lifestyle, race, gender or social issues which a television journalist will be interested in pursuing. Arts managers need to see the product they are dealing with in a broad sense so that angles of appeal are not ignored. They also need to be aware of the usual content and styles of various programs to ensure that they are approaching the relevant people.

Larger organisations often buy a publicity package with the particular event they are presenting, but still need detailed knowledge of audience profiles to make judgements about how to distribute it. In some cases television stations have become sponsors of large scale arts events and can provide the event or organisation with free publicity.

The introduction of pay television and the increased use of CD ROMS and multi-media units are subverting and changing the role of television. On-line publicity may well make television publicity an accessible source for arts managers in the future. The Australian Broadcasting Authority (ABA) refers to the realities of 'convergence' and globalisation as the beginning of a new era in television, and one which challenges broadcasters to: 'ensure that content rather

than technology drives the process of change and that more services do not result in lower quality'.[6]

Australian content requirements in television programming are increasing. The ABA, in its review of content, aims to ensure that it meets the objectives set out in the Broadcasting Services Act (1992) which raise issues of quality, diversity of services, Australian identity, character and cultural diversity: 'The ABA recognises the central role of television in the development and maintenance of Australian culture and the role of the current standard in ensuring that Australians see themselves, their lives and their society reflected on television.'[7]

Television, perhaps more than newspapers, reinforces social values through its sumptuous and sometimes mesmerising depictions of 'life', whether fictional or not, and through its well-documented addictive qualities. While the ABA sets out content requirements and guidelines, decisions made about programming are still commercial ones and the importance of ratings is paramount.

Journals

Journals, whose readership is usually one of 'converts' who have subscribed to or selected the issue because of its well-defined and specialist parameters, often go into more depth and analysis of art product than do newspapers or television or radio shows. In order to distinguish themselves from other journals and other forms of arts reportage, particular journals can offer a cohesive look at subject matter or a distinctive analytical style or approach.

Journals also lend themselves to following through a series of stories on the same organisation, movement, artist's progression or debate about artistic philosophy. The analysis of any of these things is not confined to arts journals, but may be pursued in high quality journals of a more general nature which have regular arts columns.

Columnists such as Giles Auty in the British magazine *The Spectator* are able to stimulate debate about art through a more general community readership. Auty's views go against the prevailing current thought on Modernism, bringing discussion of art into a wider arena and providing readers

with the brand of controversy they often desire from a journal. Auty claimed in a series of articles that the art world is divided into two parts: intelligent people and people who have access to power. The latter group encourage the Modernist orthodoxy and control the teaching of art and art history as well as holding all the highest positions in arts administration in Britain. Their taste for Modernist art has overrun all institutions except journalism, Auty claims, and amounts to hegemonic censorship of other art movements comparable to that practised by Lenin and Stalin.[8]

Writers and commentators who receive coverage for this kind of criticism usually have a degree of standing in the community or have gained a degree of respect for their intellect before being able to venture into such debate.

Arts managers aware of this type of debate about the role of art and its effects on managerial change can use the knowledge to assess their own practices, to pursue particular journals for coverage or to help encourage artistic debate in the broader community. Auty is particularly vehement in his criticism of the manager/curator who hijacks and controls the public's artistic taste through persistently personal choices. Such criticism and the debate it stimulates alerts the arts manager to the importance of staying in touch with community perceptions.

Newsletters

Community communication is a vital component of media relations. Newsletters are a good vehicle for this kind of communication. They usually have a friendly tone and provide relevant information to people who belong to a certain group. Arts managers can use their own organisation's newsletters to reach further into the community by distributing them beyond the membership base. The newsletters of other local organisations can also be used by arts managers to find out about other groups' activities, to compare editorial styles and membership information and, in some cases, to advertise their own organisation.

Newsletters are comparatively inexpensive to produce. They should be well laid out for easy access to information and to encourage people to read them. Sometimes

photographs are so poorly reproduced in newsletters that it is preferable to use other graphics.

Newsletters may include:

- lists of new members
- recognition of achievements of members
- calendar of coming events
- booking information
- letters to the editor
- community billboard
- report of a recent event/show/lecture
- list of recent acquisitions
- editorial
- obituaries
- message from membership society's president
- form for new membership and payment facility information
- information about membership offers
- an example of a work of art related to members' interests, for example, poetry, line drawing, photograph of craftwork.

Excessive information reduces the attractiveness of newsletters. Clear layout of information under different headings and use of regular sections which give continuity allow easy reading. Adopting a friendly tone is important, as newsletters aim to capture all members of the organisation as well as new recruits. Feedback on newsletters is easily gained through personal conversations or through attached questionnaires.

A newsletter is a good channel for a manager to assess the role of the organisation on a regular basis and report on it, to encourage and reward more participation from members, and to link with other organisations. Its compilation provides some time for assessment and rumination, some standing back and observing how recent strategies have impacted on the organisation.

While most newsletters are published monthly, the editor must consider if this is appropriate for their organisation. Some will require weekly updates to cover membership needs

and events, while other organisations will benefit from fewer newsletters of higher quality.

Brochures

Brochures encapsulate the information contained in detail in the press kit, in a more alluring format. The editor or the publicity officer who briefs the brochure designer decides which points to emphasise and which to delete. The brochure provides enough information to answer basic questions as well as giving contact names and numbers if more detail is required.

The brochure attracts its audience with the design or wording of its first page in particular. If its purpose is recruitment there should be an easy-to-use form attached to enable postage or phone inquiries.

Distribution needs to be well considered. Helpful volunteers may offer to distribute them, and permission to display the brochures should be sought from the proprietors of these locations. A list of the locations holding brochures should be kept by the publicity officer, who can then gauge how useful or popular they are with the patrons of that location. Brochures are relatively expensive to produce, especially if printed in colour; return on the expense can be judged by asking new members or customers what motivated them to use the services or venue of the organisation.

Reports

Publicity officers or arts managers are often required to produce reports on their organisation in general, or on particular events, exhibitions, functions, committee work or tours.

A report is factual, not anecdotal, and the facts in it must be correct. It is most useful when divided into topics, each with a heading numbered and subnumbered appropriately. An introduction provides information about how the report was commissioned, and gives details of how, where, when and by whom the information in it was obtained. Like the other documents already discussed, the report should be well presented and easy to reference. Its title should be marked along its spine as well as on its cover, for access from storage shelves.

It is often a worthwhile exercise for a publicity officer to document a report on an event even if it has not been commissioned, as it provides ready access to information about it which may be required for a number of reasons at any time in the future. In this way, a publicity officer will build up a thorough records section for the organisation.

Ethics and social responsibility

An arts manager's dealings with the media and the public should always be guided by honesty and accuracy. Personal gains should not override considerations for the good of the organisation.

Courtesy should prevail when gaining permission to publish names and photographs, or to mention works of art in publicity. Favouritism towards particular journalists should be avoided, and favours should not be requested of them. Working relationships should be kept on a professional level.

The publicity or arts manager has a duty to all the events or shows of the organisation, and so should not become too involved in a particular campaign at the expense of others. It is also part of the manager's duty to keep abreast of the various publications, new and old, which will most benefit his organisation.

The arts manager can monitor the degree of integration the organisation shares with the community. An organisation's alienation from its community is often the result of personality clashes between its figurehead—the manager, board director, artistic director or patron—and outside figures.

The publicity or arts manager must be able to deal personally with the complaints or inquiries of the organisation's patrons and employees. Politeness must prevail in all these dealings, and any promises of action must be fulfilled. Employee training which includes a code of courtesy is advisable. Letters and phone calls from patrons should be dealt with quickly. A good publicity manager will often initiate these calls to ensure the patrons are satisfied with the product or service they receive.

Because volunteers are so often used by arts companies to hold positions of contact with the public, the manager must involve them in the courtesy training and not hesitate to discuss with them inappropriate behaviour contrary to the organisational culture. As a public relations exercise in itself, the volunteers are to be treated as equals of paid employees and go through the same training and briefings, where appropriate.

It is important that all employees, whether volunteers or not, are armed with the information and resources that enable them to pursue patrons' inquiries. Again it may be the role of the publicity officer to produce information kits for that very purpose.

It is clear, then, that the role of the public relations officer is multifarious. Public relations officers must be resourceful, knowledgeable, genial and patient. They must be able to communicate with all levels of the public, the employees within their organisation, the community which their organisation serves, and the media. They must be able to speak confidently in public as well as produce a great variety of written documents. They must not only remember the names and positions of many of their patrons and be able to communicate with ease with all of them, but also remember personal foibles and requirements in relation to issues like travel and seating. They must show initiative in recognising and amending shortcomings of their organisation, and in always using opportunities for its promotion when they arise. They must be well read and informed of events both inside and outside their organisation, and actively pursue a profile within the community. The qualities, skills and experience required of a public relations officer form an extensive checklist for an arts organisation seeking to employ such a person.

Media relations comprise a small but important part of the public role of management. The arts are in one sense public goods, and alongside the increasing entrepreneurial role in the production of arts and culture, ethical issues will continue to inform socially responsible communication.

4

An ethical and legal framework for the arts

The role of arts managers changes as managers become more responsive to the needs of the marketplace and accept a commercial duty in developing the arts and cultural industries. This leads to the need for a new legal and ethical framework in which artists and arts managers operate. An understanding of corporate law, contracts, commissions, taxation, liability, insurance, licences, intellectual property and social justice legislation is essential in the current transformation of aesthetic experience into cultural economics. The economic attributes which have strongly influenced arts and cultural activity place controls and regulations on the practice of art, demanding rigorous accountability and social responsibility by those who facilitate the artistic experience between artist and consumer. This chapter examines:

* the duties and legal responsibilities of board directors
* the application of Corporations Law in the arts
* performer and venue contracts
* copyright and moral rights
* liability and insurance
* ethics and the development of a code of conduct in arts management.

Board responsibilities

Most non-profit arts and cultural organisations are established with a board, trust or committee of management as

the group of people appointed or elected to govern the organisation and to ensure that it has the community support, financial resources and management skills required to achieve its objectives. Under the law which applies uniformly throughout Australia the board is accountable and legally responsible for the organisation's activities. In generic terms a board is a group of advisers. In legal terms, a board of an incorporated association is the group empowered to conduct the business of that organisation as specified by the Constitution or in the case of a company, a Memorandum and Articles of Association.

While arts boards have common roles, responsibilities and functions, each has unique qualities which reflect the particular mission of the organisation. An effective board for an opera company will have a different set of responsibilities to those of a regional arts centre or an art museum. The board's responsiveness to business, government, artists and patrons will vary the leadership functions and governance role depending on the cause and nature of the particular organisation and whether or not it is for profit. With this understood, the aim of the chapter is to examine the general legal framework in which arts organisations operate.

There are four main functions of a board: fiduciary, legal, governance and policy making, and fundraising. More specifically the functions are to:

- set policy
- create and staff standing committees
- review, approve and monitor the annual budget
- recruit and select senior staff
- conduct long-range strategic planning
- represent the organisation to the community
- raise money
- evaluate organisational operations and programs.

For boards to operate successfully it is important that members are aware of their responsibilities and liabilities in the areas of finance, law and general management. Ideally board membership should include people with expertise in these areas. However, all members bear the responsibility for

the board's action and therefore it is desirable that all members have at least a general understanding of their role.

Financial

It is the board's function to provide continuity for the organisation's operations and administration through financial management. This requires the board to:

- establish the budget and financial management reporting system
- monitor revenue and expenditure
- participate in and oversee fundraising activities
- manage the assets of the organisation.

The board, not the organisation's staff, is legally accountable for sound financial management. It is up to all members of the board to ensure that the financial reporting system provides the information necessary to carry out their responsibilities. A number of board members should have expertise in financial affairs, but it cannot be considered that is solely their responsibility. The board should ensure that all members understand and are able to interpret financial reports. Financial statements should be clear and structured in such a way that at an early stage, potential problems with expenditure or lack of funds can be identified.

Legal

Board members are legally responsible for the following functions:

- the development and maintenance of relevant articles of incorporation and by-laws
- the control of taxation and tax-exempt matters
- compliance with all laws
- approval and safeguarding all legal documents
- monitoring and familiarity with government reporting
- keeping records through minutes and audits
- evaluation of the organisation's chief executive officer.

Guidelines based on the principles of honesty, diligence and care are set out for board members in terms of their legal liability in *The Arts in the Australian Corporate Environment*.[1] Directors (board members) and officers (general

managers, chief executives) are required to discharge their duties in good faith and with the degree of diligence, care and skill which would ordinarily be considered prudent by others in positions of corporate responsibility. The same duties and liabilities apply whether the person is a volunteer or in paid employment for a small arts organisation or a director of a large business corporation. Board members must exercise reasonable diligence and due care to be free from personal liability. Exercising due care means:

- attending meetings (members are responsible for all action at a board meeting whether or not they are in attendance)
- keeping informed of the general activities and operations
- examining financial statements
- overseeing work delegated to staff and volunteers
- making decisions and recording votes (a vote is assumed affirmative unless recorded as negative)
- supervising the handling of money (if funds disappear, board members are held responsible)
- ensuring minimum statutory or technical requirements are met (filing annual reports to government departments)
- avoiding any activities associated with personal gain.

In order to avoid conflict of interest board members must be able to prove that loyalty to the organisation came before personal gain. When conflict of interest arises, board members must declare this and remove themselves from discussion and the right to vote on the conflicting matter.

An example of this has occurred in recent years through the Australia Council and state arts department's peer assessment committees. Artists appointed to such advisory committees because of their skill, knowledge and expertise in an artform area cannot be discouraged from continuing their own practice of art which may include application for government funds. In the event that this artist's funding application reaches peer-group assessment at committee level, the artist withdraws from attendance, discussion and decision making at that time. Similarly if a person is appointed to the board as a member with marketing expertise and at a later

date this member's company is one of a selected list tendering for a feasibility study, publicity contract or market survey, that board member would declare a conflict of interest and withdraw from discussion and decision making.

It is inevitable in a country with a small population such as Australia that those people with an interest in and commitment to the development of the arts and cultural industries will find themselves in business and practice in arts-biased enterprise, and also volunteering as board members. These board members must ensure their board performance clearly adheres to the legal duties of honesty, reasonable care and diligence, and declared conflict of interest.

Because of the extensive obligations and liabilities of board members it is possible to seek protection through officers' and directors' insurance. However, this is often expensive and contains exclusions such that it would be preferable for board members to adopt a policy of self-insurance by rigorous attention to the functions, responsibilities and legal obligations of board membership.

General management

The third area of responsibility and liability for board members incorporates the practice of the principles of effective management. These require the same diligence and care as the financial and legal aspects of the organisation's business, particularly in the contemporary industrial and corporate environment in which the arts operate. The principles comprise strategic planning, personnel management, marketing and public relations, policy and decision making, evaluation and reporting, as well as financial management and legal liability.

While not becoming involved in day-to-day operational management, the board is responsible for the policies that inform management, personnel, marketing and artistic practice. It is through policy that the board interprets the organisation's mission and objectives. The board facilitates planning, provides guidelines for management, communicates the values of the organisation and maintains the organisation's profile in the community in order to attract audiences and private support. The non-profit board has a

pivotal role in the organisation's structure. It communicates and reports to the corporate sponsor and to the government funding agency measuring performance indicators and maintaining the value of the marketing relationship. The board responds to communication from the artistic director, the general manager and the marketing and development officer monitoring artistic excellence and innovation, financial information and audience research. Accountability for the balance of artistic and economic achievement rests with the board. Board members must be adept at the cyclical process of policy setting, monitoring, evaluating and creating new policy. Theirs is a crucial role in setting strategic objectives to carry out the mission of the organisation.

Board survey

The demands on board members are such that a survey was carried out in 1993 in Australia to gather data on the type of person volunteering or being recruited to boards of arts and cultural organisations and on board members' knowledge of their organisation and the tasks involved in performing board responsibilities.[2] The outcomes indicated that board members comprise a high profile, articulate, well-educated, business alert and artistically sensitive group of individuals. When asked to nominate their legal duties, a small proportion of respondents to the survey indicated that they were not aware of any. Most supplied statements such as: act honestly and diligently in fiduciary capacity as per law and accepted practice; act in the interests of the organisation with due care, honesty and diligence, avoiding conflict of interest; honesty, integrity and responsibility as a citizen; as per corporations law; as for directors of a public company, ignorance is no excuse; as governed by the Act; ultimate financial responsibility; within securities legislation; responsible for policy and procedure; and to ensure that it is run on a sound basis in accordance with the aims and objectives of the organisation. The final question in the survey required the board members to indicate in which of the following content areas they would attend seminars:

- policy making
- marketing

- group processes (team building)
- meeting procedure
- strategic planning
- legal responsibilities of boards.

The highest percentage (53 per cent) of respondents nominated legal responsibilities as their area of interest in seminar training. This gives a clear indication of increasing board awareness of their legal responsibilities.

There were, however, in the survey, strong indications that recruitment, orientation and training practices are ad hoc and are not designed to meet the needs of the organisation and the community in the near future. The emphasis of the mission and objectives of these arts organisations was to produce high quality arts product for the community. Phrases referring to access, regional extension, artistic achievement, arts industry development, cultural enrichment and education were included.

Only two organisations included market development and business support in the mission or goal statement. This indicates that the use of the mission or goal statement as a contributing factor to the board member profile, calls for board members with significant arts experience. The biographies and demographics of the surveyed board members emphasised business and professional experience. Former artists and arts educators are recruited, and some boards conscientiously include in their membership an artist or director in that art form. However, the current trend is to recruit *not* to exemplify the mission of the organisation, but to operationalise the mission, that is, managers, solicitors, accountants, intellectuals, policy makers, fundraisers or marketers.

If similar research had been conducted ten years ago, the findings would have shown heavily concentrated artistic board membership. The profile of a board is influenced by the political, economic and social agenda in the region. As governments change, so do policies affecting funding for non-profit organisations; as the economic situation of the nation changes so does the available sponsorship from corporations and so do the accountability requirements for

government-funded organisations; as the social responsibilities of a state or nation change so do the needs for policies for equity in gender, indigenous people, ethnic groups, regions, age, disability, access and participation. The current profile of arts and cultural boards in Australia reflects these political, economic and social variables.

The environment in which most of these non-profit arts and cultural organisations were established encompassed the typical Australian community: non-competitive, inventive, socially and politically stable, independent, individual and with limited government intervention. However, organisations operating in the nineties and beyond need to address competitiveness, arts export, cultural tourism, internationalisation, aggressive management practice, a united direction between government and the private sector, and a visionary approach for the place of the arts in the Australian community. This is the environment in which arts boards must perform. It is a competitive environment incorporating complex legal and ethical issues.

Board recruitment

Recruitment should never follow an informal social conversation such as, 'Does any member know someone who would like to join the board?' Recruitment should be carried out as every other corporate business practice. Either of the following two methods may be appropriate for particular organisations.

Once the organisation has identified its needs, an informal approach may be made to a potential board member and a curriculum vitae and written statement collected for evaluation. This written statement should involve completion of a questionnaire and comments giving an indication of the applicant's commitment to the arts, the arts industry, and to the development of this organisation. Appointment or election then may follow.

Alternatively, following the usual procedures for employment, a media advertisement calling for expressions of interest is followed by a mail out to respondees containing information on the organisation. Curriculum vitae are collected and these are matched to selection criteria (for

example, arts interest, fundraising skills, education profile, legal expertise, management experience). Candidates are shortlisted and interviewed. The process is handled by a professional personnel management company with or without involvement of the chief executive officer of the arts organisation.

The problems of patronage, self-promotion and political interference are minimalised by following the established procedures in these recruitment models.[3]

In identifying its recruitment needs, the board must consider the organisation's mission, constitution and strategic plan. These regulations, goals, objectives and plans may determine selection criteria for board membership. A thorough environmental (social, political and economic) analysis together with a listing of the organisation's strengths, weaknesses, opportunities and threats could also influence board member selection. Depending on the expertise and experience of the board member, training for board management may or may not be necessary. During the life of a particular board, consequent events may involve specific training programs. This process is explained in the model in Figure 4.1.

Fundamental legal concepts

In order to understand the areas of law and regulation involved in arts management it is essential to be familiar with the fundamental legal concepts of contract, diligence, duty, negligence and crime. These definitions provide a framework in which to examine legal entities, intellectual property, liability and ethics.

Under Corporations Law the executive officer who takes a significant part in the management and administration of the arts organisation has specific duties in relation to honesty, reasonable care and reasonable diligence. An arts manager is deemed executive officer under Section 9 of Corporations Law if the manager is involved in such activities as entering into contracts, authorising disposal of resources and terminating employment.

Duty to act honestly

The duty of honesty requires arts managers to act honestly

Figure 4.1 Model for recruitment and training of board members of non-profit arts organisations

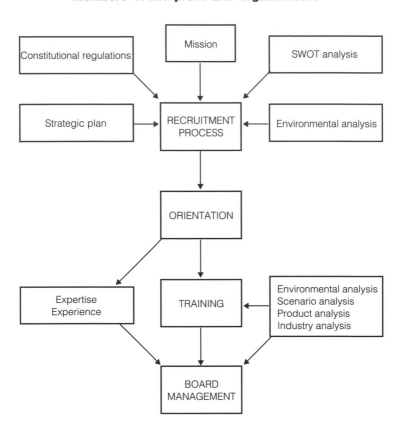

and with the utmost good faith for the benefit of their organisation in carrying out their duties.

Duties of care and diligence

Arts managers have a duty of care under the common law as a result of what is known as their fiduciary duty (a duty owed to others when one holds a position of responsibility). Arts managers, who are also executive officers of companies, have a similar duty of care under the provisions of Corporations Law. Workplace health and safety acts also demand high standards of care.

In the management of any arts organisation, whether a

performing arts company, museum, writing group or a major performing arts centre, the same degree of care and diligence must be exercised as by a reasonable person in a similar management position in any organisation. The law recognises that the performance of the manager will be influenced by the financial status and size of the organisation and the extent of the negligence.

Contract

In law a contract is an agreement between two or more parties containing promises by each party which they intend to be enforceable. It may be by word of mouth or in writing as a letter or formal document. The area of contract is discussed in detail later in this chapter.

Tort

As opposed to a criminal wrong actionable by the state, a tort is a civil wrong or injury actionable by a private individual. A tort arises out of duties (care, diligence and honesty) owed between members of society, not out of agreements such as contracts. Defamation, civil assault and trespass are all torts.

Negligence

Negligence is the tort of causing damage unintentionally by failing to exercise a reasonable degree of care in relation to other people, exposing them to risk of harm or injury.

The issue of negligence relates to the regulations in the workplace health and safety acts in each state of Australia. Within the operation of an arts centre, for example, the areas of responsibility are quite specific. The local government, town clerk, board, general manger and technicians can all be sued for negligence. While not abrogating responsibility, the arts manager must attempt through preliminary negotiations, agreements and contracts with venue hirers, promoters, producers and artists, to ensure that their duty of care is clearly understood. The areas prone to negligence by both parties (specifically technical) must be thoroughly studied, planned and recorded so that the user accepts responsibility for the skill of operation.

Crime

A crime is an act which is forbidden by law. It is an offence against the whole community; criminal proceedings are carried out by the state through the police and successful prosecution usually results in punishment of the convicted person.

As example, if the arts manager suspects or detects that stealing has occurred, a report should be made to the police. Staff criminal activity may be covered in the employment agreement resulting in the instant dismissal of the offending employee. The police may investigate the report and take statements from the arts manager and other employees.

The arts manager should take precautions to avoid any potential criminal activity in the arts organisation. The following examples may help:

- The performing arts centre manager should research the negotiable range of fees for promoters. Check with the performing arts centres network for fees being paid elsewhere to eliminate possible misrepresentation or fraud.
- Managers should investigate artists or employees being contracted if there is any doubt in any clauses. If the contract stipulates that your organisation is the only employer, consider the implications if the contract is signed fraudulently by the artist or prospective employee.
- Stage managers should establish rules for backstage behaviour: no consumption of alcohol, drugs or prohibited substances. Display a disclaimer notice in dressing rooms.

Legal entities

The arts and cultural industry functions around a variety of management structures: individual artists, membership associations and networks, performing arts companies, theatre groups, arts and cultural centres, museums, institutes of art, festivals and events, arts fringe societies, radio stations, government arts departments, and statutory authorities formed by an Act of Parliament. Usually, arts organisations are established as non-profit, membership-based incorporated associations with an elected board of management. However,

there are many legal structures in operation in the arts and entertainment environment. Arts managers who may also be entrepreneurs, venue managers, employers, lessees, borrowers, contractors, partners, agents, public servants, consultants and employees, should be familiar with the definitions, rights and restrictions of legal entities and structures. This is essential for the negotiation of contracts, relationships with employees and the public, and in selecting the most appropriate structure for a new or changing arts organisation.

The legal entities that follow are described by definition and example.

Natural person

In the context of legal personality, a natural person is a human being rather than an artificial person such as a company.

Sole trader

A sole trader is an individual person who trades and undertakes business with a view to profit. There is no separate legal entity and so sole traders are legally liable and responsible for their actions and the direct outcomes of those actions.

Many artists working on short-term projects operate as sole traders. In contracting such artists for services, arts managers need to be aware of the legal, financial and risk management implications of doing so. Artists and artsworkers would not normally have their own public liability insurance. It is possible for the arts organisation to include public liability insurance coverage on the artsworker or artists and on participants, as a clause in the employment contract.

Independent contractor

An independent contractor is a person or group of persons who are contracted for services. An independent contractor is not paid wages but is paid a fee. The independent contractor, not the contracting organisation, will then be responsible for taxation, workers compensation and public liability insurance. An independent contractor, having been contracted for services, may employ other people and contract out labour. The arts organisation as an employer is not

liable for negligence of the independent contractor or those employees in the execution of the contract.

An arts manager may contract, for a fee, a lighting designer who is operating as an independent contractor. That designer may then contract the services of support staff or a lighting assistant. An artist may be engaged as an independent contractor for the purpose of the commission of a work. The copyright of works created by the independent contractor will remain with the artist unless otherwise agreed upon.

Partnership

A partnership is an association of two or more people formed for the purpose of carrying out business for the purpose of making a profit. Partnerships are covered in Australia by the *Partnership Act 1890*. Unlike an incorporated company, a partnership is not a separate legal entity and therefore all partners are liable for all the debts of the business. General partners are fully liable for these debts, limited partners only to the extent of their investment. A partnership may be formalised by agreement or may exist out of the partnership-like actions of persons.

An arts centre manager may have dealings with promoters as a partnership such as investing in the production; an arts marketing consortia may be a partnership of three or more small performing arts companies, or a gallery and performing company; two people may operate a gallery as a partnership, investing jointly with money and time.

Company

A company is a body of persons associated together for the purposes of trade or business.

In an arts context, the term 'company' is often used to describe a group of performing artists, for example, a theatre company or ballet company. To avoid confusion the word 'corporation' should be used as a substitute in legal situations.

Arts organisations which are incorporated as companies limited by guarantee, have had to respond to major changes in their responsibilities with the introduction of the Corporations Law in Australia in 1991. Companies have to file an

annual return, and must also print and display an Australian Company Number (the ACN) on all public documents signed, issued or published and on all negotiable instruments, including cheques. If the ACN number is not apparent then an offence will be committed.

The Corporations Law provides for the incorporation of companies, including a company in which the liability of the members to contribute to a company's debts in the event of winding up, is limited to a guaranteed amount. A company limited by guarantee offers a number of advantages to arts organisations:

- perpetual succession: the company continues indefinitely and is dependent on the particular individuals who are its members from time to time.
- limited liability: the liability of the members is limited to the amount of their guarantee.
- capital: members are not required to invest in shares or contribute to the capital of the company.
- trading: there is no restriction on the company being involved in trading activities as there is with an incorporated association.
- national operations: the company is incorporated under Corporations Law and is so recognised and can carry on its activities throughout Australia.

An arts manager may be established as a company and contract to provide management service, for example, to the local government to manage the cultural centre. Arts managers will have dealings with many companies for services, goods, productions, tours and sponsorship arrangements. It is wise to be familiar with company structures.

Trust

A trust is an arrangement for the holding and management of property by one party for the benefit of others. Trustees must never place their own interests over those of the beneficiaries. They must be acquainted with, obey and carry out the terms of the trust, and act with care and diligence in the business of the trust.

Some arts organisations and arts centres under government statute are managed by trusts as boards of directors. While the corporate responsibilities of both legal entities are similar, these trustees also hold a custodial responsibility for property and funds of behalf of the government.

Unincorporated association

An unincorporated association is a form of organisation where there is no corporate entity separate from the members who make up the organisation. It is not capable of acquiring property in its own name or suing or being sued in its own name.

The governing committee of an unincorporated associated enters into a contract or undertakes the acquisition of property on behalf of the association. Members of the governing committee are personally liable if things go wrong. Because of this situation it is generally not recommended that arts organisations adopt this structure unless public liability insurance is arranged to cover activities involving members.

Local theatre groups and community organisations hiring venues in a regional arts centre may be unincorporated associations. Arts centre managers are advised to discuss the terms and conditions of all agreements with unincorporated associations, to protect the arts centre and the local government in any legal dispute.

Incorporated association

Incorporated associations are associations formed and carried on for any lawful purpose or specifically formed for the purpose of promoting or encouraging literature, science or the arts, or for the purpose of recreation or amusement. There is a general prohibition on incorporated associations securing pecuniary gain for their members. An incorporated association can sue and be sued in its own name, acquire and deal with property, accept gifts or bequests, enter into and enforce contracts. The incorporated association has perpetual succession as does a company limited by guarantee.

The most beneficial aspect of incorporation for members (including committee or board members) is that they have no responsibility to contribute for debts and liabilities of the association as distinct from unincorporated associations.

However, specifically the duty of directors and managers to exercise care and skill is contained in Corporations Law and although it applies to companies under that law, it is possible in future that it will be used by a court as a guide, when determining appropriate behaviour by committee or board members and officers in an incorporated association.

This legal entity is common in local arts organisations as it removes liability for the organisation's actions and financial commitments from the organisation's members.

Statutory authority

A statutory authority is an organisation created by legislation and is an authorised, legal structure that by law has the power and/or legal permission and control to do something. It is also answerable to the laws of the land.

The Australia Council is a statutory authority which was established to be at arm's length from the government in its role of arts funding and policy advice. Employees of statutory authorities work under similar conditions to the relevant federal or state public service. Most state art galleries, libraries and museums are statutory authorities. Local governments themselves are statutory authorities. Officers of such authorities are not likely to be personally liable for their actions.

Co-operative

A co-operative, in simple terms, is a group of individuals who come together to form an organisation for a common purpose, in such a way that the organisation runs democratically and can sustain itself. A co-operative bases itself on the individuals who make up the membership. The existence of the common purpose is the basic reason for forming the co-operative. The key distinguishing factor between a co-operative and an incorporated association is the motive of profit generation for members. There are three different types, each best serviced by a particular organisation structure:

1. Worker co-operative
 Primary purpose: conducting a business and enjoying the benefits of employment on a continuing basis.
2. Marketing co-operative
 Primary purpose: selling goods and/or services collectively.
3. Consumer co-operative
 Primary purpose: providing common goods, services and/or facilities on a continuing basis.

The rationale for artists forming co-operatives is to gain and maintain control over the situation in which they are working. Arts co-operatives empower artists: firstly, by virtue of the fact that members of the co-operatives own and control the organisation; and secondly, the co-operative is internally organised and run on a democratic basis where each member has one vote and the ownership of the capital by members does not influence decision making.

Contracts

It is of little importance that the arts manager is aware of and practises the duties of care, diligence and honesty if a dispute arises because of misunderstanding or assumption over the business or artistic activity of the arts organisation. In order to ensure all people involved with the organisation have a clear understanding of their obligations and responsibilities, a contract is essential. Arts managers are regularly preparing contracts for actors and directors for productions, leasing equipment or venues, publicity and marketing, visual artist commissions, insurance, sponsorship and government grants. The following principles and sample contracts aim to provide the manager with a basis of understanding of the importance of contracts in the arts organisation.

Principles

A contract is a legally binding and enforceable agreement, and must be suitably detailed, so all concerned are aware of their rights and responsibilities. The essential elements of a contract are an offer, an acceptance, the consideration (cash, in kind or mutual promises) and an intention to create a

legal relationship. A contract may be made verbally or in writing, in which case it is properly termed a simple contract. A contract made in writing under seal is properly termed a deed.

Arts managers should wisely use a contract to make enforceable by law any significant agreements into which they enter. These would include employment agreements (including performance agreements); service agreements; agreements for hire of equipment, venues or vehicles; and agreements regarding responsibility and liability such as in the case of promotion or touring a production or exhibition. In addition the arts manager enters into a contract with the customers by promising to put on a performance or exhibition after they have purchased tickets.

Terms

The minds of both parties must agree or coincide with respect to every material term of the agreement if there is to be a contract. For example, it would be impossible to say that the performing arts centre manager and the venue hirer are in agreement and have formed a contract where the arts manager believes that the theatre venue only has been hired and the hirer understands this includes a foyer suitable for exhibiting visual art to the patrons attending the theatre.

Exclusions

When a contract contains an exclusion clause or exemption clause or limitation of liability clause, the rights of one party to the contract are in some way limited under the contract.

Exclusion clauses are used as defences to actions of breach. Excluded events can include contingencies which otherwise would be one party's responsibility to remedy.

Performers and hirers contracts may include an indemnity clause protecting the arts organisation or arts centre from and against all actions, suits, proceedings, claims and demands.

The courts usually attempt to invalidate the exclusion clause in the event of a dispute implying that the intention of the contract to create a legal relationship cannot exclude the rights or responsibilities of one party to another. This is another reason for ensuring that the details of the contract,

especially the terms and conditions attached to a contract, are clearly understood by all parties.

Breach

A breach occurs where one party fails to perform one or more of the obligations imposed by the contract.

For example, if a writer or painter under commission fails to complete the work in question, the gallery, publisher or individual who has commissioned the work confirmed by a contract between the parties may take legal action for this breach.

In addition, a performing arts centre manager, as a safeguard, must maintain constant communication and networking with promoters and other venue managers, thus choosing shows and entrepreneurs that have a good business record. Beware of verbal agreements based on trust.

Termination

Termination is the end of a contract before its expected conclusion due to breach or misrepresentation.

Checklist of action

To avoid court action or conflict resulting from breach or termination, the arts manager should have a checklist or action process to follow before signing an agreement or contract:

- plan (preparation of contract, terms, details, question-naire to avoid negligence, covering letter drawing attention to terms and conditions)
- consult (other arts managers, promoters, arts agencies or service network associations, advisory arts law centres)
- include all details and discuss the agreement
- negotiate the terms and conditions
- make the offer
- get an unconditional acceptance (must be of the negotiated terms of offer)
- agree on the consideration (fee, costs, in kind, promise)
- sign and create a legal relationship
- while it should be paramount that the contract addresses all the terms and conditions necessary for the work involved to be carried out to the satisfaction of all parties

concerned, it is not always possible to cover all contingencies.

A contract provides controls and safeguards. It is a form of risk management. A properly drafted standard contract works for most situations. It ensures terms and conditions are agreed to before the important issues of fees and costs are discussed. A standard employment contract includes clauses addressing most of the following items:

- nominated parties to the contract, such as name of artist and name of employee
- a detailed description of the job or position, its status or classification level and the duties of the employee
- rate of pay and how payments to be made
- hours of work
- term of employment or contract, extensions, termination
- supervision (reporting and command chain)
- benefits—study leave, superannuation, sick leave, holiday leave, child care
- taxation and insurance
- financial administration responsibilities if a grant or project
- assistance and access to support and resources
- consultation—with people other than the employer; who has ultimate artistic control; design approval
- volunteers—who selects, insures, instructs, holds responsibility
- promotion and publicity—whose responsibility; artist's obligations
- copyright, moral rights, authorship and attribution
- documentation and archival records.

The following sample contracts have been used by certain arts organisations quite satisfactorily. They are included here to demonstrate that standard contracts can and should be customised to meet specific needs, and as long as they contain an offer, acceptance, consideration and intention and are signed by both parties, are legally binding documents.

Community arts organisation's artsworker contract

<div align="right">

Name of Organisation
Address
Phone
Fax

</div>

CONTRACT FOR ARTSWORKERS

<div align="right">

No /Year

</div>

This is a Contract of Employment between:
Name
(hereinafter referred to as 'the Artsworker') of
Address . Phone
and ARTS ORGANISATION INC (hereinafter referred to as 'the Employer')
Whereby the Employer agrees to employ the Artsworker in accordance with
the following terms and conditions.

1. Term of Employment
 i) Commencement Date Completion Date.
 ii) Time iii) Venue.
2. Salary
 i) The Employer agrees to pay the Artsworker the sum of
 per hour
 ii) hours in accordance with the attached budget.
 iii) Payments shall be made fortnightly on presentation of invoice from
 the Artsworker.
3. Object of Employment
 The Artsworker will .
 .
4. Obligations
 i) The Artsworker shall not assign this contract to any other party
 without the prior consent of the Employer.
 ii) The Artsworker shall give the Employer prior notice of illness or
 reason for his/her inability to attend any sessions.
 iii) Should the Artsworker be unable to fulfil the obligations of this
 contract due to illness, he/she will not receive payment for sessions
 not attended.
5. Materials
 Purchase of materials and equipment shall be the responsibility of
 the Employer. Purchases by the Artsworker shall only be made after
 consultation with the Employer and shall be at the Employer's cost
 in accordance with the attached budget.
6. Venue
 The Employer shall be responsible for venue selection.
7. Times
 The Employer shall be responsible for scheduling times after consultation
 with the participants and Artsworkers.
8. Promotion and Publicity
 i) Promotion and publicity for all projects shall be the responsibility of
 the Employer.
 ii) The Artsworker agrees to any reasonable request by the Employer
 for assistance.
9. Copyright
 The Artsworker and the Employer will have joint copyright in any artwork(s)

and/or any design(s) created by the Artsworker in the course of this employment. Neither party will exploit the copyright without the prior written consent of the other party. Such consent will not be unreasonably withheld.

10. Authorship and Attribution

Notice(s) including the Artsworker's name shall be provided by the Employer and publicly displayed with any artwork(s) created in the course of this employment. All reproduction(s) of the artwork(s) for publicity or otherwise shall properly attribute the role of the Artsworker.

11. Termination

 a) Either party may terminate this contract upon:
 i) One (1) week's written notice.
 ii) Payment in lieu of one week's wages.
 b) i) Insufficient number of participants.
 ii) Lack of punctuality.
 iii) Failure to complete duties as listed in the Artsworkers Duty Statement.
 iv) Failure to accept direction.
 v) Failure to comply with the Employer's policies as outlined in the Artsworkers Booklet.
 vi) Failure to attend a project on three scheduled occasions without prior arrangement.

12. Insurance

The Employer shall arrange Public Liability insurance coverage on Artsworkers and participants.

13. Reports

The Artsworker shall be required to write a weekly report on the relevant activity to be maintained in a current condition in a book to be provided by the Employer.

14. Special Conditions

. .
. .
. .

15. Budget

. .
. .
. .

16. Waiver

A waiver of any breach of the provisions of this agreement shall not be construed as a continuing waiver of other breaches of the same kind or other breaches of a different kind or any of the provisions of this agreement.

17. Disputes

Should any dispute arise concerning any matter referred to in this contract, such dispute shall be referred to arbitration by two arbitrators, one to be appointed by each party. In the event of the appointed arbitrators' failure to reach agreement, any dispute shall be referred to an umpire selected by the arbitrators. No further action or suit shall be brought by either party until an award has first been obtained by the arbitrators or umpire.

Signed:
(The Artsworker) (The Employer)
Dated this day of Year.

Commercial gallery/visual arts partnership and overseas artist

This Agreement is made the day of 199
Between (organisation) and (artist)
Address Address
Telephone Telephone
Fax Fax
Whereby the parties agree as follows:

1. *The Work*:
 (The artist) agrees to paint and deliver to the
 organisation the paintings described in Appendix A of this agreement for
 the purpose of exhibition and sale.

2. *The Exhibition*:
 (The organisation) agrees to exhibit the work
 Title of Exhibition .
 Place of Exhibition (venue and address) Dates
 of Exhibition Times of Opening

3. *Delivery*:
 (a) Surface freight . . . (number) paintings to (the
 organisation) as documented in fax of (date)
 (b) Airfreight the remainder to arrive on (date)

4. *Financial Arrangements*:
 4.1 (the organisation) will purchase paintings to the value
 of A$ (artist's sale price) as follows:
 (a) (the organisation) will deposit in an account in
 (name of Australian City) nominated by (the artist). One
 half A$ on arrival at the organisation's storage venue of the
 paintings in either 3(a) or 3(b) above, whichever is the sooner.
 (b) One half A$ will be paid into the same account on the arrival
 of the remainder of the paintings at the organisation's storage
 venue.
 4.2 No further payments will be made to the artist until (the
 organisation) has sold paintings to a value exceeding A$
 (artist's sale price).
 4.3 Any further payments to the artist will be made following the close
 of the exhibition when all monies have been received by
 (the organisation)
 4.4 Artist sale price for each painting in the exhibition will be agreed on
 between (the organisation) and (the artist) prior
 to the exhibition. (Refer to fax dated)

5. *Insurance*:
 5.1 All freight and insurance charges from (overseas city
 of origin) to (name of Australian city)
 will be covered on a 50% each party basis.
 5.2 (the organisation) will arrange burglary insurance while
 the paintings are in storage and on display at the exhibition venue.

6. *Agency*:
 6.1 (the organisation) retains the rights to sell . . .
 (the artist's) paintings for the period of time up to and
 during the exhibition and for a further six (6) months after the close
 of the exhibition. Any further arrangements for unsold paintings will
 be negotiated by (end of year date)
 6.2 (the organisation) retains the right to have first

option to become (the artist's) agent after the end of . . . (the year).

7. *Exhibition Costs*:

7.1 The exhibition is being held in conjunction with (charitable organisation). Expenses incurred for the staging of the exhibition of (the artist's) paintings in (name of Australian city) such as mailing costs, invitations, advertising costs and catering will be the responsibility of (the organisation) and the (charitable organisation) of Australia.

7.2 In lieu of these costs(the artist) will donate a small painting to be raffled in aid of the charity.

8. *Disputes*:

Should any dispute arise concerning any matter referred to in this contract, the dispute will be referred to the arbitration of two arbitrators, one appointed by each party. In the event of the two arbitrators disagreeing the dispute will be referred to an umpire selected by the arbitrators.

Signed
 Artist Partner in organisation Date

.
Date Partner in organisation Date

 Partner in organisation Date

APPENDIX A					
Inventory of works.					
No.	Title/Description	Medium/Materials	Dimensions	Inscriptions	Value
1					
2					
3					
4					
5					
6					
7					
8					
9					
10					
etc.					

Venue hiring licence agreement

AN AGREEMENT made on the day of 19 . .
BETWEEN hereinafter called 'the Centre' which is owned
and controlled by hereinafter called 'the Owner' and the Hirer
named in Part 1 of this Agreement hereinafter called 'the Hirer' AGREE to the
Northern Australian Regional Performing Arts Centres Association Inc. Terms
and Conditions of Hire and the following Parts pertaining to the following Terms
and Conditions of Hire -

PART 1 (Clause 1.1,4.32—DEFINITIONS/NAME AND ADDRESS OF HIRER
The Centre means the (name of your venue) and comprises . . .
. (details of your facility, e.g. Theatre, Space and Foyers) and all works
and conveniences incidental thereto or necessary therefore including without
limiting the generality of the expression all plazas, walks, paths and open
spaces connected with or comprised in the (name of your venue)
situated . (address of venue)
Owner means the(name of your Council/Trust/Board)

Hirer .

Address . Postcode

Contact Name .

Telephone/Fax Business .

A/Hours Fax

PART 2 (Clauses 2, 3.6)—VENUE AND PERIOD OF LICENCE

Venue

. .

Period of Licence	Day	Date	From	To

PART 3 (Clauses 1.1, 3.9, 4.1, 4.2)—AGREED USE

Name of Performance

. .

Type of Usage

. .

	Day	Date	From	To
Bump-in				
Rehearsals				
First Performance				
Other Performances				
Final Performance				
Bump-out				

Performance times, unless otherwise agreed as stated above, will commence
as follows:

Venue	Evening Performance	Matinee Performance
.
.

PART 4 (Clauses 3.1, 3.2, 3.5)—PAYMENTS
Rehearsal Fees $ x = $
Performance Fees ($ or % of Gross Box Office which is the greater)
Minimum Fees $ x = $
Total Rehearsal/Performance Fees $
Security Deposit to be paid by = $

PART 5 (Clauses 3.9.6, 4.4)—PRODUCTION CHARGES
Pianos—Concert Grand a fee of $ plus tuning
Other Pianos a fee of $ plus tuning $
Bump-in/out Fee $
Technical Costs $
Power and Airconditioning
. at per hour per Rehearsal
. at per hour per Performance
Technical Questionnaire to be returned by

PART 6 (Clause 3.6)—OVER-RUNS
Over-runs are charged at the rate $ per half hour or part thereof.

PART 7 (Clauses 3.9.2, 3.9.3, 6.6)—BOOKING FEE AND CREDIT CARD CHARGES
Book Fee $ per ticket
Credit Card Charges At the rate of % of the value of tickets sold through Credit Card Agencies
Ticketing Printing/Event Creation $ per performance
Complimentary Tickets The first tickets free and thereafter cents per ticket.

PART 8 (Clause 3.9.1)—STAFFING
Technical labour is charged at per labour hour incurred, plus any applicable penalties.
Additional Front-of-House labour as required beyond the basic levels provided in the rental is charged at the rate of $ per performance, plus any applicable penalties.

PART 9 (Clause 4.22)—PROGRAM AND MERCHANDISE SALES
PROGRAMS A commission of % on programs sold plus the cost of a Program Seller
MERCHANDISE A commission of % on merchandise sold plus the cost of a Merchandise Seller

PART 10 (Clause 6.8)—HOUSE SEATS

Venue	No. of House Seats
. .	. .
. .	. .

PART 11 (Clause 8.6)—CANCELLATION FEE
If performance/s are cancelled the following cancellation fee will apply in accordance with Clause 8.6. $

PART 12 (Clause 4.20)—BROADCAST FEE

If performance/s are broadcast the following fee will apply $

PART 13 (Clause 8.24)—OTHER AGREEMENTS

Signed for and on behalf of

. .

In the presence of:

. .

Signed for and on behalf of

. .

In the presence of:

. .

Intellectual property

Copyright

Copyright is the exclusive right which the owner of literary (including computer software), dramatic, musical or artistic works, sound recordings, films and broadcasts, has to reproduce the work in material form, publish the work, broadcast the work, cause the work to be transmitted to subscribers of a diffusion service, make an adaptation of the work, and authorise the use of that adaptation.

Unlike intellectual property such as patents and trademarks which require registration and deposit, copyright is automatic. It only protects the form of original expression and the work must be in material form. Copyright does not protect ideas or concepts, just the expression of those ideas and concepts.

Ownership generally rests with the author or joint authors, unless the work is created in the course of employment (employer owns), is a commissioned photograph, portrait or engraving, or is Crown copyright. In general, copyright exists for the lifetime of the author plus fifty years. As a property right, copyright is transmissible, or licence may be granted from the copyright owner to another person to do any acts restricted by copyright. There are some permissible uses of copyright works without approval of the copy-

right owner, including research, private study and copying for archival use.

The recommended copyright notice for printed or electronic works is © *Author's name Year of publication.* The requirements for protection in Australia are that the author is an Australian resident and the work is original, a product of the author's independent skill and intellect. Resolution of dispute could involve injunction, damages, account of profits or calling in the infringing items.

An arts centre that commissions an artist to write musical works for performance will be subject to the provisions of the *Copyright Act 1968.* The author may own copyright (unless it is otherwise assigned) of the musical work and therefore it cannot be performed, recorded or broadcast by the arts centre without express permission from the author. Contract terms and conditions should contain a copyright clause defining ownership and any licensing agreement.

Managers must ensure that sheet music is not photocopied unless a licence is obtained or copyright royalties paid. Playing interval and pre-show music in the theatre or venue foyers is subject to the payment of an annual fee to the Phonography Performing Rights Association (PPRA).

If artworks are to be copied and used on brochures and postcards, the artist's permission must be sought and a fee may need to be paid.

The author of a book retains copyright of that work except for material which is not the author's own, for example, photographs or diagrams created by another person and included in this work.

Assignment

Assignment is the transfer of a legal right such as a transfer by one copyright owner to another person of the rights comprised in the copyright. For example, composers of popular music often assign the copyright to an association such as Australian Performing Rights Association (APRA) of which they are members so that the association can collect royalties on their behalf and enforce the copyright.

Commission

A commission is a request for a work (play, painting, musical

score) from an artist in exchange for a fee. A contract must be involved. The commission fee is usually paid by way of progress payments on receipt of drafts of the writing or at stages in the development of the visual art piece or musical score. In general the artist retains copyright except for commissioned photographs, portraits and engravings.

Licence

A licence is the authority to do an act. When a copyright owner of an artistic work grants a licence, that person is permitting another to use the work but retains ownership and thus a certain control over that work. As a safeguard, a series of questions need to be asked of the licensee regarding exclusivity, length of time required, permissible media and geographical area of licence.

Lump sum payment

A commission, licence, or fee for service may be made in one payment, as opposed to periodic payments during the work in progress and at the conclusion of the project. This one-off payment is often called a lump sum payment and is legally acceptable. Whatever monetary exchange occurs for licence, assignment or service, it should be discussed, recorded and agreed upon in a contract signed by both parties.

Royalty

Royalty is a payment made to owners for each use of patents, trademarks or copyright materials, and for any sale made by an individual or organisation that includes the patent, trademark or copyright material.

In the instance of copyright, a royalty is paid to the copyright owner by persons making use of the work for which they have permission or licence. The royalty payment can be established in relation to the use of the work or in relation to the profits gained by using that work.

An arts organisation must, if using work in which it does not hold copyright, negotiate a royalty agreement with the holder of the copyright and allow for the costs of doing so. If the organisation is creating new works in which it holds full or joint copyright, the opportunity may arise to earn

royalty income from other parties who wish to use those works. Situations where these instances arise include a new theatre production, a new production of an existing script (in which the arts organisation would have a copyright of the production but not of the script), publications or new musical works.

Royalties must be paid for the use and sale of any artistic work in a museum, gallery or arts centre's merchandising activities.

Patent

A patent relates to an invention of something new, which is of utility to the community. Once registered at the Patent Office, a patent is granted for twenty years. A patent will give the inventor sole legal right to the use and sale of the invention. The patentee may grant licences or assign the patent to be used. If anyone infringes the patentee's monopoly, the patentee may sue for injunction and damages. Patents are exclusive for the country in which the patent has been granted. If the patentee wishes to protect these rights elsewhere, a patent must be applied for in all the countries where it is required.

A recording company might develop new technology that allows music to be recorded with more tracks and CDs to be pressed more quickly at a cheaper cost. The recording company might patent the invention to have exclusive right over the technology and secure a competitive edge.

Trademark

A trademark is defined as including a device, brand, heading, label, ticket, name, signature, word, letter, numeral or any combination of the above. A trademark is a mark used, or proposed to be used, in relation to goods and services for the purpose of indicating a connection in the course of trade between the goods and services and some person having the right, whether as proprietor or as registered user to use the mark whether with or without any indication of the identity of that person as provided in the *Trade Marks Act 1955*.

A museum, gallery or arts centre may develop a trademark as part of the marketing strategy, and register it under the education and entertainment section of the Act. The

organisation is then able to identify itself uniquely to consumers. Artists using trademarks in their works must preserve the provisions of the Act. In this case the artist may have to apply for a licence to use the mark.

Business name

A business name is the name under which individuals or firms carry on business. Where the business name is not the actual name, there is generally a statutory requirement that it be registered in relation to the persons using it.

The trading name or business name of an arts organisation is a component of corporate property and the visual image of the organisation to the community. The use of an arts centre's business name and trademark (or logo) must be controlled under the terms and conditions of the contract of hire of the venue facilities.

Moral rights

Moral rights are personal rights belonging to individuals and organisations in relation to their creations. The main moral rights are the right to authorship, the right to integrity, the right to make a public work, the right to correct, and the right of reply to excessive criticism.

Unlike copyright, which can be assigned or sold to another person, moral rights are personal to the artist and recognise the link between a creator and the work. These rights are to be respected whether the artist owns the property in the work or the copyright. Three examples of these rights are:

- the right of integrity: the protection of one's work from alteration, mutilation and distortion
- the right of disclosure: the right of the creator to determine when a work is complete and when it should be revealed to the public
- the right of attribution: the right to have one's name associated with one's work.

The inadequacy of the law to protect such rights means that artists should address these issues through contractual arrangements such as commission contracts, contracts for the purchase or sale of an artist's work and contracts for the

publication or reproduction of a work. The artist currently has some protection against wrongful attribution under the *Copyright Act 1968*, if the artist's work is falsely credited to another person. Any action affecting the integrity of an artist's work is a breach of moral rights. For example, a particular metal sculpture was considered no longer suitable by the local government who commissioned the work. The local government, as owner of the sculpture, removed the work and scrapped the metal. This affected the moral rights of the artist to protect the work.

Such integrity has been addressed in 1995 in Australia with legislation proposed to 'Shield original works from subsequent uses seen derogatory and ensure that artists were attributed with authorship. The law . . . would seek to control those who borrow, rearrange and reinterpret original works'.[4] Some groups in the arts community do not agree with the legislation because, as it is framed, it will discourage those who create new works from old, such as filmmakers adapting novels.

The right of integrity caught public attention in the city of Adelaide in Australia in 1991 and 1992 with the antics of 'Driller Jet' Armstrong who exhibited under his name a work entitled 'Crop Circle Conspiracy' painted over a work originally painted by Charles Bannon entitled 'Picaninny Sunrise, The Olgas' in 1981. Driller Jet had overpainted Bannon's acrylic blue landscape with white crop circles, without obliterating Bannon's name but adding his own. It is not uncommon for artists to paint over works. Even Bannon admitted that as an art student he bought canvasses at sales and painted new pictures over other works. 'But I never added, detracted or trivialised another's work or held it up to ridicule,' he said.[5] Armstrong's Post-Modern daubism style was painted on twenty-three works for this exhibition. He had renamed this painting 'Crop Circles on Bannon Landscape'.

Charles Bannon brought an injunction to prevent the work being exhibited or sold and the arts community waited as the issue of moral rights was tested in law. Regrettably the action was settled after the interim injunction was granted without any final determination of whether Bannon had any

actionable rights. Under the current law Bannon could not claim a breach of copyright or moral rights and his action for damage to his reputation could only be brought under trade practices legislation or the tort of passing off or defamation laws.

If the action had occurred elsewhere in the world, Bannon might have succeeded in protecting his moral rights. Civil law countries have protected moral rights for decades, France for over one hundred and fifty years. Common law countries, such as Australia, have largely denied their artists that protection.[6] For this reason current proposed legislation in Australia has majority support of the arts community.

Liability and insurance

The arts manager who is also a venue manager, that is a manager or director of a museum, gallery or studio, performing arts centre, pottery or craft workspace, writers' centre or community arts space pursues a general objective of attracting as many customers as possible to the venue to experience the variety of quality arts activities. The venue must be accessible to the public. At the same time the arts manager should ensure the physical and moral security of those customers. The law accepts that there is risk involved in public areas and does not impose absolute liability on the managers of such venues. The law does, however, expect that reasonable care will be taken.

This section of the chapter deals with the liability that individuals and artists have in the course of their employment, and the liability of the arts manager in relation to visitors to the buildings or place of artistic activity.

Defamation

Defamation is the general term used for words which injure a person's reputation (personal or commercial) by degrading them in the opinion of others. Legal definition and laws differ from state to state in Australia. In some states defamation is divided into libel and slander. Libel consists of matter published in a permanent form, for example, a newspaper, a film, a letter, a photograph and includes matter broadcast, while slander consists of matter published as com-

ment or statement in an oral form. For defamation to be found, the offending matter must be published to a third party.

A performing arts centre, museum or gallery which has contact with the public through means such as the media, public performances, exhibitions and public seminars must not through words or actions defame an individual or an organisation. A theatre company, festival or community arts organisation that engages in activities such as satirical theatre or comments on artistic works must pay particular attention to defamation laws.

Defamation is generally a matter of compensating the injured party rather than punishing the wrongdoer. In some state legislation if the defendant can establish accuracy of the material then he or she is not judged liable. In fact, the courts regularly stress the value of freedom of expression and it is rare for a court to issue an injunction stopping publication of alleged defamatory material for this reason.

While it is generally assumed that Australians enjoy freedom of expression, the law imposes restrictions about what people may say, to whom, when and where. The constraints of censorship on books and films are rarely challenged by the majority of the public. We unquestioningly accept most of these restrictions. However, cases of defamation against arts critics have resulted in considerable media attention and support for 'artistic freedom'.

In 1943 William Dobell was 'defamed' through accusation that his prize-winning portrait of fellow artist Joshua Smith was a caricature and thereby ineligible to win the Archibald Prize. Dobell had to defend his art in court. Peter O'Shaughnessy took theatre critic Katherine Brisbane to court over her 1967 review describing his performance of Hamlet as 'dishonest'. The judge rejected the case, but a High Court in 1970 overturned the ruling. Most recently, Edmund Capon, director of the Art Gallery of New South Wales, was quoted in a Sydney newspaper describing his dislike for an Archibald Prize entry painting. The artist took Capon to court claiming defamation and damages. The artist won, with $100 in damages being awarded.[7] The principle of artistic expression had been challenged and a reminder

presented to all artists and arts managers of the legal and ethical framework in which they operate.

Court action is a last resort. Non-legal forms of redress for defamation should be considered, such as moral support for the defamed employee or artist, a letter to the perpetrator, a solicitor's letter demanding a proposed form of apology or other favourable publicity. If the arts organisation has a solicitor on the board or a legal adviser, seek such legal consultation before any action is commenced.

Obscenity

A publication, production or work of art is deemed to be obscene if when judged against the prevailing social attitudes towards morality, its effect is such as to tend to deprave or corrupt persons who are likely to read, see or hear the matter contained or embodied in it. Defences against the publication of an obscene article or production of a play include it being justified as for the public good on the grounds that it is in the interests of science, literature, art or learning, or of other objects of general interest.

The possibility of defences against charges of obscenity gives some reassurance for arts organisations although because the works produced by an arts organisation, in many art forms, may come under public scrutiny, charges of obscenity may still be made.

The arts manager's safeguards lie in the terms and conditions of the artist's contract particularly where a producer or performer must agree to ensure 'that the entertainment is in no way crude or offensive'. If in doubt the arts manager could request to see the script before agreeing to contract the production. At all times the conditions of the contract must be acceptable to the marketplace which is decidedly more liberal in the 1990s than it was in the 1960s and 1970s in Australia. The following incident in Brisbane in 1969 would pass unnoticed nowadays, but it is a valuable reflection on the ethical and legal environment in which actors and directors worked at that time.

The final production in April 1969 by the Twelfth Night Theatre company in its Gowrie Hall premises before moving to a new, purpose-built theatre complex was Alexander

Buzo's one act play *Norm and Ahmed*. The play is about racial bigotry and ends with Norm attacking Ahmed and using the words 'Fuckin' boong'. On 19 April, a few days after opening night, as the lights went out, the police charged on to the stage to arrest actor Norm Staines who played the role of Norm. He described the incident as follows:

> I was chosen for the part, I believe because I am the typical Australian, short and podgy . . . We are not long and lean like the legends say. I was shocked when I read the play but I knew it was important to do it because it was about racialism, and Australians are racial bigots . . . They arrested me in the dressing room, full charge, warning, the lot. I must say they really knew their lines . . . Funny thing when I was walking past one cell (later in the watch-house) a woman was screaming out the same word I was arrested for and no-one was taking any notice . . . [8]

Fellow actors raised the bail money and Staines was released and played the role, using the word, till the end of the season, while awaiting appearance in the Magistrate's Court. Police appealed to the Supreme Court for an injunction against Staines' continued performance, but to no avail. Staines was eventually convicted and fined, and then appealed to the Supreme Court and was cleared. The police appealed to the High Court over the Supreme Court ruling but failed and legalities ended. The theatre company director, Joan Whalley, was reported in *The Courier Mail* as saying:

> The judgement by the Full Court is a judgement in favour of theatre in Brisbane. Theatre belongs to the people, and symbolises the feelings and actions of the people. If theatre is to be a true picture of humanity, actors must be able to say what is said in true life, and in the circumstances of life.[9]

In the same article the play was described by one of the judges as a 'sordid play of little merit' and another suggested that the standards of 'ordinary decent-minded people' should not be urged to change by 'those who peddled obscenities and indecencies'. Interestingly, publicity over the

event failed to boost audiences for the production.[10] The prevailing social attitudes seemed to concur with the judgement that obscenity in public is not to be admired. Unfortunately Buzo was not in the enviable position to seek defamation in reference to the judges' comments on his playwriting.

International examples have recently highlighted the responsibilities of gallery managers, some of whose visitors may find a work obscene when others find it exciting or challenging. Such was the case in the United States of America over the exhibitions featuring work by photographers Andres Serrano and Robert Mapplethorpe in 1990. The exhibition was funded by the National Endowment for the Arts and resulted in continuing public scepticism, loss in government and private funding for the arts, and ongoing debate on censorship, obscenity and the role of government in the arts. The case involved a

> seven-city tour of the Mapplethorpe exhibition *The Perfect Moment* (1988–90), where different audiences projected their distinctive concerns onto the same material. As it travelled, the response varied from nonchalance and respectful critical evaluations (Philadelphia and Chicago), to outrage, a cancelled exhibition site, and an attempted obscenity prosecution (Washington, D.C. and Cincinnati), to veneration and active defense (Boston). The work remained the same; it was the reaction that diverged dramatically.[11]

If a gallery manger or director is deciding whether to display a possibly obscene artwork consider the following procedure:

- be clear as to the reasons for choosing to display the work
 contractual obligation
 matter of principle
 to bring the gallery/artist into the public view through controversy

- consider hanging the work in a separate area with appropriate warning signs
- prepare arguments in the work's defence and in the gallery's defence
- brief staff on these arguments and how to deal with public reaction
- prepare a press release for use if necessary
- keep the board informed.

Public liability

It is the occupier, not the owner, who has legal responsibility for the safety of people in an arts venue. Usually the arts organisation is the occupier unless the venue or one area of it has been hired by another organisation or individual. In that case the venue hire agreement includes a public liability clause and insurance policy verification. However, the arts manager must fulfil the obligations under law and exercise care and diligence in establishing a safe venue for staff, visitors and trespassers alike. It is the arts manager who is most aware of the maintenance and repair required, the operation of all equipment, the cleanliness of all spaces, the potential hazards in the centre and the areas of possible negligent behaviour by users of the venue.

The board and manager of an arts venue must have public liability insurance. Factors to consider in such a policy include an accurate description of the business and activity, the process of reporting and recording any accident, the breadth of the policy cover, exclusions and the financial limits of the cover.

Insurance

Insurance is a contract under which one party (the insurer) undertakes for a consideration (the premium) to pay the other party (the insured) a sum of money on the occurrence of an event causing loss to the insured.

Arts organisations should be insured for workers' compensation, public liability, building furniture and fittings, goods on loan (e.g. merchandise), volunteers and indemnification. Clauses in contracts protect the venue from misuse by hirers.

Ethics

It could be assumed that if the arts manager conforms to all legal requirements under Corporations, Contract, Common and Criminal Law, the management behaviour of that person is sure to be ethical. There are, however, areas of behaviour not covered by legal restrictions. For example, employers and employees should demonstrate respect for individuals in the workplace and encourage an environment free from stress, rivalry, discrimination, harassment, disharmony and aggression. The arts manager must practise effective listening, concern for others, interest in achievement, praise for success, attention to weakness and those actions which embrace effective and supportive human resource management. Ethical managers plan for the achievement of individual goals as well as organisational goals.

While it is necessary under Corporations Law for the arts manager to carry out duties with honesty, it is also expected that someone in a position of responsibility and seniority dealing with the public will demonstrate ethical behaviour at all times. The practice of ethical behaviour is more than embracing a code of ethics. It is also more than publicly demonstrating accountability for actions, decisions and management practice. The arts manager represents to the community the arts, the arts industry, all arts centres and organisations, and all arts managers. Their reputation is at risk if the manager enters into controversy over an ethical issue.

Consider the following:

- A regional performing arts centre manager may be the writer, director or producer of the theatre work being prepared for presentation at the centre. To avoid any conflict of interest the board must be informed and all contractual and financial matters discussed at board level with the board accepting management responsibility.
- Merchandising must not involve any kickbacks, only the agreed arrangements in the terms and conditions of the contract. An arts centre manager would be unwise to vary these conditions for different hirers.
- The schedule of fees and charges in the venue hire

agreement may vary for predetermined categories of users. For example, government-sponsored users may be given special rates. These predetermined categories should be the only categories. Any variation or request for special consideration or free use of even a meeting room must be ratified by the board or trust.

- Acceptance of a gift or donation from a satisfied community group or visiting hirer or promoter is both pleasurable and risky. The innocence of the transaction may be misunderstood. If a policy exists for declaring gifts over a certain monetary value, the manager is protected.

- Offers of consultancy or outside employment must be considered in relation to the demands of the job. For example, managers who have significant artistic talent or marketing ability may receive requests for performance, production or the design of a marketing plan for another arts organisation. If the employment contract does not place a condition on other employment, then the manager makes the decision based on ethics.

- The growing need to attract sponsorship for specific projects may require that particular individuals receive special attention. Like any other relationship, this is a business relationship and must be based on a contract. Such an agreement sets out the rights and responsibilities of each party and minimises the risk the arts manager takes in empowering another group in the development of the arts organisation.

The ethical issues of employment practices, consultancies, discounts, use of equipment and facilities for private purposes, donations, sponsor relationships, merchandising and conflict of interest must concern every arts manager. However, the decision for appropriate action cannot be made on a case-by-case basis with the manager acting in a fair and honest manner. A policy should be designed and approved by the board. Ethical practice is a management issue.

If a code of conduct does not exist within the arts organisation it would be wise for the manager to develop one alongside the policy paper for management practice in controversial areas.

All people can expect to work in an environment that sets and maintains certain standards of ethical behaviour for employers, employees and for the customers of that organisation. The rationale provided through the examples in this section should result in a code of conduct similar to the following code which can be adapted for specific organisations. It contains an introduction that sets the arts or cultural organisation within the legal context of responsibilities and within the context of its mission and objectives. It does not contain clauses relating specifically to the conduct of employees in relation to artists or artistic product. Each organisation must consultatively decide whether clauses ensuring the respect for the creative nature of artistic work and the value of the creative product form part of a code of conduct, or can satisfactorily be included in a policy and procedures manual within the organisation.

CODE OF CONDUCT FOR ARTS ORGANISATION

1. Introduction
 1.1 This arts organisation is a non-profit distributing incorporated association/incorporated company/statutory authority operating within a constitution/memorandum of association/legislation and is responsible for regular reporting to its members, to regulatory authorities and to the public.
 1.2 The mission of the organisation is .
 .
 and forms a guide for conduct of staff.
 1.3 This arts organisation aims to (outline any objectives referring to the human resources of the organisation and to the social responsibilities of arts and cultural organisations).
2. Performance of Duties
 2.1 All staff must act in accordance with the requirements of the law.
 2.2 All staff must act in good faith, with diligence, with care and observing the highest standards of honesty and integrity.
 2.3 All staff should provide conscientious, effective, efficient and courteous service to the public, so that their standard of work reflects favourably on them and on the organisation.
 2.4 All staff should treat other employees with respect and dignity.
 2.5 All staff must refrain from the consumption of alcohol and drugs while at work, or at any time that may adversely affect their work performance or conduct.
 2.6 All staff, in using the organisation's property, facilities or funds, must be scrupulously honest and careful, and must not permit misuse by any other person.
3. Conflict of Interest
 3.1 Members of staff of the organisation should ensure that there is no conflict or incompatibility between their personal or business interests and the impartial fulfilment of their public and professional duties with the organisation.

3.2 No staff member shall seek or accept from any person or organisation, any gift or reward relating to the work of the organisation.

3.3 No staff shall engage in other employment or consultancy without first seeking approval from the board (or nominee).

4. Confidentiality

4.1 Staff who have access to official records should ensure that confidential information is not used to gain advantage by any person, nor used to cause harm to any person or the organisation.

4.2 All staff should hold respect for individual privacy in their dealings with other staff or the public.

Rudi Mineur of Rock 'n' Roll Circus displays his balancing skills in the Out of the Box Festival, 1993.

SECTION 3

Arts management and the organisation

The infrastructure designed to facilitate the operational planning of an arts or cultural organisation comprises human and financial resource components. Arts organisations are simple and complex. The artistic vision of the organisation defines a clear, simple and forceful direction; the planning and reporting mechanisms between the many layers of accountability are complex. The business of art in the current economic environment necessitates that managers acquire and demonstrate quantitative and qualitative skills in measuring funds and people in order to achieve sustainable revenue and audience development. Within each arts and cultural organisation the manager must create an environment that represents stability and independence in order to establish external relationships within communities, the nation and global regions.

—— Case study 2 ——

Arts and crafts industry development

The development of a craft manufacturing shared workspace with a retail and tourist focus in regional Queensland.

This case study addresses the needs of local art and craft producers in the Cooloola region of rural Queensland and proposes a strategy for facilitating these producers through training in business enterprise to contribute to their own economic status and that of the region.[1] It introduces the issues of artist as manager, structures and operation of shared workspaces, quality assurance in craft manufacturing industry development, business planning and initiatives led by a regional development bureau.

The Cooloola Shire in Queensland is a relatively new shire formed by the amalgamation in 1993 of the Gympie City Council and the Widgee Shire Council. It covers an area of 2973 square kilometres with a population of approximately 29,000 people of an average age of 33 years. Twenty-seven per cent of the population are self-employed largely in agriculture, dairy and beef cattle establishments and in small business in the major town of Gympie. The average annual household income is between $25,000 and $30,000. There are 79 manufacturing establishments, the majority in wood and furniture, fabricated metal products and food, beverages and tobacco. Gympie has a fascinating history which contributes now to its heritage and tourism interest. In fact, Gympie is accredited with 'saving' Queensland in 1867, when the young colony was in financial difficulties, and gold was discovered in the Mary Valley surrounding Gympie. The many mullock heaps and National Trust listed buildings (former banks, stock exchange, hotels, post office and churches) remain as evidence of the great wealth in Gympie at the end of the last century. Like most rural communities, Cooloola, which is approximately two and a half hours

drive north of Brisbane, is committed to new economic initiatives which will provide industry and business growth and employment.

In 1991 a tourism investment study in the region recognised the potential for a significant cottage/semi-autonomous arts and crafts manufacturing industry to be established using local raw materials, particularly wood. The Cooloola Regional Development Bureau identified the economic opportunities and, assisted by funding through the Office of Labour Market Adjustment, determined to undertake a feasibility study into the establishment of an arts and crafts shared workspace, with a manufacturing and retail focus. Three community workshops were held in April 1994, attended by over eighty representatives of the arts and crafts community in the Cooloola region. The findings from the workshops provided the basis for the brief that the Bureau prepared for the feasibility study:

- outline the most suitable organisational management and operational structure for a shared workspace
- identify the form and location of the workspace to best address identified market segments
- determine the support required from the shared workspace by home-based arts and crafts people in the Cooloola region, to facilitate the development of their businesses
- nominate the most feasible methods of funding the establishment and operations of the workspace
- indicate ongoing sources of funding for the continued sustainable operations of the workspace facility.

The objectives for the feasibility study emphasised the provision of continuous employment for people involved in the arts and crafts industry, and finding a focus for the fragmented industry through the establishment of a manufacturing facility and retail tourist outlet.

The consultants selected to conduct the study were confident from the outset for three reasons. Firstly, because national statistics showed that Australia's cultural industries earned more than beef, wheat and wool put together and were growing industries. In Queensland alone, the growth rate in employment in the arts, cultural and entertainment industry between 1986 and 1992 was 44 per cent, the highest of any industry sector in Queensland. Secondly, the high number of arts and crafts workers attending the preliminary workshops and public meetings organised to discuss the development of an arts and crafts manufacturing industry

indicated that the equivalent full-time employment in the creative arts in the Cooloola Shire exceeded the national statistic of .0864 per cent of the workforce. And thirdly, the fact that the initiative had occurred from the Regional Development Bureau with its business, industry and economic development objectives signified that there would be the necessary business support for artists prepared to take up the proposed activity.

The feasibility study involved an analysis of supply and demand for the arts and crafts within the Cooloola region in southeast Queensland, a study of shared workspaces and site options in and around Gympie, financial projections for the sustained development of an arts and crafts industry, training needs and provision for arts and crafts workers in small business skills, management and operational structures for a shared workspace and retail outlet, and employment projections. It was completed over a period of four months utilising the following methodology:

- literature search on shared workspace operation, management, training for artists and cultural tourism
- in-depth interviews and workshops with arts and crafts workers
- site inspection and discussion with architect
- steering committee briefings
- surveys and interviews with arts and craft network and service associations, trainers and educational institutions, small business association and government departments
- secondary data research
- data analysis
- report presentation.

The analysis of supply provided a profile of the artists based on demographics (age, gender, income) and psychographics (personality, motives, lifestyle). Three homogeneous groups were identified: hobbyists, semi-professional and professional artists. The hobbyists were the largest group (57.2 per cent) with income less than $2000 per annum. They were generally of retirement age, perceived their art and craft work as a hobby, sold it personally through shops, markets and home, and had poor business skills and a desire for business training. The smallest group were the semi-professionals aged between 36 and 60 years and earning between $3000 and $6000 per annum. Most work was sold through markets and exhibitions and as commissions. Business skills were good, but training was desired. The professionals ranged in age from 20 to 60 years, earned approximately

$10,000 per annum, and spent more than 40 hours per week working on their art or craft form. Most sold their work personally through markets, shops, and to a lesser extent galleries and exhibitions. They rated their business skills highly and only half were willing to participate in a business training course. The interviews resulted in the following summary SWOT analysis of supply, that is, of artists and the environment.

Summary of supply analysis

Strengths	Weaknesses	Opportunities	Threats
• natural resources • proximity to coast and highway • regional growth • historical attractions • diversity of arts/crafts within region	• regional unemployment • lack of arts/crafts facilities • no co-ordination of the arts/crafts • education levels • low demand for arts/crafts within region • average age of population within region • low average income within region	• gallery and tourist information centre • shared workspace	• proposed route from Noosa to Rainbow Beach bypassing Gympie • opposition to change • Montville and Eumundi markets nearby

A demand analysis revealed a network of galleries exhibiting and selling visual arts and crafts in southeast Queensland with approximately seventy galleries in and around Brisbane alone. Additional markets existed in restaurants, cafes, local agricultural and industry annual shows, community festivals and events, craft expos and street markets. Audiences for arts and crafts exhibitions were well developed and required minimal encouragement to become purchasers. Galleries and retail outlets were generally reluctant to disclose financial information relating to turnover. Market research was nonexistent for artist/gallery relationships, and artists were said to be creating to whim rather than market demand. Buyers tended to seek quality, originality and value in products, while price influenced gift shoppers.

Using data from the Australian Bureau of Statistics an esti-

mation of market demand for the Gympie–Brisbane region based on per household expenditure on pottery, painting, jewellery and other arts and crafts amounted to $24,462,000. ABS data provided the percentage of households which purchased these goods, the average expenditure on these goods, and these figures, adjusted using the CPI to current dollars, were applied to the number of households in the region. The estimated demand in the Cooloola Shire alone was approximately $300,000 per annum. A SWOT analysis of the market demand, that is, the wholesale marketing strategy into the Brisbane market produced the following summary.

Summary of demand analysis

Strengths	Weaknesses	Opportunities	Threats
• a current major market available • quality local products already available	• no existing distribution structure • fragmented structure • poor margins • an industry based on part-time workers • struggling retail outlets • the effort required to develop marketing channels	• proximity of a major market • minimal competition • no organised marketing in the industry • no current major 'players'	• growth of 'weekend markets' threatening distribution chain • ease of market entry

In order to assess site options, research into shared workspace development and requirements was conducted. The concept of the shared workspace can be traced back to the earliest industrial times, for example, to the craft guilds of the middle ages where craft and commercial enterprises flourished together sharing common location and facilities. Modern shared workspaces have re-emerged as part of the value of small business to both local and national economies. Around the world they vary in size, organisation and philosophy and are greatly influenced by the local environment and conditions that prevail in the locality in which they operate. By description shared workspaces (or managed workspaces), whether in purpose-built or renovated build-

ings, are generally designed to meet the needs of new start-up small businesses, by co-ordinating services and financial resources and thus reducing the costs and risks that all businesses face.

For effective working and demonstrating by arts and crafts workers, and for exhibition, display, management, marketing and selling of arts and crafts the following requirements were considered essential in the location and operation of a shared workspace:

- parking
- access for visitors, tourists, disabled
- bus access, turnaround and parking
- attractive external environment
- safe environment for visitors, workers
- natural light
- airflow, ventilation
- group/individual workspaces
- access for equipment, materials
- dust-free zones
- equipment (e.g. kiln, timber lathe)
- water, shower, toilets
- exhibition/display space
- workshop/demonstration space
- storage
- above flood level (Mary River in Gympie has history of flooding)
- office
- refreshments availability
- heritage sensitivity
- proximity to highway
- noise free

Eleven sites were investigated with architect consultation and only three proved viable given the workspace requirements and local government regulations. One site involved extensive pest control and some renovation of an existing coach centre currently used to garage local government cars; the second was a purpose-built structure on local government parkland at the southern entrance to Gympie; and the third was the heritage listed Old Railway Centre which was to be linked to a tourism-focussed short railway journey on disused rail lines. Given local government preference and the links to heritage and tourism, this third option was the most likely to receive vital government, business and industry support.

Access and safety for visitors so close to a working rail line

and the separation of arts and crafts workers in small rooms in a long narrow building were the only significant concerns. All sites were eligible for capital subsidy through the state government Office of Arts and Cultural Development provided an approved arts and cultural organisation was established which could demonstrate ownership and management capacity through a business plan, strategic vision and ability to maintain the structure. The capital subsidy scheme covered new buildings or renovations for a visual arts studio, sculpture and craft workshop, art gallery space, office area, toilets, showers, storage, kitchen facilities, fixed equipment and outdoor cultural facilities for creative arts and crafts. Twenty per cent of costs would have to be obtained from non-government sources such as trusts, foundations, corporate sponsorship, membership shares or investment.

The consultants prepared financial projections and likely scenarios based on turnover achieving 2.5 per cent or 5 per cent market share, and on the differing capital costs of the selected sites for the shared workspace. These scenarios assumed the following:

- cost of capital at 8 per cent
- peppercorn rents and rates for some initial interval
- marketing, management and clerical wages including on-costs at $100,000
- promotional costs at 20 per cent of turnover
- cleaning, repairs and maintenance at $10,000 per annum
- power, telephone and other operating costs at $10,000 per annum
- gross margin on all products at 100 per cent
- equivalent full-time employment for ten artists in the workspace based on $30,000 per annum commission per artist
- net returns from training programs of $700 per equivalent full-time employed artist.

Thus, on existing demand, projections were made of direct employment for 11 to 24 full-time persons and indirect employment likely to be three times that level. As demand increased from the marketing activities, so too would employment increase.

For successful operation of the shared workspace, business training for the arts and crafts workers was a high priority. Almost half (44.2 per cent) of the respondents to the artists' questionnaire and interview were self taught in their respective art or craft form. While others had received arts training from a TAFE institution (13.6

per cent) and short courses (17.3 per cent), formal arts training through the Gympie TAFE was not available. Over 78 per cent of the artists rated their business skills as average or good yet 63 per cent said they would like to participate in a business training course. These skills need to be evaluated and applied in early planning and discussion of the management and operation of the shared workspace. In 1994 Arts Training Australia completed a Vocational Education and Training Plan for the Arts and Cultural Industries (Libraries, Design, Visual Arts and Crafts, Film, TV and Radio, Performing Arts, Music, Museums, Community Arts, Writing, Publishing and Journalism). Without exception every sector of these industries nominated business skills including financial management, marketing, law and project management as the common gap in Vocational Education and Training in the arts. This national research verified the importance of providing business skills training for arts and crafts workers in order to sustain the development envisaged for the industry nationally and, in particular, in the Cooloola Shire.

The proposed management structure for the shared workspace was developed with the artists during the consultation process and from investigation of other shared workspaces and artists collectives. It was designed to serve the needs of the fragmented but enthusiastic and talented artistic community which required management by committee and the services of a marketing-oriented director. The board, representing the major regional stakeholders, would be responsible for nominating members to a subcommittee overseeing quality control of the products. A committee of management comprising representatives of artist groups would work as volunteers in the day-to-day operation of the workspace, exhibition space and retail outlet. Subcommittees would monitor the ongoing policies and procedures in fundraising, marketing, finance, exhibition, display and retailing.

The outcome of the feasibility study showed that the arts and crafts shared workspace concept was financially and artistically achievable in the Cooloola Shire. The consultants recommended a three-stage process:

Stage 1
Empowerment and motivation of the artist and community support groups for the project by the Cooloola Regional Development Bureau, including the formation of a steering committee.

Case Study 2, Figure 1 Proposed management structure for arts and crafts shared workspace

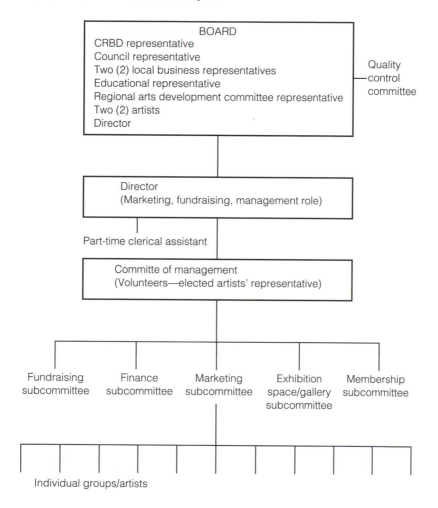

Stage 2

Establishment of an appropriate management structure securing seed funding and the appointment of a director.

Stage 3

Acquiring the preferred site and seeking funding for renovation and operation. This included establishing workplace practices, employment, training, retailing and marketing.

The value of the feasibility study is that it represents an objective, detailed report of the resources available and required to develop the arts and crafts manufacturing industry initiatives. However, as with any feasibility study, the consultants 'hand over' the recommendations and the implementation requires more than a boardroom decision. It requires a motivating factor such as an individual and financial support to set up the structure and the action. In this case, the issues involve the historical self-limiting factor of regionalism; the capacity for artists to be managers; the response by training providers to survey data; the political influences of strong local governments and development bureaus on the arts; the advantages and disadvantages of linking arts and cultural development to tourism and heritage development; and the empowerment of artists to take a stronger role in regional economic development.

Case study questions
The following questions and activities may resolve these issues:

1. Discuss the training needs in business skills of artists working and selling privately in a home workshop or community market. Compare these to the business skills required for artists working within the management structure of a shared workspace.
2. Develop a proposal to local business and industry groups to invest in the development of an arts and crafts manufacturing industry and shared workspace in the town. Consider 'earn-back', joint venture and other entrepreneurial schemes.
3. Devise a policy and procedure for membership of an artists' shared workspace.
4. Prepare the recruitment and selection procedures for the position of director of the shared workspace. Devise the selection criteria, advertisement, interview panel composition, interview questions, assessment rating sheet and terms of employment.
5. Develop a project that links the arts and crafts shared workspace in this case with tourism and heritage.

— 5 —

Management of people and place

Management in the arts is a very complex task made so by accountability to the many publics or customers these managers report. Commercial managers and arts and entertainment entrepreneurs generally report to shareholders and a board of directors, and in some operations to a co-producer. However, managers in the non-profit arts and cultural sector report to boards, governments, statutory authorities and funding agencies, sponsors, taxpayers, audiences, members, volunteers, network service organisations, peer assessment panels, strategic alliance partners, venue owners, producers and promoters. This vast reporting web influences organisational structures, management style, strategic planning, lines of communication, marketing practice, financial management, recruitment processes, controls and evaluation techniques. In addition, arts managers are often venue managers and require the dual skills of managing people and place.

This chapter provides an overview of the tasks and application of effective arts management in the contemporary corporate environment and includes:

- the role of the arts manager
- four key functions of management
- strategic planning
- human resource management
- leadership

- industrial relations
- volunteer management
- quality assurance
- venue management.

The role of the arts manager

Arts managers in the 1990s are usually university educated in an art form with a business degree in management or marketing, or with graduate qualifications in arts administration. In the past many managers were artists who turned to management out of necessity or a desire to be more involved organisationally. The most effective arts managers are those who combine a sensitivity to the arts and an administrative background. The increasingly corporate nature of arts organisations requires a manager who displays sophisticated business skills but not at the expense of a genuine appreciation of creativity in art and cultural practice. The following definitions of the role of an arts manager from 1965 to 1995 bear remarkable similarity given the evolution of environmental influences and industry position.

> What constitutes a good manager in the arts field? A man [*sic*] 'who must be knowledgeable in the art with which he is concerned, an impresario, labor negotiator, diplomat, educator, publicity and public relations expert, politician, skilled businessman, a social sophisticate, a servant of the community, a tireless leader—becomingly humble before authority—a teacher, a tyrant, and a continuing student of the arts'. *Rockefeller Panel Report, 1965*[1]

> What then is the principal mission of the professional arts administrator? It is to facilitate the work of the artist(s), to create, provide and sustain the resources, environment, and atmosphere in which artists can develop and flourish. *Raymond and Greyser, 1978*[2]

> Given the basic enthusiasm for the arts which makes a good administrator tick, he [*sic*] can and should acquire the best technical skills available to enable him to give full support to the artistic enterprise,

knowing how not to overweight his operations, how to make the best use of available and desirable resources, human material and financial, how to seek and use expert advice, how to communicate, how to read the signs of social and economic change and respond to them and to their influence on his company and his audience. All this in the context of artistic excellence not necessarily equated with opulence but appropriate to the corporate purpose and resources. *Elizabeth Sweeting, 1980*[3]

The categories (of arts administrators) include:
 Administrator as artist
 Administrator as partner of artist
 Administrator as servant of artist
 Administrator as director of artist
 Administrator as servant of the State
 Administrator as servant of the audience
 Administrator of a building.
. . . the categories of behaviour of the arts administrator might be:
(a) as manager of routines
(b) as problem solver
(c) as entrepreneur and risk-bearer
(d) as idealist. *John Pick, 1980*[4]

A role player extraordinaire, the arts manager performs as the casting director in recruiting compatible players for the team; the orchestra conductor in ensuring that all members of the organisation play the same tune; the potter in shaping and moulding the organisation; the acrobat in administering upwards to the Board and downwards to the team while on the highwire balancing sponsors and subscribers needs with limited resources. *Kevin Radbourne, 1995*[5]

I believe my role as a cultural manager is to stimulate the development of Australian culture at all levels, to facilitate dialogue and exchange about our cultural identity, to foster and promote the development of a

viable cultural industry which makes an important contribution to the Australian economy. *Libby Quinn, 1995*[6]

Arts managers must be multiskilled. A survey of Canadian arts managers in 1987 found four areas of skills and knowledge were required by arts administrators: administrative skills, cultural administrative skills, attitudes and values, and art form knowledge:[7]

Administrative Skills

- Marketing management

- Financial management

- Personnel management

- Computer applications

- Communications
- Organisational behaviour

- Strategy planning

- Quantitative analysis

- Business law

Cultural Administrative Skills

- Market research and analysis
- Cultural appraisal methods
- Marketing and media planning
- Financial management of arts/heritage organisations
- Fundraising in arts/heritage organisations
- Quantitative project management
- Human resources management in cultural organisations
- Program and board volunteer organisation and management
- Labour relations
- Computer applications in cultural organisations (box office, membership database
- Arts and the media
- Theory of arts organisations
- Theory of arts administration
- Organisational planning
- Strategic management of cultural organisations
- Quantitative analysis in arts organisations
- Arts and the law
- Arts facility management
- Touring and special event management

Attitudes and Values

- Ethics in arts

Art Form

- Discipline specific studies in musicology, visual arts, dance, theatre, music

- Role of arts/heritage in society
- National cultural issues
- Cultural policy
- Policy-making in arts/heritage
- Culture, society and human values

- History of/contemporary issues in civilisation and culture.
- National cultural organisations (companies, professional organisations, government departments, cultural industries).

A training needs analysis of the arts administration sector conducted by Arts Training Queensland in 1994 concluded with a set of arts administration tasks resembling the 1989 Canadian survey:[8]

Major activities of the sector

This sector covers managers and administrators whose primary role is one of administration of arts projects, arts operations and support services to the arts industry. Although this sector crosses over many industry sectors, the arts administration area focuses strongly on those whose responsibilities include overall management and administration of a project, venue or organisation.

Specific activities in which arts administrators engage include business/financial management, marketing and sales, customer service, technical elements, public relations, human resource management and development, fund raising, volunteer management, industrial relations and project management.

Management functions

While these areas of activity comprise the skills base of arts management, the effective application of the four key functions of management will determine a manager's success or failure. These functions are planning, leading, organising and controlling. Planning is by far the most important and involves knowing where the organisation wants to go and establishing how it will get there. Planning begins with a mission and a set of objectives and extends to the detailed stages or activities outlined over a period of time designed to achieve those objectives. It may be a corporate plan, a strategic plan or a business plan.

The terms 'corporate plan' and 'strategic plan' are at times used interchangeably in middle-sized and large organisations for a plan covering three to five years. More often, corporate plan is used by large organisations with departments or units of work activity called strategic business units (SBUs). Corporations have longer term plans, for example a national mining manufacturing or oil company may have international development plans that extend six to ten years in the future. A strategic plan is used to define and provide a framework for the strategies for the business of the organisation. A business plan is the operational plan usually set for one year. Small organisations may have a business plan rather than a strategic plan.

The manager must allocate human and financial resources, deciding who will carry out what task with which resources to achieve plans over a set period of time. Leading involves motivating the workforce in the organisation through shared vision and shared goals. Management and leadership skills are discussed in more detail later in this chapter. The final management function of controlling is fundamental as a means of assessing effective and accountable management. Checks and evaluation mechanisms should be set in place with plans so that all employees with organisational or unit responsibility, including the manager, can check results against project plans and budgets and make changes if necessary.

Mission

It is essential for arts managers to embrace strategic planning in order to maximise achievement of the mission of the organisation. Missions are long-term vision statements which position the organisation following an assessment of the environment and the organisation's strengths and weaknesses. The mission should answer the questions regarding the purpose of the organisation, what product or service is offered, for whom and how it is to be delivered. Once in place the mission becomes the symbol of the organisation's driving force for several years. It motivates action, and the quest for excellence and a competitive position. The follow-

ing missions gathered from arts and cultural organisations around Australia and the world provide a valuable comment on the strategic development of the arts and cultural industries.

The Children's Museum of Indianapolis
The Mission of The Children's Museum is to enrich the lives of children by:

- Creating excellent exhibits, programs and experiences to share knowledge, stimulate imagination, kindle curiosity and affirm the joys of life-long learning.
- Welcoming each visitor as a partner in discovery, and encouraging people of all ages to explore, analyse, wonder and grow.
- Sharing our treasury of artifacts and the talents of our staff as we facilitate learning about our own culture, other cultures, the arts, science and technology, seeking to animate the past, understand the present and prepare for the future.

Historic Houses Trust of New South Wales
To conserve and manage with imagination and excellence the cultural heritage of the State as represented by key places and to realise their potential to foster an informed awareness of this heritage.

Musica Viva
Musica Viva Australia aims to foster the knowledge and promote the interests of music and musicians to audiences around Australia and internationally. In doing so, its focus is primarily geared to promoting fine ensemble music through concerts and related activities designed to inform and entertain.

Carrick Hill Trust, South Australia
The Carrick Hill Trust is committed to preserve and improve the real and personal property forming the original Hayward Bequest and to develop Carrick Hill and encourage the use of the property as a cultural, botanical and recreational resource available for the enjoyment and education of the widest possible audience.

Western Australian Opera Company Inc.
To be an opera company whose high standards, integrity of performance, creative processes and administration are recognised by artists and audiences; who make opera a highly accessible and stimulating part of West Australian cultural life; who develop and nurture Australian artists and audiences and through them, enjoy the continuation of the artform.

West Australian Ballet
We are the major professional dance company in Western Australia with specific responsibilities to:

* develop Australian dance and associated art forms; and
* to seek key dance works from the international repertoire
* provide dance performances for the people of Western Australia.

Our task is to achieve excellence in the creation, promotion and presentation of dance performances for the community.

Festival Fringe Society of Perth Inc
The aim of the Society is to provide an environment and network for arts and cultural exchange between new or innovative artists and the general public. This environment and network takes the form of an annual multi-arts festival, entitled 'Artrage', held in spring.

Contact Theatre Company, Manchester
Contact Theatre Company will produce great theatre for and with young people.

Contact will present theatre which is remarkable in professional productions of high quality. It will both champion new work, and rejuvenate classic plays. It exists to create new audiences for theatre. Its program will entertain, inspire and surprise.

Contact must attach equal importance to its productions, youth theatre, community and education programs if it is to succeed. Contact will invest in talented young people.

Contact's building and all the work within it will be welcoming to, involve and give voice to the young people for

whom it exists. It will reflect the cultural diversity of young people in Manchester.

This approach to creating great theatre for and with young people is what makes Contact unique in Manchester, in the North West and nationally.

Liverpool Playhouse
To become a theatre of international standing renowned for quality and innovation, whilst remaining a local and regional resource.

Victoria and Albert Museum, London
The Museum exists to increase the understanding and enjoyment of art, craft and design through its collections.

Fremantle Arts Centre
The Fremantle Arts Centre works to:

- foster and promote the development and practice of artists in Western Australia
- create opportunities for the general public throughout Western Australia to enjoy, participate in, and develop an understanding of all aspects of the arts.

The values of the organisation are responsiveness, openness, rigour, accountability, innovation, and a sense of place.[9]

Strategic planning

The mission of the organisation becomes the foundation on which the strategic plan is built. A performing arts centre, for example, will be guided either by a carefully prepared mission or an unwritten vision or idea of the value this centre has to its local community. This mission is translated into a set of artistic, social and financial goals and objectives which are then developed into a strategic plan for the arts organisation or venue detailing how resources (human and financial) will be used to meet the goals and objectives. The plan moves from the idea in the mission to the reality of implementation.

The mission statement for the Queensland Performing Arts Trust is influenced by statutory obligations to the government defining public benefits, community service and the

Queensland state geographical priority, but also reflects the Trust's traditional purpose of venue management and promotion. The mission positions the venue internationally, states the business of the Trust, that is, production and community service, nominates a quality of life purpose and the place of delivery. The eight corporate goals that follow very definitely translate this mission into financial (commercial strategy, occupancy), artistic (image of excellence, best performing arts), social (working environment, community and regional access to arts activities) and management (management information systems, operational infrastructure) goals. Strategies to achieve these goals would then form the strategic plan.

Queensland Performing Arts Trust
Mission Statement
> To enhance the quality of life in Queensland by promoting, presenting and managing performing arts productions of the highest artistic standards from Queensland, elsewhere in Australia and from overseas, principally through the Queensland Performing Arts Complex.

Corporate Objectives
> Provide the community with access to the best performing arts available.

> Establish the trust as an organisation committed to excellence, integrity, responsibility and reliability.

> Ensure optimum occupancy of the Performing Arts Complex.

> Provide Queensland's regional areas with specialised, relevant product consistent with the Trust's Regional Performing Arts responsibilities and Government policies.

> Maintain a stimulating caring working environment to develop a motivated and responsive workforce.

> Operate information systems, specialist technologies and facilities which match international standards, methods and practices.

> Amplify, diversify and secure the Trust's financial

base through entrepreneurial and commercial activities.

Ensure that QPAT's infrastructure is adequate to support QPAT's operations and growth—and is maintained to a standard in keeping with QPAC's status as a major Australian performing arts venue.

The plan moves from the idea in the mission to the reality of implementation. Each strategy gives direction and impetus to the organisation, forming an action framework that can be planned and measured in time and in financial and human resources. While all employees in the organisation will have consultative input into the strategic plan, it requires the philosophical and financial commitment of the general manager, board and all senior staff to succeed. It should become the basis for decision making in the organisation. If the information feeding the plan is correct (that is, market research, environmental audit, organisational audit and industry analysis), the strategies designed to achieve the corporate goals and mission should not have to be altered over the three to five year time frame of the plan. The middle management of the organisation will be involved in translating the strategies of the plan into action for each business unit, department, project or objective. Constant monitoring and evaluation of these action plans will provide senior management with feedback on the performance of the strategic plan.

Human resource management

Contemporary management practice in all areas of business and corporate activities benefits from close attention to the human resources of the organisation. The arts and cultural industries have only recently embraced human resource management policy as a measure of success in delivery of the arts and cultural product. This may be because the arts have developed in the non-profit subsidised sector with a tradition of value-laden missions and objectives, a lack of strategic planning and corporate practice, and an attitude that people who work in the arts are at all times creative and caring.

Employees in the arts industry have been viewed as

Figure 5.1 Strategic planning process

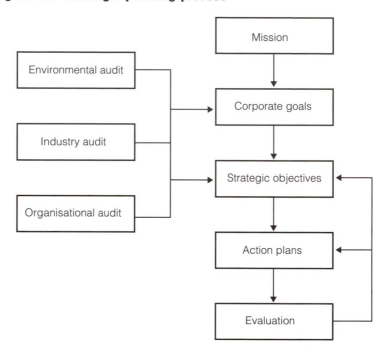

enjoying the rewards of commitment to the arts rather than favourable workplace conditions and payment. However, the arts are one of the most labour-intensive industries and rely significantly on human resources—the creativity of artists, the above average input in terms of time and energy by managers and staff, and the appreciation by consumers (theatre patrons, audiences, art museum visitors and community participants). Human resources management is a vital component of the management and marketing function of an arts organisation.

Arts managers must recognise the dynamic relationship of human resources management and the organisation's objectives and operating goals. Human resources must be co-ordinated closely with the organisation's strategic and related planning functions.

The organisational structure of the arts organisation or venue is designed to fulfil this plan through the establishment of job descriptions, lines of communication, and

workgroup relationships and responsibilities. In some organisations this structure is necessarily formal and fixed to ensure work functions, reporting and customer transactions meet deadlines and financial returns. The organisational structure of a major performing arts venue would normally be a formal hierarchical structure with the chief executive officer reporting to a board or trust, and leading a variety of departments each with their own hierarchical structure. Many arts organisations operate in a more 'organic' structure with a consultative democratic, multiskilled workforce assuming responsibility for the various tasks and jobs of the organisation. This 'collective' style of organisational management is the most fluid, as all decisions and activities are shared among a group of staff employed to fulfil the organisation's objectives. In all organisational structures, hierarchical and organic, some functions must be organised formally, for example, ticketing and payroll, where clear work tasks, responsibilities, timelines and reporting must be set and completed. Reference to organisational structures is made elsewhere in this book in the areas of leadership and legal structures.

Staff are the human resources required to fulfil the mission and support the strategic plan. Staffing is the key element in the success or failure of the enterprise. The strategic plan must contain staffing objectives. For example, the Queensland Performing Arts Trust's corporate objective for employees provides a focus for work practice, the culture of the organisation and for human resource management policy and procedure in that arts centre. A strategic plan for recruitment, training, performance and practices has been designed to carry out the work of the Trust in accordance with the corporate objective.

Human resource management comprises functions that are performed as part of the management system. It evolved from scientific management theory which analysed productivity data as performance evaluation, and from human relations theory which focussed on individual differences and the need for feedback from employees. Human resource management focusses on the total organisation environment, that is, on the social, political, behavioural, cultural, physical,

economic and technological aspects of the workplace. Staff are seen in relation to and as part of the whole organisation.

While the arts organisation determines its mission, strategic plan and position in relation to both the internal and external environment, the human resource management policy and procedure is best viewed as an extension and interrelated component of the external environment and the organisational goals. Figure 5.2 explains the place of human resource management in the arts.

The external influences in the community and in the arts industry may result in an arts centre management developing an objective and strategies to produce arts product for an ageing population. This is because demographic data indicates significant numbers in a particular community of that age group with disposable income and strong artistic interests. The plan and external information may also influence the management of the human resources through the establishment of a volunteer or 'friends of the arts centre' group. Similarly technological or economic factors determine recruitment strategies and training programs within the organisation. When all three factors are integrated the arts organisation or centre is performing most effectively. This is the 'impact zone'.

The human resources branch, department or section in a large arts centre or the manager in a small centre is responsible for identifying the role, functions and procedures for maintaining a policy that encourages employees to work diligently, efficiently, responsibly and ethically in a creative, challenging and supportive environment. This requires knowledge of relevant employee legislation, union agreements, recruitment processes, performance evaluation, training and development schemes, volunteer programs, strategic management and planning. In addition the arts manager must display high level 'people skills' in all aspects of communication with artists, producers, government officials, patrons, clients and sponsors.

Personnel management
While human resource management represents the interaction of personnel functions with each other and with the objectives of the organisation, there still remains a need for

Figure 5.2 The interrelation of external influences, organisational goals and human resource management

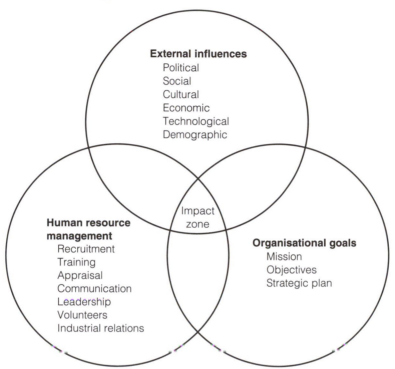

External influences
Political
Social
Cultural
Economic
Technological
Demographic

Impact zone

Human resource management
Recruitment
Training
Appraisal
Communication
Leadership
Volunteers
Industrial relations

Organisational goals
Mission
Objectives
Strategic plan

the arts manager to know and understand the various personnel functions performed in managing human resources.

Personnel management involves the operation within the organisation of the basic functions of recruitment and selection, training, performance, evaluation and compensation. The most important asset to the arts manager is the staff. In contemporary business and corporate practice most successful service organisations manage their personnel within a system of procedures that reflects the goals of the organisation and the strategies of the business plan. The system starts with an organisation chart and ends with a job description for all positions.

The purpose of a job or position description is to provide accurate and objective information about the duties and requirements of the position. It outlines the tasks, duties and

responsibilities of the position; the relationship of the position to other positions in the organisation; the relationship to the corporate objectives and mission of the organisation; and the personal qualities in relation to qualifications, knowledge, skills, abilities and competencies required to do the work.

An accurate job or position description is devised through the process of job analysis, interviews with supervisors and the incumbent employee, and through observation.

The following selection criteria illustrate the range of personal qualities required for management positions within an arts organisation.

- Demonstrated ability to consider and contribute to the resolution of organisational problems and exploration of opportunities
- Knowledge and skills in the formulation and management of budgets
- Demonstrated ability to organise and manage productivity measures to enhance the efficiency and effectiveness of the organisation
- Ability to handle personnel and industrial matters in a sensitive and constructive manner and the possession of a thorough knowledge of appropriate industrial legislative requirements
- Ability to work effectively under pressure and to respond appropriately to emergency situations
- Demonstrable commercial and financial literacy
- Demonstrated knowledge and understanding of the full implications of customer service and a commitment to its delivery
- Ability to communicate ideas and to present information in a logical and coherent manner
- Ability to win support and co-operation for projects within a multi-disciplinary workforce
- Sound knowledge of or experience in operating in-house computerised payroll systems
- Ability to demonstrate a high level of accuracy and attention to detail, together with a high degree of mathematical aptitude

- Good electronic data processing knowledge and experience working with computer hardware/software, including wordprocessing and spreadsheets
- Highly developed interpersonal skills and the ability to supervise, motivate, support and train staff
- Developed organisational skills, including effective time management, prioritisation and project co-ordination skills
- Personal characteristics of initiative, self-motivation and enthusiasm demonstrated in an arts environment.

When job or position descriptions are being prepared, the requirements under racial discrimination, sex discrimination, equal opportunity, human rights and workplace health and safety legislation should be considered.

Recruitment

The process of recruitment ensures that a suitable number of qualified people are attracted to apply for employment by making them aware that vacancies exist.

The supervisor initiating the recruitment determines the need to fill the vacancy. This involves reviewing the operations of the section, considering the organisation's strategic plans and action plans, possible improvements to structure and a cost benefit analysis of the work to be performed. Advertisement should occur internally and externally in appropriate newsletters and newspapers. The advertisement should provide clear and concise details of the position or job, an indication of the working conditions and environment, the closing date for applications and a contact point for additional information.

Selection

To assess the suitability of applicants, each person's knowledge, skills, experience, qualifications, abilities and personal attributes are compared individually with the requirements of the position. The following steps comprise the selection process:

- development of selection criteria
- establishment of selection committee
- formulation of standard assessment criteria
- shortlisting

- interviewing
- reference checking
- recommendation for appointment
- letter of employment
- notification of unsuccessful applicants.

Orientation/induction

Employees are familiarised with the duties and responsibilities of the new positions in a series of developmental stages. The aim is to have employees brought to full and efficient productivity as quickly as possible. As part of the orientation process, the employee is informed of organisational and work goals, the means of achieving them, required behaviour and general rules by which the arts organisation operates. There are two components: a corporate program and a workplace program.

The purpose of the corporate program is to provide the necessary information, facilities and motivation to assist the employee to adjust to the new environment and to encourage the development of loyalty and commitment to the organisation. The workplace program is the key component in this early training and is the responsibility of the relevant supervisor. It should take place over a specified probationary period and involve productive work as soon as possible.

Performance appraisal

An effective performance appraisal or evaluation program benefits the organisation through a management information system for all aspects of human resource management, and benefits individuals through feedback about performance.

The objectives are to:

1. Provide employees with adequate feedback concerning their performance.
2. Serve as a basis for modifying or changing behaviour toward more effective working habits.
3. Provide managers with data to assess future job assignments and pay rates (compensation).
4. Determine training needs of employees.
5. Evaluate strategic and action plans.
6. Establish recognition for achievement.
7. Plan career development for employees.

8. Create an open and constructive communication climate between employees and management.

Methods of employee appraisal include rating scales, written statements, measurement of achievement against objectives set down in interview with a supervisor, and the use of assessment centres. The most common approach which arts managers find useful is the annual appraisal interview. The interview should be planned for by both participants; should reflect the organisation and section goals and action plans; should be formalised by recorded notes and signatures of both participants; and should be a positive manager–employee communication experience.

Grievance processes

The grievance procedure is designed to enable employees to have a complaint or concern dealt with quickly and informally through correct channels.

From a management point of view, the process promotes the prompt resolution of grievances by consultation and so reduces possible time lost due to disputation. It also promotes efficiency, effectiveness and equity in the workplace. In the industrial setting, it has been demonstrated that solving a specific problem for an employee reduces absenteeism, accidents, interpersonal problems, turnover and job dissatisfaction. It is also an important means of avoiding the cost of losing valuable employees and safeguarding the investment in training, recruitment and long service. Employees should be encouraged to raise any issues of concern before the grievance becomes severe.

The arts manager should initiate a discussion between the employee and supervisor at an appropriate time and place. Confidentiality, active listening, feedback checking, options for resolution and follow-up action should be promoted. The second stage involves discussion with the department head or manager which is recorded and followed by possible independent investigation and notification to the human resource department and general manager. A final discussion then takes place with the general manager or chief executive officer of the organisation in order to achieve

resolution. In small organisations an independent mediator may be brought into the process.

Diminished performance

The process for managing diminished performance can be initiated at any time when an employee is experiencing difficulties achieving predetermined and agreed performance objectives.

The possible reasons for diminished performance are unclear performance expectations; lack of knowledge, skills or motivation; overqualification for the job; low morale due to lack of challenge in the work, inappropriate procedures or systems, excessive workload, competing deadlines; personal circumstances (stress, emotional or personal problems, ill health); work environment (lack of required resources/equipment, unsuitable working conditions, organisation change); or problems associated with others (distractions, harassment, personality clashes, tensions in the work environment).

The objectives of a policy on the management of diminished performance are to establish an equitable procedure which will provide a positive and problem-solving approach to the management of affected employees; ensure that employees are informed when they have not met or are unlikely to meet any required performance outcomes; and assist employees to overcome performance difficulties by implementing agreed action.

The procedure is as follows:

1. Identification of diminished performance through either performance appraisal interviews or supervisor practices.
2. Discussion with employee to jointly reconfirm performance objectives and standards and to clarify the shortfall in performance.
3. Notification in writing to employee of consequences should the diminished performance continue and notification to the human resource department.
4. Remedial action and reassessment, if possible.
5. Instigation of disciplinary procedures.

The arts manager is advised to have a diminished perfor-

mance procedure documented to maintain the effectiveness of the organisation's operation.

Termination

Recent legislation states that an employer cannot terminate an employee without a valid reason. Invalid reasons include illness, injury, union membership, pregnancy, race and gender discrimination. Dismissal cannot be considered harsh, unjust or unreasonable. Certain employees are exempt from termination: casual employees with the organisation for less than six months, probationaries, and those with an employment contract specifying a time and task of employment.

A certain procedure must be followed before termination eventuates.

- If diminished performance is the cause, the employee must be counselled, warned and given time to improve performance. If ongoing consultation fails to improve performance, termination can take place.
- If minor misconduct is the cause, the employee must be given counselling and a discipline interview.
- If serious misconduct is the cause, the manager should investigate the facts immediately and seek the employee's response to why termination should not occur.

Training and development

Employee training programs are designed for two reasons: to provide instruction and education to encourage efficient work practices, and to guide the development of employees in the workplace. Training begins with a new employee's orientation and continues throughout their employment with the organisation. To be successful the training program should guide the employee through a series of exercises or experiences that teach the employee how to respond to the specific requirements of the job.

Currently the working activities of employees in all areas of arts organisations and venues are being assessed to establish competency standards for satisfactory performance. National standards that relate to arts administration are drawn from competencies set down in the clerical adminis-

trative, live theatre technology, museums, libraries and design areas.[10] This measure of competency-based standards will be invaluable to arts managers in selection criteria, performance evaluation, staff objectives in strategic planning and identification of appropriate training programs.

Every job situation has different problems, approaches and solutions. The manager must determine the most effective training plan and then make sure that it is implemented. Training is an important part of the career development of all employees, not just new recruits, and must be constantly reinforced by the manager.

The following issues require consideration:

- Productivity and multiskilling as part of enterprise agreements often result in a greater commitment by management to training employees.
- The training program must emphasise the objectives of the organisation, for example if audience development is a goal of the organisation, the training program should include the importance of audience development.
- An effective training program must also demonstrably contribute to the satisfaction of the employee's personal goals.
- The employee acquires 95 per cent of job knowledge in the work environment in a superior–subordinate relationship. The manager plays a key role in employee training.

The training of managers is also critical to the success of the organisation. Management training is not aimed at improving specific job skills, but rather at developing managers as leaders and instructors. The emphasis should be on educational development rather than on mastering specific subject matter.

Training is an important managerial tool for modifying behaviour towards specific organisational goals. The best results are achieved when individual goals are consistent with the goals of the organisation.

Management and leadership skills

Arts managers should analyse their role as managers and their potential as leaders. A manager solves problems, plans,

handles resources and expenditure, is responsible for performance and training, organises staff, delegates duties and tasks, directs the business of the arts centre. Leadership is about vision, about setting goals and devising the means to achieve those goals. A good manager should be a good leader, although many leaders may not be good managers.

An understanding of the theories of leadership based on the characteristics and recurring behaviour patterns of leaders and on the motivation and power exerted on groups in certain leadership situations will enable arts managers to perform an audit of their leadership in their organisation and in the community.

In Stodgill's *Handbook of Leadership* the attributes most frequently associated with leadership were identified as adaptability, aggressiveness, assertiveness, dominance, independence, originality, personal integrity, self-confidence, intelligence, decisiveness, judgement, knowledge, fluency of speech, ability to enlist co-operation, administrative ability, popularity, interpersonal skills, social participation and diplomacy.[11]

Early research into leadership characteristics concluded that a combination of qualities such as vigour, persistence in the pursuit of goals, self-confidence and the ability to influence others and to tolerate frustration usually demonstrated a 'leadership personality'.[12]

Leadership behaviour theory resulted in the formulation of four leadership styles which focussed on the leader's behaviour towards tasks and people. These styles are autocratic, democratic, laissez-faire and human relations. Some leaders are more concerned with tasks such as planning and achievement. Other leaders are more people oriented. Participative or democratic leadership demonstrates both high concern for people and for task. The arts manager should consider leadership style in association with experiences of various arts leaders and determine individual goals alongside organisational goals.[13]

These leadership styles may change with the situation. For example, if the arts organisation management has determined that a fundraising campaign is to take place, the manager must provide autocratic or directive leadership in

appointing a subcommittee and establishing the campaign details and procedures. This leadership style may then change as a team of volunteers is engaged and trained to carry out certain aspects of the fundraising campaign. Participative or democratic leadership will be demonstrated to define the objectives of the campaign and motivate and train the volunteer fundraisers. It is possible that during the campaign conflict may occur between volunteers and paid employees in the organisation regarding office space or equipment usage, production priorities or marketing and promotion. Here the manager's leadership style should be to encourage an harmonious work environment of mutual respect in a supportive or human relations role.

Leadership has been described as the use of power to influence the behaviour of others. Power should not be seen in negative terms. The arts manager can have both position and personal power. Position power is usually the legitimate power granted by the board or employing authority. Personal power is achieved through expertise, charisma and ongoing credibility with employees.

Managers have leadership responsibilities and one of them is to create and maintain employee groups and keep them productive. An understanding of the factors motivating employees is essential. Individuals may be motivated by the satisfaction of unmet needs. According to Maslow's theory, people have a hierarchy of needs ranging from basic survival, safety and social to the more sophisticated esteem and self-actualisation needs.[14] It would be difficult for the manager to motivate employees who worked in a poorly lit and poorly ventilated office, or who never had group meetings with other employees and never shared common goals, or who never received praise or support for work achievements or initiatives. The patrons of an arts centre must also feel that the basic needs of comfort, safety and a sense of belonging are fulfilled if they are to pay a return visit to the centre.

Certain of these factors are part of the manager's commitment to the workplace health and safety requirements, and others are factors in motivating work productivity and maintaining a caring working environment.

The process of motivation requires managers to utilise

the skills of effective communication, consultation, negoti-
ation, assertion, conflict resolution and performance evalu-
ation.

Communication

The communication process involves the transfer of mes-
sages. The communicator must plan the communication,
remember that meanings are in people not in words, and
select the best method for transmission.

Most work activities in an arts organisation are carried
out as the response to some form of communication—a
letter, memo, report, telephone conversation, instruction or
directive. The hierarchical organisational structure usually
determines the flow of communication. The arts manager
who practises the principles of human resource management
will be aware that success as a leader relates directly to the
ability to send, receive, interpret, monitor and disseminate
information.

Effective communication requires practice and skill to
avoid misunderstanding. Contracts, stage management cues,
meeting reports and reprimands in oral form provide poten-
tial examples of misunderstanding if the communicator does
not speak clearly using vocabulary that can be understood,
and seek feedback in an environment that is noise and
distraction free. If the committee of management states to
an arts centre manager 'We did not know it cost that much
to produce a free concert' when the budget is severely
overrun, or the local fundraiser says 'But I thought we agreed
that my association would get 80 per cent of the money raised
from the concert', there is communication breakdown.

The communication model in Figure 5.3 shows that the
communication process is both complex and simple. The
sender who is encoding the message prepares and delivers
it in a framework that encapsulates a set of experiences,
values, interests and attitudes combined with a certain cul-
tural, social, educational and environmental background. In
addition the gender and occupational position of the sender
may influence the construction of the message. The receiver
also embodies a set of variables that may affect the decoding

Figure 5.3 A model of communication between two individuals

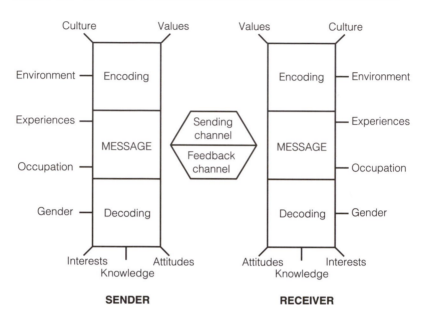

process. Internal and external noise can mean that the receiver is not concentrating or cannot hear the message.

All these factors must be taken into consideration to ensure the accurate transfer of information from one person to another, or from one person to a group. Communication breakdown in the two arts centre examples occurred because the manager presumed the committee of management had read and understood the financial report and had not made the information clear nor sought feedback or confirmation. Secondly, the communication with the fundraiser was influenced by the listener's attitude or experience, not by a clearly stated message, checked through feedback orally or in writing.

The 'maintenance of a stimulating, caring working environment' promoted by the Queensland Performing Arts Complex can only occur in an organisational communication climate that is empathetic, non-evaluative, focussed on tasks not controls, demonstrates equality, and responds to a changing environment.

Listening

Effective listening requires the concentration of physical and mental energy. The concept of listening is too often misunderstood as the natural activity of 'hearing' which requires no practice or skills. Effective listening creates an encouraging environment for the speaker and is a vital factor in the communication climate of the organisation.

Managers must practise empathetic and active listening as a means of receiving information, improving relationships, resolving problems, understanding people, and encouraging positive listening behaviour.

Listening behaviour to be avoided is that which judges the speaker's actions and ideas, or directs the speaker to think or act, or soothes and probes by ignoring the problem or question. The arts manager must strive for listening that focusses on the speaker's ideas and feelings, demonstrating interest and providing clear and unambiguous feedback at all levels throughout the organisation, from the board to subordinate employees.

Assertiveness

Assertive behaviour means acting in your own best interests, expressing feelings honestly, and exercising personal rights without denying the rights of others.

Passive behaviour means acting in other people's interests, which may be denying your own rights.

Aggressive behaviour means acting in your own best interests with no regard for the rights or feelings of others.

While it may be appropriate for a leader to demonstrate aggressiveness in order to achieve or maintain leadership under threat or competition, the preferred behaviour for all employees is assertiveness. Managers, in particular, must practise assertive behaviour to motivate individuals and workgroups, and to demonstrate personal and position power in directing the operations of the organisation.

Forthright communication which respects both self and others will be effective in negotiating with producers, government employees, community groups and staff. The manager who suppresses information or opinions in reporting on a work practice or a preferred line of action

because of unwillingness to offend or face reality, will cause great damage to personal relationships, the reputation of the arts organisation and the industry in general. Weakness in decision making, awkwardness in social situations, reticence in offering ideas, subservience to superiors, passivity in opportunity are inappropriate qualities in managers. Assertiveness is positive and demands respect from others.

Managing change

Change is any alteration to the status quo. In recent years change is a part of daily life. Changes in technology, in employee relations, in legal and financial accountability, in audience expectations and in work practices mean that the arts manager must understand the nature of change, its effect on communication and on the process for managing change. There is often great resistance to change. The reasons for resistance are logical, psychological and sociological. Employees fear increased responsibility, economic loss and technology, and are unwilling to lose old habits and assume the risk involved in change.

If change is necessary in the arts organisation, employees must be involved in consultation during the process to ensure they understand the need for change and become committed to its rewards.

Through skilled communication the manager can implement the following strategies for managing change:

1. Surfacing: by establishing a climate of trust, encourage the employee to open up and relate exactly why he or she has difficulty with the manager's direction.
2. Honouring: treat the employee's concern with dignity.
3. Exploring: jointly probe the resistance to change to determine its basis.
4. Rechecking: establish the manager and employee's position in relation to the required change.

Industrial relations[15]

The basis of any relationship between the management and staff of an enterprise, organisation or business is some form of contractual document setting out terms and conditions of

employment. In Australia this agreement is called an award; in the USA a labour contract; in New Zealand an employment contract.

Whatever the name and the variations, the purpose of such an agreement is to fix a fair and equitable arrangement for employees of a company or enterprise to go about the stated mission and objectives. In most countries, the arrangement is made within a structured format set by state or national government. It contains such obvious conditions as rates of pay, hours of work, skill recognition and public holidays. In some cases, awards can be site and enterprise specific but historically are very generalised covering all employers and employees in either a certain type, a certain public sector, or by skill or trade (e.g. metalworkers, carpenters, electricians).

The trend in Australia and New Zealand in the last three years has been towards site specific awards, reached directly between management and staff of an enterprise. The old concept of generalised craft and trades awards has been considered outmoded, being too complex, unwieldy and inefficient for the competitive 1990s.

Tariffs and other protective trade mechanisms have been abandoned in favour of international free trade and governments are introducing a level of industrial reform unparalleled in recent history. This has led to micro-economic reform as a way to achieve structural efficiency specifically through enterprise bargaining and has made productivity the key word in industrial relations.

Enterprise bargaining is the process of negotiating directly between an employer and the employees (through the employees' representative, that is, the union) at the enterprise to reach an agreement which is acceptable to both parties in regard to wages, working conditions and work practices which pertain to that particular enterprise.

The change in the industrial climate provides the opportunity to re-examine the principles of employee relations. It is essential to involve employees in as much of the organisation, its aspirations and methods as is practicable, by regular meetings with supervisors and staff to explain and reinforce company philosophy. Listening to criticisms, constructive and

otherwise, encouraging work variety, giving responsibility to employees, and recognising the work of individuals and workgroups are the key ingredients of a successful workforce. In this way the relationship with employees is improved and a mutual confidence and respect in each other's work is established.

It is with such a structure that the best results can be obtained during industrial negotiations or in fact, disputation. An estranged management that only talks to its employees at award renegotiation time, or even worse, only through a union, is inevitably going to face difficulties compared with an organisation whose management understands, listens to, and regularly meets with the workforce.

Once confidence and good faith are established, the whole process of negotiating with employees becomes far less complicated and less likely to be hijacked by outside parties such as unions, governments or network organisations. The introduction of change to the way of working is obviously easier within a tightknit organisation where cynicism has been replaced by respect and enthusiasm.

The issues of bargaining, negotiating and proposal presentation in industrial relations require some familiarity by arts managers if they are going to move further in creating an open communication climate in the organisation. Managements that have come to terms with this commence the bargaining process from a position of great strength, whether it be regular year-end negotiations, the introduction of major changes or a complete overhaul of the industrial culture. A bargain refers to an agreement between equal parties establishing what each will give, receive or perform in a transaction between them. The basic purpose of bargaining is to achieve a satisfactory outcome for both parties. In forming a negotiating position it is essential to define the outcomes that must be achieved followed by the prioritised desired outcomes and then any matters that can be used as bargaining chips during the process. For example, the priorities for a forthcoming round of negotiations at an arts centre might read:

1. Necessary outcomes

removal of weekend penalties
change to the spread of hours
no net increase in rates of pay without equal and
measurable productivity gain
2. Desired outcomes (in priority)
broad banding of skill levels
flexible rostering of permanent staff Monday to
Sunday
elimination of post 6.00 pm penalties for casuals
3. Negotiable outcomes
lump sum payment of holiday loading
training for multiskilling
higher duties

This prioritising process involves an audit of every aspect of the arts centre operation in conjunction with department heads.

In recruiting the negotiating team it is important to show a united group in any bargaining structure, and as such, the team should be representative, knowledgeable and consistent in attendance. It should not necessarily consist of the entire senior management, but rather key people whose combined experience and knowledge match the negotiating position.

The decision to utilise a professional negotiator or consultant depends on the size and structure of the organisation. If the organisation does not have a professional industrial relations or human resources department, it is probably wise to employ a specialist from the beginning of the bargaining process. Most agreements have to be ratified by a commission or regulatory body with rules that are complex, subject to frequent changes and unintelligible to the average arts manager.

Staff should always be properly informed of their rights, obligations and most importantly, that it is their jobs, conditions and rates that are under negotiation. The union in this case is only their representative. The employees are the principals and management must encourage staff to participate to ensure that their team represents the broad view.

The negotiating team together with senior management should prepare a proposal for presentation. This proposal

should not be ambivalent, but set out clearly the employer's position which is a direct extension of the discussions with the employees over the past months.

The focus is on the management preparing an agenda for the arts organisation workforce. In the bargaining process, staff and employees can attend meetings up to and including the formal bargaining period (the open door). Unquestionably, this is a preferential position than that of having a union serve a log of claims on the organisation, or having an employers' association group the organisation with others and bargain collectively on their behalf. In each case the agenda is being set by others and the specific needs of the employees are subjugated to a greater cause.

The negotiating team should be prepared for a possible negative response from the union. This is simply positioning. Every negotiator has a starting position, which often bears no resemblance to the finishing or settling position. Some people find this frustrating and time wasting. There is always an amount of ambit in the negotiating process. The danger of having a large gap between a starting and a finishing position is that the credibility gap grows in direct proportion.

The team should take care conceding to a point at a meeting. Always ensure that there is a higher authority in the organisation to refer to. As the gap between the parties narrows and negotiations approach finalisation this becomes less important, but always remains a valuable tool. It is important to ensure that the chief executive officer or board (or the group to whom the manager reports) is always sure that the manager is negotiating within an agreed framework. To gain the authority to negotiate, the manager must assess the organisation's capacity to pay by measuring the gains against the losses and determining an economically acceptable position; consider the state and national economy so that the bargaining is in line with the consumer price index, inflation and unemployment; investigate competitor and similar organisation positions; ensure that unacceptable inequities in previous arrangements are addressed; establish the non-negotiable elements; apply a regular reporting process; and allow for flexibility in the negotiations within defined limits.

The total reformation of the industrial agenda has given the arts and cultural industries the tools and support to reassess completely the awards under which their employees work. Opportunities to negotiate directly with staff and the local union have never been stronger as previously restrictive work practices are overturned and new practical, efficient and logical systems replace generalised awards.

Volunteer management

Volunteers are people who freely give service to an organisation for the benefit of the community. They are a valuable human resource in an arts organisation that require the manager's attention in the same way as professional paid staff. As a response to the social, political, economic and cultural environment in which the arts and cultural industries operate, the inclusion of volunteers in the workforce must be seen as an opportunity to strengthen the commitment, advocacy and involvement of the community. The principles associated with volunteering are those of participation, empowerment, sharing of goals and culture, the development of skills, the exchange of services and the sense of belonging.

A policy for volunteers should be developed for the arts organisation as a part of a networking policy to bring the community closer to the product and the cultural experience. This includes creating schemes for friends, members, subscribers and board members. The use of volunteers reinforces the networking process and harnesses additional resources. The volunteer program can be utilised as part of the marketing plan. Volunteers offer specific skills and expertise, time, labour assistance and liaison with the community. In return the organisation offers training and work experience, social interaction and aesthetic rewards in the association with an organisation that the volunteer believes in and wants to serve.

It is the responsibility of the manager or the appointed volunteer co-ordinator to make effective use of the volunteers, and to ensure that in representing the arts organisation, volunteers understand the mission and maintain

loyalty. The following list of qualities to seek in volunteers should assist in a recruitment program and in developing the volunteer policy:

- willingness to embrace the mission, goals and objectives of the organisation
- reliability in completing assigned tasks
- ability to involve others, to attract new people, and to move freely within the organisation's market
- a sensitivity to the unclear line that separates functions related to staff and volunteer responsibilities
- the flexibility to move on when necessary
- eagerness to acknowledge the assistance of others
- interest in training for workplace activities
- time and energy to commit to the organisation.

Establish a procedure for organising the volunteer program:

1. Assess the arts organisation's needs for volunteers.
2. Establish administrative support.
3. Appoint a volunteer co-ordinator.
4. Plan appropriate volunteer tasks with written job descriptions.
5. Establish policies and procedures for recruitment, orientation, training, support and termination.
6. Develop an adequate record-keeping system.
7. Encourage integration with paid staff; the roles of each must be clearly defined and communicated.
8. Recruit for specific jobs as they are developed.
9. Interview and assign volunteers.
10. Ensure the appropriate work is available.
11. Give volunteers orientation.
12. Provide for initial and ongoing training.
13. See that volunteers are adequately supervised.
14. Evaluate both volunteers' work and volunteer administration (to meet changes in the program).
15. Reward volunteers appropriately through recognition.
16. Make the necessary changes in volunteer assignments and/or programs.
17. Review these steps regularly.

The arts manager must make better use of volunteer

groups in order to meet the challenges of managing in the future. The task is both intimidating and exciting, but a vital component of community cultural development and an entrepreneurial use of a valuable human resource.

Policy and procedures manual

To enable the organisation to achieve strategic objectives in human resource management, a manual should be developed. This manual should identify the role and responsibility of the human resource section, or the human resource management strategy of the manager, and should focus on the participation of all employees to implement and apply the policies and procedures outlined in it.

The following contents list is taken from the human resource manual at the Queensland Performing Arts Trust.

Policy and Procedure Documents
 Position Descriptions and Person Specifications
 Recruitment and Selection
 Induction
 Grievance Handling Procedures
 Management of Diminished Performance
 Equal Employment Opportunity
 Sexual Harassment
 HIV/Aids in the Workplace
 Attendance and Leave Entitlements
 Employee Assistance Program
 Smoking in the Workplace
 Freedom of Information and Human Resource Management
 Workers Compensation Administration
 Occupational Rehabilitation
 Study Assistance
 Work Experience

The manual is a document designed to meet the human resource needs of a particular arts organisation and as such should identify policies that are common to management, staffing and the arts and cultural industries, but may also contain specific policies and procedures that the manage-

ment and staff determine reflect the supportive and effective human resource management of that organisation.

Consider including a policy and procedure on the following topics:

- Statement of philosophy (culture of the organisation, basis of work practice)
- Code of ethics (performance and disciplinary)
- Staff development and training
- Communication
- Staff appraisal
- Volunteers
- Customer service.

Once in place the manual of human resource policy and procedure is an invaluable reference for all employees in the arts organisation.

Quality assurance

All strategic and action plans culminate in evaluation, monitoring and reporting mechanisms which provide direct feedback to managers so that changes can be made, if necessary, to further delivery of the arts product or service to the customers. This evaluation and feedback procedure works alongside other measurement devices and performance indicators in action plans to ensure the quality of the arts organisation.

Quality assurance is the result of careful planning, strong leadership and a particular concern for all the customers of the arts organisation. In effect, arts organisations have always been subject to quality assurance: audiences, visitors, peers, critics, sponsors, government funding agencies all provide or require regular reporting and measurement of success. The difficulty lies in defining 'success' or 'quality' or 'excellence' in art. Is the answer in the number of tickets sold or visitors to the exhibition or readers of the book? Is it in the number of or financial amount of grants received? Is it in favourable critical media review? Is it an intangible feeling of success for each individual artist following creation of a work of art? Or is quality assurance a process of management where

projects and tasks are monitored according to time taken, budgets reconciled and clear, concise reports written? Probably all of these have a place in quality assurance, particularly if government performance indicators are used to achieve and measure results.

The Arts Advisory Committee to the Office of Arts and Cultural Development (Arts Queensland) in the Queensland Government selects from a list the performance indicators it considers best to measure the outcome it is seeking from grants it recommends.[16] These indicators span artistic, community benefit, financial, management and board performance outcomes which reflect the general policies of the government, the policies of Arts Queensland, and the accountability requirements of government in the spending of public money.

Artistic
- achievement of stated aims and objectives
- demonstrated benefit of project or program to the development of artform
- evidence of creativity, originality and artistic risk
- demonstrated benefit to artistic and/or professional development of artist/s involved
- demonstrated ability of artist/s or organisation to implement project effectively
- increased employment of Queensland artists
- increased use of Queensland originated material
- evidence that project challenges prevailing practice through exploration and/or experimentation of artform (if appropriate)

Community Benefit
- evidence of strategies to develop access for and increase participation by community in project or program
- evidence of attention to equity concern, with particular reference to women, Aboriginal and Islander people, people of non-English speaking background, people with disabilities, young people, and people in the workplace
- evidence of assistance to development of

professional arts activity in regional Queensland communities
- demonstrated provision of greater access and participation to regional communities through touring activities that incorporate local workshops and development programs
- evidence of networking with local artists or arts organisations to ensure community input into selection of programs and touring schedules

Financial
- evidence of ability to budget with accuracy and exercise responsible financial control of project or program
- increased income from box office, admission charges, workshop fees, sales and/or commission on sales
- improved ratio of organisation's earned to unearned income
- increase in net assets of organisation
- increase in organisation's income from other government sectors and/or non-government support (specifically cash and 'in kind')
- increased income from membership and/or subscriptions
- evidence of sound balance between expenditure on artistic product and administration and other costs

Management
- achievement of stated aims and objectives of project or program
- evidence of long-term planning and policy development undertaken by board/committee and management
- evidence of measures taken by organisation to improve management skills and operational efficiency
- evidence of professional development initiatives for staff and management of organisation
- improvement in publicity material and public relations profile for organisation

- evidence of measures taken to improve occupational health and safety of workplace/s
- evidence of equal employment opportunity initiatives in all areas of operation and management

Board Performance
- evidence of attention to equity concerns (particularly in regard to gender and cultural diversity in selection of board membership)
- evidence of regular attendance of board members at board meetings (at least 60 per cent of scheduled meetings)
- clear separation of functions and membership of board and management of organisation
- proof of recording of declaration/s of board membership (individual membership should be not longer than six years)
- demonstrated range of talent, skill and experience of board members.
- documentation of annual revision of corporate plans
- evidence of regional membership of boards of organisations with State charter

As part of the administration of arts grants programs all Australian governments, commonwealth, state and territory, have performance indicators and accountability measures that are usually more than artistic and financial reports. The grant acceptance process involves a contractual agreement whereby the client agrees to fulfil certain performance indicators. In this way the non-profit arts and cultural sector can maintain the government's quality assurance, but quality in the marketplace is still determined by the personal transaction between audience member or visitor and the art experience. For example, how is the quality of a science museum visit measured? The museum product may be the collection of spiders, a travelling exhibition, or a 'hands-on' self-discovery in physics, for which the quality is in personal measurement. If the visitor came for information on spiders, no doubt that educational experience was of high quality. Without first asking all visitors their expectations, it is diffi-

cult to measure outcomes. Any visitor survey would contain distortions. The museum can measure venue and facility quality; it can measure number of attendees; it can measure research achievements; but as in most cultural organisations, there are limitations in measuring the intangibility of the cultural experience.

Venue management

Venues for presentation of the performing and visual arts may be arts organisations in themselves, such as a regional performing arts centre which presents touring product, entrepreneurs its own product, and provides a rental service to arts and cultural organisations in the community. Venue management is often the responsibility of a gallery or museum director or a performing arts company manager who offers informal performances in rehearsal space associated with the administrative headquarters. Management of place involves attention to design, construction, building maintenance, property laws and insurance, health and safety regulations, bookings and hiring, scheduling and programming, merchandising and crowd management. Many of the people-managing components discussed in this chapter, such as industrial awards, personnel management, customer service, leadership, strategic planning and organisation structures, are also functions of venue management.

The focus of all effective venue management is people: staff and customers. The impact of the venue or facility on the public is the responsibility of the venue, arts centre or art museum manager. With the developing professionalism in the arts and cultural industry it is expected that managers are capable of addressing each of the following areas of venue management and establishing plans and procedures that meet the needs of owners and users.

Design and construction
The arts manager should be a key person in the design and construction team for an arts facility. Planning and consultation with customers, industry competitors, users and the management team will ensure audience and visitor needs, performance or exhibition space requirements, management

issues and cost and resource implications are considered along with site restrictions, government regulations and building requirements.

Building maintenance

The physical cleaning, arrangement of furnishings, repair and maintenance of the equipment and building reflect the organisation's mission and profile to the customers. Guidelines for operation safety, staffing, inventory, repair and storage should be established and routinely reviewed.

Property law and insurance, health and safety regulations

Insurance is necessary as part of an overall risk management plan for a venue. Identification and control of risk requires constant management overview. For example, managers should create a pro-safety workplace culture and environment and thus avoid exposing staff or customers to risk. Public liability and event insurance are available and should be evaluated through management action plans involving training for crisis management and compliance with the regulations for venue standards: Workplace Health and Safety, Codes of Practice, Building Fire Safety regulations, and national Building Codes and Standards. In summary a risk management plan has four components: identify the risks, evaluate the risks, design a risk management program (risk avoidance, risk control, risk financing, insurance) and implement and review.

Booking, hiring, scheduling and programming

Booking an event into a venue should never be considered as an unimportant activity and given to an employee low in the organisational hierarchy. Not only does the bookings manager have to be familiar with venue rates and charges, but has to have a detailed and accurate knowledge of all venue spaces, an understanding of audience and visitor potential requirements, information regarding the financial stability of the client making the booking, the ability to forecast the likely success of the event, the capacity to determine the relationship of one event with another and of competing events, knowledge of the legal implications of bookings, and a public relations manner in the task.

Merchandising

Sales of merchandise can make a considerable contribution to the revenue of the arts centre or venue and can provide a more memorable occasion for patrons and visitors, giving a tangible quality to the intangible arts experience. The arts manager needs to make a full assessment of opportunities for sale and hire items, method and shop.

Crowd management

The actions of the manager and staff in the venue can effect a change in the behaviour of the group of patrons or visitors. Effective crowd management results from a policy, procedure, trained personnel and a preferred outcome where the behaviour of the crowd reflects the culture and behaviour desirable in the venue. Techniques in practice include computerised barcode systems for purchase items and tickets; turnstiles and wristbands to control entry and exit; metal detectors and primary observation to discover undesirable objects; signage and loud hailers to direct crowds; and two-way radios for supervisor communication. Crowd management is in constant practice in an arts venue where demand is high. It should not only be addressed in evacuation circumstances, but embrace the recurring movement of people in and out of venues.

The emphasis in this chapter has been on planning, leadership and people. It began with a series of definitions of the role of the arts manager, and it concludes with another. These comments are from a 1994 address by Michihiro Watanabe, a senior Japanese arts bureaucrat and scholar in cultural economic policy and the education of managers of cultural enterprises. In discussing the role of the cultural administrator, he said:

> . . . the role of arts managers and administrators changes in scope and dimension dramatically. Today, the importance of management personnel in developing cultural programs and in organisations is widely recognised. Only experts with a strong knowledge of both arts and culture and their socio-economic environment can organise creative

activities effectively by bringing together creative talent, audience and capital.

. . . It will be the responsibility of cultural administrators to create fertile conditions for all cultures and mobilise them in furthering arts and cultural development overall.

. . . the economic role of arts administrators will change from running a marginal, generally small-scale industry to running what is one of the largest economic segments of our society . . . they must play a pivotal role in the overall economic development, as leaders in a leading industry, whilst protecting the particular values and mission which are unique to creative activity.

. . . Arts administrators will need to deal with the emergence of 'virtual reality' technology, utilising it to expand the range and depth of creation.

. . . and finally, but not least, arts administrators should endeavour to liberate people from the spiritual poverty that is spreading in many parts of industrialised society.

. . . it is only they who can mobilise the cultural resources within a society and engineer a balanced cultural development which integrates creativity, economy and technology.[17]

— 6 —

Financial management

Successful arts management relies heavily on the effective management of the financial resources of the organisation. Many arts practitioners have in the past reluctantly taken on managerial duties out of necessity, with very little if any financial or business management skills. While financial mismanagement has certainly been one cause of the demise of arts organisations in the past, it cannot be considered in isolation from other management practices.

This chapter outlines basic approaches to financial management practice suitable for arts organisations. Both cash and accrual accounting systems are discussed, the former being used more often by small organisations, and the latter by large ones. The main areas covered are:

- financing non-profit and for-profit organisations
- planning
- structure
- budgeting
- reporting
- funding
- investing
- entrepreneurship.

Non-profit and for-profit financing

A non-profit organisation is designed to recoup any expenses outlaid with an equal amount of income, thus creating a

zero-based budget. Nevertheless, in each of the organisation's projects, the recouping of expenses through income should be considered as a minimum goal. Aiming for a zero balance of income and expenditure may leave the organisation with a short fall; achieving the aim is dependant on the accuracy of forecasted figures in the budget. The creation of some reserves for reinvestment is highly desirable so as to allow for contingencies or for future development of the organisation.

'High' art and art delivered for the 'public good', and 'profit-making' art are not mutually exclusive. In chapter 1 the concept of 'social improvement' or the enlightening and uplifting experience gained from the arts was discussed. While the value of such experiences cannot be quantified in terms of money, the mechanisms which bring them to fruition are completely quantifiable and as such are subject to deliberate choices based on figures. Such choices do not lower the value of the art.

Artforms which are less accessible to the people either by virtue of their esotericism, price or geographic location must still be considered in terms of profitability and marketability once an audience is desired. Commercial art ventures which aim at popularity consider profitability and marketability from the outset. If the mission of a particular company is to produce art which is by coincidence unpopular, that company will have to find more popular forms to subsidise its driving force. This is a common way for arts companies to organise their programs, and can be likened to the research and development departments of large corporations. The risky or new art is experimental and will hopefully lead to some form in the future which contributes to cultural growth. Like the research and development experiments, not all products from this department will in the end be marketable, but they will in some way contribute to the lifeblood of the organisation.

It is the responsibility of management to seek profit and aim at financial self-reliance in order to achieve continuity of existence. In the current climate of reduction of grant money to the arts, it is essential to operate with these aims in mind.

Are different financial management techniques required in the non-profit and for-profit sectors? Certainly there is a different decision-making process as far as programming is concerned: a profit-driven company can base decisions on earnings and expenditure figures, while a company whose foremost aim is to create the kind of art it thinks worthwhile should aim to maximise profit within that sphere.

In the first case profit dictates product, and in the second product restricts profit. Neither of these dictates is entirely true. The profit-driven company has to produce a product of high enough quality to gain and retain market share. In successful commercial companies, that product tends to be one of which employees are proud, and management works towards maintaining that pride by maintaining product quality, employee satisfaction or market position. So there is a subtle point of compromise between profit and product. The non-profit-driven company also has to compromise with its product to ensure that it will at least have an audience, no matter how small. Unless the arts product has an audience it will not exist as a work of art, because it has not expressed itself beyond its creators to others. So again there is a point of compromise often reached in the product-driven company.

In management situations it is as rare for decisions to be made purely on financial figures as it is for them to be made purely on social or cultural prerogatives.

Planning

Effective financial management results from good planning and control. The financial plan of an organisation must form part of the overall business plan and be subject to a formal system of control and checking. The financial plan should have short, medium and long-term goals, with details relating to their implementation. The operational plan sets out daily and monthly practices for short-term goals. The strategic plan addresses the long-term goals, of up to five years ahead or more.

The philosophy at the basis of the financial plan should support the organisation's mission. The choice of what prod-

ucts to develop and what markets to pursue in the long term is dictated by the mission. Budgets should evolve directly from the missions and objectives set at board level. The board is accountable for the financial condition of the organisation. Both board and manager need to plan and review the organisation's finances regularly. Communication must be open between all levels of the organisation to establish good information flow and so contribute to better financial monitoring. Project staff, accountants, artistic directors, designers and production teams all need to be aware of the organisation's finances in order to balance these needs with artistic standards.

While the cash accounting system which is most commonly used by smaller arts organisations does not assume continuity of the business into the next financial year, the strategic plan does. Part of the financial plan should encompass the goal of eventually becoming self-sufficient and stable.

Structure and budgeting

From a management viewpoint, finances can be administered by a number of departments within an organisation. Each can have a degree of independence and responsibility induced by their control of separate budgets.

If the budgets are to be controlled by a completely separate financial department, care must be taken to ensure that communication with other departments remains open. The separate finance department is more common in a large organisation, and runs alongside departments such as marketing and production, all reporting to the general manager then to the board of directors.

Project budgets

Arts organisations and their products often lend themselves to project budgeting, wherein separate events or programs are each organised with separate budgets and financial management is integral to that department.

Advantages of project budgeting are:

- distribution of expense and revenue across the organisation
- distribution of resources across the organisation
- provision of more information for decision making on operation
- support of specific fundraising activities
- ability to evaluate whether the budget is best serving the organisation.

The budget is the framework around which the entire operation is organised. Accounting is identifying, collecting, analysing, recording and summarising business transactions and their effect on business. When preparing a budget, the financial manager should:

- ensure that the accounting system matches the budgeting system
- budget income first so as not to set unattainable goals to meet the expenditure budget
- base budgeting assumptions (for example seat prices and audience attendance) as much as possible on market research or data from the Bureau of Statistics
- budget for the fixed costs of electricity, rent, wages, telephone, advertising, with increases on the previous year's expenditure for each.

Operating Budget = Revenue Budget − Expense Budget

The financial manager should also consider developing a computer database or utilise the services of a specialist to install software and train staff. A variable cost budget is best utilised on a computer spreadsheet where changes can be inserted as they occur. In this way the forecast budget figures are eventually replaced by the actual figures and total costs and income are accordingly adjusted. The development of the budget should involve staff down the line as it represents a part of the planning process based on the organisation's mission.

Control measures should be set in place to keep a check on how the operating budget is being adhered to. The control devices may be weekly or monthly checks by at least

two different people, or a review by a subcommittee of finance at set meetings.

The cash flow budget

After the operating budget is established, it is necessary to see whether or not the organisation will be able to meet cash payments as they arise. Grant money and other income can sometimes boost one month's figures but may not be available to draw at crucial payment times.

Monthly cash income and expenditure should be detailed in a cash flow budget. This assists management in its short-term financial planning and indicates when surpluses and deficits exist. The figures for each month are set out in column form, beginning with cash income details. The total of this income is underlined and followed by details of cash outlays. Total cash outlay is subtracted from total cash income to give the closing balance. The closing balance for one month then becomes the opening balance for the following month, whether it is a positive or a negative amount.

Statements and reports

Information provided by accounting reports should be that which is most useful for decision making. Preparing reports involves the classification and summary of an enormous amount of detail.

Control of the information flow between various departments within an organisation and from those departments to external authorities is a major part of financial management. Financial information should be readily available to board members, public and governmental authorities, patrons and members, and funding bodies.

Reports are required within the organisation (internal reports) and without the organisation (external reports). A financial manager of an arts organisation might be required to make the following reports:

- statutory reports to the Corporate Affairs Commission
- funding authority reports as a condition of grant
- annual reports to government departments
- project/event reports to arts manager

Figure 6.1 Financial management

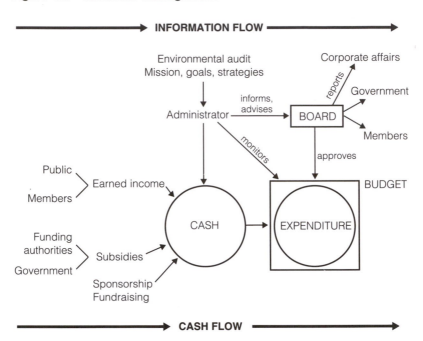

- project manager reports to arts manager
- arts manager reports to board monthly.

The Australia Council publication *The Arts in the Australian Corporate Environment* succinctly outlines the duties of directors in relation to the publication of accounting reports. Its main points are listed here. This reference should be used for further details of particular Sections of the Act.

Corporations Law specifies that a publicly funded arts organisation has certain duties to its stakeholders. These duties include reporting accurately on the organisation's accounts. The directors of a corporation must, under Sections 292 and 293, provide a profit and loss account and balance sheet to all members not less than fourteen days before the annual general meeting. Section 294 specifies that before making the balance sheet and profit and loss account, directors must:

- ensure that action has been taken to write off all known bad debts
- make adequate provisions for doubtful debts
- write down or provide for any current assets, other than bad or doubtful debts, which are unlikely to realise their book values in the ordinary course of business, and
- ensure that accounts contain notes, where any non-current assets are shown at a book value greater than the amount that it would have been reasonable for the corporation to pay for the assets at the end of the financial year (unless the assets are written down), to prevent any misleading overstatement of the value attributed to such non-current assets.

The directors must keep all documentary evidence relating to the accounts for seven years, and must comply with Australian accounting standards in their preparation.

A directors' statement to the effect that there are reasonable grounds to assume that the corporation will be able to pay its debts at the due dates must accompany the reports.

At the end of each financial year, the directors must prepare a report no more than eight weeks before the annual general meeting. The report must include:

- the names of the directors
- the principal activities of the corporation in the course of the financial year and any significant change in the nature of the activities
- the net amount of profit or loss after income tax
- the amount of recommended dividend to be paid
- a review of the operations of the corporation during that year and results of them, with particulars of any significant changes in the affairs of the corporation during that year
- particulars of any matters or circumstances that have arisen since the end of the year that have significantly affected or will affect the affairs of the corporation
- reference to likely developments in the operations of the corporation and the expected results of those operations in future financial years.

This report is to be signed by two of the directors after a resolution to pass it has been made by the directors. If a director fails to take all reasonable steps to comply with the requirements of the Corporations Law in presenting accounts and accounting reports, a penalty of five years imprisonment or $20,000 or both may be enforced.[1]

Reporting on finance involves interpretation and categorisation of figures and preparation of documents which reflect different aspects of activities such as sales, receipts, investments and maintenance. The various reports a manager can employ to illustrate the financial standing of an organisation each provide perspectives of the whole picture.

The major financial statements required of a financial manager of a for-profit organisation are the income statement, retained profits statement, balance sheet and funds statement.

A non-profit organisation will often record only the cash situation and therefore compiles a report of cash receipts and payments, and a statement of cash balances.

Each of these offers a different reflection of the finances of the organisation. Accrual accounting is employed by for-profit organisations because it offers a thorough record of the economic events, wherein profit is the measure of performance. The accrual system records all transactions between the company and external parties, whether they are for cash or credit. Thus the total expenses are deducted from the total revenue to give the net profit figure.

Cash accounting is often employed by a non-profit organisation and records cash receipts and payments only. Instead of an income statement and balance sheet, the reports are cash payments and cash receipts. The difference between the cash received and cash spent amounts to the cash balance available to the organisation. The cash accounting system does not allow for depreciation schedules which in an accrual system allocate the cost of an asset over its predicted lifespan. Purchases such as equipment, furniture, land, or computers, for example, are immediately written off at purchase. The cash surplus left at the end of an income

period is not the same as the net profit figure in an accrual system.

Because assets are not designated a continuing value in the cash accounting system, it can be difficult to make informed decisions about how to manage them efficiently. The detailed financial figures available in the accrual system assist in deciding whether or not to sell or hire out some assets, or how much time and money should be allocated to their maintenance.

By concentrating on the cash flow figures rather than the results of them, an imprecise picture of the organisation's financial status can be developed. Arts managers who work within the confines of the cash accounting system, which is often suitable to a small business, should be aware of its shortcomings. Bad debts, for example, are often not written off, nor are future bad debts anticipated by writing off a set amount in each period. Assets other than cash are not recorded, so that items such as prepaid insurance are not offset as an asset against the current insurance cost. The total cost of projects undertaken or services provided is not measured in this system. On the other hand, the cash system allows management to assess safely what they can afford or spend at any given time. Many non-profit organisations operate on a cash basis but make their financial reports on an accrual basis which then allows for deeper insights into the financial prospects of the organisation.

The cash system is used by government departments. A yearly approved budget details how the cash allocated is to be spent according to the objectives of that department. Reports on expenditure take the form of cash receipts and payments. Any funds left over at the end of the financial year are reverted back to Treasury.

In brief, the financial statements each provide a different view of the organisation in question, as summarised here.

Reports used in accrual accounting

Income statement: Extreme detail of revenue and expense figures are not legally required in annual reports. The basic information on the income statement is expressed in the equation

$$Profit = Revenue - Expenses$$

Retained profits statement: The net profit arrived at from the income statement is then apportioned to retained profits and appropriations (or appropriated profit). In the case of a public company, shareholders are issued with a dividend from the retained profits account, of an amount recommended by directors and agreed upon at the annual meeting. Some of the retained profits may also go to general reserve, indicating the amount which is not to be distributed to shareholders, although it can be transferred if necessary into the retained profits account.

Retained profits (this year) = Retained profits (last year) + Net profit (this year) − Appropriations (dividends + general reserve)

Balance sheet: This shows the relationship between assets, owner's equity, and liabilities.

Assets should be able to cover liabilities at any given time, so the balance sheet makes a distinction between current or liquid assets (assets that can be sold within a year such as merchandise) and non-current assets such as land and buildings (if the intention is not to sell them within the current period).

Similarly, liabilities are divided between current liabilities (taxes and creditors to be paid within the current period) and non-current liabilities (for example mortgages, debentures).

Owner's equity is the amount of capital the owners have invested in the business after liabilities have been deducted. Profit is measured by the increase in owner's equity.

This information can then form the equations which reveal how readily a company can meet its short-term debts. The following equation can be read from information on the balance sheet:

$$Assets = Liabilities + Owner's\ equity$$
or
$$Owner's\ equity = Assets - Liabilities$$

Funds statements: These statements reveal both the sources of funds and the uses of funds. The changes that may occur

between one balance sheet and the next can be explained in this statement. The information is the same as that contained in the balance sheet and income statement, but it is presented differently to reveal such circumstances as how particular investments were financed; how shortages of cash can occur during record profit periods; or how dividends were paid when a loss was incurred. In short, the movement of funds is closely depicted in the funds statement.

Sources of funds = *Uses of funds*

Reports used in cash accounting

Cash receipts and payments: information in the cash receipts journal and cash payments journal is posted from a cheque book into the appropriate columns for double entry book-keeping. Debit entries balance with credit entries, debit indicating to which accounts the funds are deposited, and credit indicating to which accounts they are credited. The chart of accounts assigns code numbers to each account in the journal. The figures in these books of original entry are then totalled in separate columns in the ledger, or book of secondary entry. The same procedure can be reflected in a computer program which will automatically calculate totals.

Statement of cash balances: The ledger provides the information for this statement. A trial balance should be prepared before the final statement so that new information and adjusting entries can be accommodated. A bank reconciliation should be prepared at the end of each month to reconcile the bank records with the cash journal records. In this way unpresented cheques and deposits are added to the cash book total, and payments are subtracted to reach the cash at bank figure.

The cash accounting system requires sensible book-keeping practices. All payments should be made by countersigned cheques, and all income received should be detailed on a numbered receipt. The board should approve all expenditure, unless a specific arrangement has been made for board approval of expenditure up to a limited amount. Payment authority forms signed by the two signatories should accompany withdrawals by cheque. All cheques should be crossed

with the words 'not negotiable', and blank cheques should never be signed.

Petty cash slips should be filled each time money is taken out of petty cash and checked against the total remaining in petty cash on a daily or weekly basis.

Financial records should be stored in a secure, fireproof place.

Funding, investing and entrepreneurship

The Australian Bureau of Statistics has developed data relating to the National Culture-Leisure Statistical Framework. Government funding of culture is provided by the three levels of government—federal, state/territory and local—to varying degrees according to the activity in question. On a total basis, however, the federal government funds nearly 50 per cent of the whole, the state/territory governments roughly 34 per cent and the local governments 18 per cent.

The statistical categories for cultural funding are very broad and are recorded below in order of funding size [as at AC Report on 1992–93 figures]:

- radio and television broadcasting
- libraries and archives
- national parks and wildlife services
- museums
- other cultural heritage
- film and video production
- performing arts venues and arts centres
- public halls and civic centres
- art galleries
- other performing arts
- administration of culture
- community cultural activities
- Aboriginal and Torres Strait Islander cultural activities
- music
- other visual arts/crafts and photography
- other literature and publishing
- other culture not elsewhere classified.

Funding varies dramatically according to the type of

cultural activity and the level of government involved. Local governments, for example, are important funding sources for libraries, while the federal government plays a major role in the funding of broadcasting. States/territories have a significant input into the funding of cultural facilities, museums and art galleries.

Arts managers who wish to apply to the government for financial assistance should be familiar with the trends in funding and the different approaches of the three levels of government. Knowledge of the types of assistance available and the criteria set out by the funding body are essential.

Overall the trend towards less government arts funding is increasing. Managers must look for new methods to retain their organisation's stability in the marketplace. The emphasis on multimedia funding in recent federal arts policy documents illustrates how easily arts funding can be subsumed by other industries' needs while simultaneously increasing the employment rate of artists.

Project funding, or funding of a particular event or exhibition, is often used by smaller arts organisations. Funding is provided by government or sponsors to achieve a planned program. Reports to the funding body, including financial details of revenue and expenditure, are made at the end of the project. Organisations which rely solely on project grants find it difficult to build up a strong subscriber base.

Recurrent funding, or funding of the organisation from one year to the next, provides more financial security for the organisation. Increased financial security allows for increased ability to plan, presell, employ appropriate staff and secure venues.

Multi-year funding by governments for core infrastructure of arts organisations has some advantages over recurrent yearly grants and project funding. The obvious advantage is being locked into a possible three year grant. Funding agreements between government and organisations can detail management procedures and objectives which are then regularly reviewed. This can reduce the administrative costs of annual review processes and encourage accountability of management procedures.

Flexible funding

Flexible funding schemes are encouraging entrepreneurship amongst artists and within organisations. Such incentive schemes of assistance enable the applicant to set the terms of the contract. The artist or arts organisation in effect borrows money from an arts funding agency to produce a work of art or to fund a project. The loan is repaid in part or full at some stage after the completion of the project. The agency may not specify time limits for repayment or amounts of repayment. Such details are specified by the artist or arts organisation in individual contracts and subject to peer assessment. Repayments or profits form a fund which is then recycled into other projects which might not have otherwise received funding from the agency.

For example, the different Funds of the Australia Council expound different policies, programs and criteria to which the applicant is expected to conform. Beyond these broad constraints, investment schemes allow the applicant to set the guidelines for Council support and participation.

The agreement reached between artist and agency may take the form of a loan agreement, a contract for specific performance, a partnership or joint venture arrangement, or an equity investment. In some cases, the applicant may not be an artist or an arts organisation, but may be the commercial production house which an artist or company uses to exhibit or publish work. Publishing companies and educational organisations may in this way become applicants for investment schemes and expose artists' work through commercial channels.

These schemes are most valuable for organisations which can predict sales for their product, therefore guaranteeing a return by a particular date for the agency.

Investment proposals should include enough information for the assessment committee to make its decision, including:

- name
- contact details
- detailed project outline
- detailed project budget (including all assumptions regarding income to be earned)

- cash flow projection
- proposed rate of return and time frame over which the project will run
- curriculum vitae of key personnel
- details of any other interests involved in the proposal
- an outline of the contractual relationship between applicant and agency
- supporting documentation as per existing artform requirements.

A proposal such as this requires sound financial planning and management. Applicants who lack these skills should seek professional assistance in documentation and planning. Flexible investment schemes provide a basis for good business initiative and planning, and a model for other funding bodies to adapt to their specific environments. They provide artists, particularly visual artists and craftworkers, with opportunities which might otherwise be unfulfilled, and so increase the artistic standards and vitality of the community. The entrepreneurial spirit encouraged by such schemes can enrich the arts marketplace through improving financial planning skills of managers.

Resource sharing

Resource sharing is a simple means for artists and arts organisations to reach a wider audience and cut costs. A market consortium made up of a number of different organisations can offer combined subscription packages, or share a database, publicity expenses or venue.

Some companies which might find it difficult to provide a yearly subscription discount because of the small number of events they present throughout the year, can link with other organisations to offer discount and membership deals and subscriptions. The prodigious benefits of presold tickets and sponsorship which go hand in hand with subscription packages can then be employed. Other benefits such as eligibility for grants for improvement of management or the provision of training seminars may also derive from networking arrangements.

Criteria for joining a group subscription scheme should be carefully planned. Companies accepted into the network

should meet the broad criteria and be able to provide details of their program content, dates of events and prices of events. A company may wish to include only one or two of its events in the yearly subscription package, and aim other events at different market segments. In this way, more risky or experimental events may be arranged on a flexible basis, with decisions on dates, venues or prices deferred.

Other criteria for joining a scheme might include product matching. A subscription package should offer variety but keep within a product range which has appeal to defined market segments. To mix traditional opera in an expensive venue with experimental circus theatre in a disused warehouse may be a mistake. Administrators of joint subscription packages need to work within the confines of a mission statement about aims and product decided on by the participating companies.

Evidence of detailed financial planning should be provided by participants. A budget should then be made by the group network to determine ticket prices and costs of venue hire, administration and printing. Participants with different areas of expertise or different contacts may decide to divide tasks accordingly.

Part of the mission of such a co-operative might include subsidising one member which would not otherwise receive operational funding, or which, owing to its newness, has no management infrastructure. A new company, or a company operating on minimal project funding rather than under the assurance of recurrent funding, may be subsidised by the more financially established organisations. Schemes may be set up on a fluid basis whereby the companies involved can move in and out of the scheme yearly. This flexibility increases networking and resource sharing opportunities, and encourages co-operation within the arts community.

Evaluation of the success of the scheme must be based on both quality and financial considerations. An important result of such schemes might be the mutual assistance and support they encourage amongst the arts community and in particular amongst the scheme participants.[2] Financial managers can evaluate the advantages of revenue from ticket sales against costs to their organisation in areas such as labour,

printing and advertising. If the result shows a negligible financial improvement on previous income, this must be weighed against issues of the quality of the art program, increased opportunities for development of management skills and sponsorship agreements, increased lobbying ability to governments, industry, media and public, and increased opportunities for networking and public exposure. In the case of a consortium of small companies whose work would be otherwise seen as infrequent, random events, measurements of quality may take into account the creation of a calendar of vital and contemporary events co-ordinated to ensure regular events of high quality. The regularity and quality of the events would supposedly encourage a change in audience habits and develop regular users. Financial managers must then decide whether or not to consider the benefits of these as a future investment, in which case lack of substantial immediate monetary gain is a less important part of the equation.

Individual artists may also use the power of numbers by sharing a workspace and its accompanying costs of rent, equipment, and business loan repayments. Case study two, 'Arts and crafts industry development', outlines such a scheme and illustrates resulting synergies between local council and community. Again workspace sharing schemes must be arranged with clear guidelines for all parties to agree on, and should be accompanied by contracts relating to financial and legal obligations of the participants.

Employment schemes

Artists may be able to cut costs and improve financial planning through the use of a service organisation. Services offered by such alliances might include group purchasing power, health insurance plans, accounting services, financial training and education.

Successful employment schemes have also been set up by some alliances to act as artists' agents in procuring employment. Artist employment services can provide private or government bodies who wish to employ artists for projects with advice on the choice of artists, budgeting for art projects and developing appropriate briefs for the artist.

The financial plan of an organisation should take into account the assets represented by both staff and venue. Money and time spent on maintenance of buildings and promotion of staff stability involves liaison across various departments or between a number of individuals. Financial managers must ensure that these 'assets' are being used efficiently and to their maximum capacity for longevity.

Some assets of the organisation may be used on a barter or lease basis by other organisations, and the financial planner should be aware of what the organisation has to offer to others as well as what it seeks from others.

Competitive tendering
Competitive tendering is becoming increasingly common as a means of forming contractual arrangements between governmental bodies and artists. Arts projects which call for tenders might include development of public spaces or buildings, management of arts centres, establishment of artform groups with a program of events, festival administration, arts policy planning and documentation for specified groups or areas, commissions of monuments or artworks, or the development of strategic plans which combine art with education, health or welfare facilities. Some of these tenders may call for long-term service agreements whereby the arts company can assure the community of a particular service over a specified period.

The individual artist or arts organisation who tenders for a particular job must address the criteria set out by the commissioning body. Detailed financial planning will be necessary, and tenderers should clearly understand the corporate objectives of the authority funding the project and apply their own organisation's objectives and programs accordingly. Completing tender documents is a time-consuming task for arts managers, and allows them to review their work closely. It is important that consultations with the funding authority have been thorough so that time is not wasted on pursuing the wrong objectives.

The increasing instances of competitive tendering or incentive funding are consistent with the recognition amongst local governments in particular of their role in

enhancing the quality of life for local residents. Local governments are also becoming increasingly interested in attracting tourists and regenerating inner city areas. Local governments can specify particular arts projects for tender which enhance these specific objectives of community and economic development.

This form of funding tends to emphasise the function of art as an economic catalyst, or a tool for community development.[3] The pragmatic and quantifiable results of the projects which arise from such funding are likely to attract support from the business community. A number of other local departments may also perceive the benefits of the arts to their sphere and may offer support through programs relating to leisure, education, tourism and social services.

The tender should outline criteria for monitoring of performance of service agreements or for evaluation of completed projects. Criteria for this evaluation will include measurement of financial gain. Other financial constraints may include a bond to a percentage amount of the total contract value, or a parent company guarantee to the value of the tenderer's liabilities under contract.

Documentation and declarations relating to the business status of the applicant are a usual requirement. These can include the name of the person in the organisation responsible for financial matters, statements declaring any previous history of bankruptcy or criminal offences, statements which preclude possibilities of nepotism with council or governing bodies, declarations negating tax evasion, references from bankers, and evidence of previous contractual arrangements and liquidations.

Many tenders will include audited accounts of the organisation for the last three years including balance sheets, profit and loss accounts, full notes to the accounts, director's report, auditor's report, statement of turnover in relation to service/supply/works to be provided in this contract, confirmation that the organisation is still operating, and the contract termination history of the organisation. The organisation's insurer, policy number, employers' liability cover, public liability, health and safety record, health and safety policies, employer training programs and quality assur-

ance policies may also be required. Evidence of technical capability of the organisation to provide services and supply the products specified in the tender may also be required.

The detailed documentation required of tenders demands exact record keeping, detailed knowledge of the organisation's financial status, a skilled overview of the financial capacity of the organisation currently and in the future, and many hours of preparation. The financial manager must work with and across the departments of the organisation in order to faithfully record its financial status.

The entrepreneurial financial schemes mentioned here each involve the arts and financial manager in addressing and responding to community needs. Flexible funding, resource sharing and competitive tendering are each capable of creating stronger working alliances amongst arts organisations and between arts organisations and governments.

Re-defining spaces: once a state art gallery and museum, this building is now used by a variety of community and youth arts groups.

SECTION 4

The global perspective

Globalisation, internationalisation, superculture and world culture all suggest an homogenising of national cultures unforseen in the early twentieth century. Increased international travel, trade, exchanges and agreements between governments, combined with instant communication made available through computer and satellite technology have assisted in the import and export of the arts. Artists speak an international language but at the same time retain a sense of their national identity. The international arts manager is an interpreter of cultural policies and responds to changing trends in international arts markets, cultural tourism, community ideals and the development of place for arts participation.

—— Case study 3 ——

The Arts 2000 initiative

The development of a document for international recognition of a city's architecture and cultural heritage.

In 1991, the Arts Council of England (formerly Great Britain) established Awards where, through a bidding process, any town, city or region in the United Kingdom bid to host a twelve month celebration of nominated art forms in the years leading up to the millennium. The years were as follows:

- 1992 Year of Music (Birmingham)
- 1993 Year of Dance (East Midlands Region)
- 1994 Year of Drama (Manchester)
- 1995 Year of Literature (Swansea)
- 1996 Year of Visual Arts (Northern Arts Region)
- 1997 Year of Photography and Electronic Media (Yorkshire and Humberside Arts Region)
- 1998 Year of Opera and Music Theatre (Eastern Arts Region)
- 1999 Year of Architecture and Design

The initiative was planned to culminate in the year 2000 when the whole country celebrates the Year of the Artist. The much sought-after cash prize for the first five years was £250,000 increased to £400,000 for the celebrations from 1997.

The bidding process was in two stages with judges nominated from the Arts Council and professionals in the section shortlisting two or three initial bids each time. These proposals were fully developed into detailed business plans for hosting the celebration. The bidders also had to demonstrate that their city, town or region could match the financial award being offered by the Arts Council.

The inclusion of Architecture and Design as artforms to be celebrated in this initiative reflected a recent move by the Arts

Council, largely through the personal interest and support of its then chair Lord Palumbo, to create an Architecture Unit within the Visual Arts Department of the Council. He and many others (in particular architects) were concerned with the place of design in the built environment in the UK. There are many reasons for this of which the following are just a selection.

During the 1980s there was a seeming inability for many commissioners of buildings, particularly in the public sector, to create innovative new work and or solutions to changing public and environmental needs. There was a view expressed by some highly public figures, including Prince Charles, that the only good architecture was that created in the past, or at least before the modern movement. Many of the internationally recognised British architects were creating most of their buildings outside the United Kingdom. The financial constraints of the period had led to a bottom line approach and a situation where 'design' was perceived as a costly add on.

The issue of art and design in the built environment moved onto the agenda of the arts funding bodies and local authorities towards the end of the decade with the growth of the public art movement, the recognition of the role of artists in the economic regeneration of post-industrial areas and the development of Percent for Art policies.[1]

The challenge was to take this one step further to bring the design by architects of buildings into the national psyche and understanding in time for the buildings that would be created in the nineties for the twenty-first century.

The Liverpool bid

The city of Liverpool in northwest England has a population of 450,000 with a hinterland of 1.5 million people. It is internationally known for its culture (from the Beatles to Willy Russell), its sport through two premier soccer teams Liverpool and Everton, and unfortunately more recently as a prime example of the physical and social problems caused by European post-industrial inner city decline.

Despite its problems, the city had remained culturally vibrant with many young people viewing an involvement in cultural activity, in particular theatre and contemporary music, as a way out of their economic situation. In addition the authorities within the city recognised that the rich Georgian and Victorian heritage could be used in regeneration plans. For example, in the mid 1980s there

was the award-winning restoration of the central dock area which included the creation of a northern home for the Tate Gallery (conversion by James Stirling and Michael Wilford) and a National Maritime Museum.

Liverpool has a unique development agency, the Liverpool Design Initiative, promoting the work and assisting with the needs of the local design community. It has a nationally recognised visual arts festival, Visionfest, promoting the work of architects and those artists working in the built environment.

Through the enthusiasm of the city council's Chief Planning Officer, and encouragement from Lord Palumbo and the Arts Council, the city council agreed to finance an initial bid by the city to host the Year of Architecture and Design in 1999. Locally based consultants Positive Solutions were employed to undertake a consultation process with community representatives and potential partners in the bid and to write and produce the initial bid document for the Council. This process was launched with a buffet and brainstorm of over two hundred community leaders and politicians in one of Liverpool's architectural masterpieces, the finest neoclassical building in Britain, St George's Hall.

The Arts Council was seeking a city that could host a program of activity which increased public understanding and appreciation of architecture and design. That celebration was to have local, national and, where possible, international impact. Liverpool's initial bid was based on the ideas of enhancing the quality of the city's architecture and design, providing mechanisms and opportunities for changing the nature of public involvement with the processes of creating the built environment, and promoting the wealth of the city's architectural heritage. It included an initial financing and marketing plan with ideas for events and activity for 1999 and the preceding years.

The bid was submitted in September 1993 along with those from eighteen other towns, cities and regions in the country. In December the Arts Council announced that three bids had been shortlisted, those from Edinburgh, Glasgow and Liverpool.

To be shortlisted for what had become the most prestigious of the Arts 2000 awards was a great achievement for the City of Liverpool and encouraged support from the private sector and others for the second stage of the bid process. This included the appointment of a full-time co-ordinator for the bid, local architect Sue Carmichael.

The second stage of the process included continued commu-

nity consultation; the commissioning of two feasibility studies, one on the creation of an Architecture Centre for Liverpool and the other for a city-wide public art strategy; fundraising and media campaign; and the production of a second stage bid for which Positive Solutions were once again contracted.

A shadow board for a proposed Architecture and Design Trust was established, chaired by the Vice Chancellor of the Liverpool John Moores University, with office and administrative support provided by the city council. The city's vision and principle objectives in hosting this event were developed through continued consultation with many individuals and groups in the city. Furthermore partnerships were sought with other cities in the UK, such as neighbouring Chester, with national agencies and with cities and organisations in Europe.

Liverpool's vision was to establish the city as a centre for debate and a model for change in public involvement and appreciation of architecture and design.

The vision was centred on people: the general public whose lives are affected by the environment in which they live and the professionals involved in the process of designing and creating that environment. It demanded a commitment to quality, accessibility, education and innovation in all matters concerning architecture and design in the city. The achievement of that vision had planned outcomes in a range of economic, cultural and social benefits both for the citizens of Liverpool and as a contribution to the overall artistic and cultural well-being of the nation.

The bid involved five years of preparatory events and activity leading up to 1999 which included:

- developing strategies within the planning authority, namely the city council which would ensure design quality, including the creation of architectural competitions and a design quality panel
- building an Architecture Centre
- a formal and informal educational program for all ages
- a community development strategy
- the commissioning of research and publications.

The Year itself was to be divided into four seasons of celebration, each exploring a different aspect of design in the built environment. For example, winter would focus on interiors and spring on landscaping and open spaces. The events proposed included exhibitions, mini festivals, tours, performances, conferen-

ces on themes around the issues of twenty-first century cities, cultural identity, connections, pioneers and new technology.

A detailed business plan was developed which demonstrated that £12 million would be spent on the event over a five year period with support being attracted from a range of sources.

The bid was submitted in June 1995 and the judging panel subsequently visited the city in October where they were taken through the detail of the bid, including a presentation of the document and ideas on CD-ROM and visits to some of the city's architectural landmarks.

The result

At a ceremony held at the Royal Academy of Arts in London in November leading British architect Sir Richard Rogers (who had recently been appointed as Vice Chair of the Arts Council of England) announced Glasgow as the winning city.

Naturally there was considerable disappointment in the Liverpool 'camp' and not just amongst those who had been close to the bidding process. Through the use of an extensive consultation process and with the support of the media in the northwest, many individuals were aware of the city's bid and took pride in Liverpool's architectural heritage being used to promote the city in this way. There was also a strong feeling that maybe it was Liverpool's turn in some way to win such an accolade. Glasgow had been the European City of Culture in 1990, which had a remarkable cultural and economic impact on the city. To many this in itself had placed Glasgow in a better position to win the Award for 1999.

The pros and cons of the exercise

In any competition there have to be losers. It was clear immediately that impetus would be lost in terms of developing many of the ideas proposed in the bid. Other issues on the city's agenda began to assume more importance. The Trust that had been established comprised worthy and experienced but very busy people. There was a willingness but no real infrastructure in place to develop the objectives. But the city had gained considerably from the exercise.

At a national level Liverpool had been presented in the national press during the two years of the bidding process in a positive light. It had been reviewed for its culture, its heritage, its plans for the future. A local news journalist won a prestigious national architectural award for a series of articles on Liverpool's buildings. All helped to change the city's image for potential investors and future tourists and residents.

The City of Liverpool as represented by the Local Authority had demonstrated its ability to form partnerships between all sectors to work for the benefit of the city and most importantly for some, it was a cultural aspect of the city which provided the focus for this to happen. To many working in the arts community in the city this was a major step forward in demonstrating the importance of cultural activity to the future economic and social well-being of Liverpool.

The Architecture and Design Trust was officially constituted and a post of co-ordinator advertised. The principal role of the Trust is to develop some of the projects proposed in the bid, in particular, the development of an Architecture Centre.

As many of the ideas proposed were from existing organisations some will nevertheless happen, although not with the same level of resources.

A feasibility study into the community development strategy proposed as part of the bid was funded by the city council and became a case study for a larger research project into community cultural identity being undertaken by the Council of Europe.

The bid accelerated a process that was beginning to happen in the city, of all artists and creative workers involved in the built environment coming together. Rather ironically the University of Liverpool's School of Architecture, the first in the country and celebrating its centenary in 1995, once trained both architects and artists together. Already further architecture and design exhibitions are planned.

Conclusion

This case represents an international development for the role of the arts manager. Liverpool's bid to be the chosen city in the United Kingdom celebrating the 1999 Year of Architecture and Design brings together the strength of cultural heritage and the contemporary yearning for a new sense of cultural identity. The case also explores the human and financial resources required to develop a major competitive tender action. Events such as the series for the Arts 2000 Initiative by the Arts Council of England focus attention on the arts, on local community identity and on national identity in an international community. Arts managers beyond 2000 will clearly function in an international environment.

Case study questions

The following questions on this case study are designed to challenge the international vision of arts managers:

1. Select a major city in your state, nation or region and outline its strengths, qualities and potential to be developed as a city representing an art form or cultural sector of this nation to the world.
2. Develop the mission, goals and strategic objectives for Liverpool's Architecture Centre.
3. Outline the methodology to be used in a feasibility study for a community cultural development project, or the cultural mapping/cultural planning/cultural assessment of a community in preparation for a cultural development strategy.
4. What factors would influence arts and cultural policy makers in Australia to establish a set of ten year awards for Australian towns, cities or regions to celebrate nominated art forms?
5. Compare the ten year award process in this case to other funding strategies for arts and cultural development.

7

Arts management and international influences

Arts management in the global environment provides another contact for the skilled practice of marketing, financial management, media communication, managing people and place, ethical behaviour and legal responsibilities. The central issues in this chapter are the quest for identity, the growing importance of sense of place in the cultural development of communities and the powerful influence of global encounters for the arts through import and export enterprise. Cultural and economic policy initiatives, cultural tourism, festivals, events, foreign policy and international cultural exchanges have enabled Australians to explore relationships with the arts and arts audiences overseas in an attempt to define Australia's national identity and place in the world.

Diagrammatically, the arts management core reaches out from the organisation to the community, the nation and the global environment. If the organisation's management has not embraced the mission and its human and financial resourcing requirements, the organisation cannot establish successful marketing, media and legal relationships with its community. If the community is burdened by questions of policy, sustainable industry development and cultural identity, it will find difficulty in forming a global reputation through a foreign policy for the arts, through cultural tourism and through national economic stability.

Arts management in the future, though founded on the basic knowledge and skills explained in this text, will

Figure 7.1 Arts management and its environments

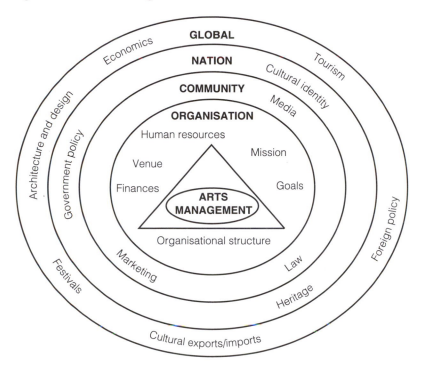

undergo constant change as relationships with communities, governments, sponsors and businesses reflect the changing economic, social and political environments. This is the challenge of dynamic arts management.

Arts policy in practice

The management tools of policy making and planning construct a framework in which the arts manager can operate with confidence and assertiveness. Policies include those within the organisation for functions such as recruitment, conduct, use of equipment, programming, training and merchandising, and those external to the organisation as devised by local, state and federal governments to address issues such as social justice, industry development or institutional development. Cultural policy which results from a cultural assessment of the region identifying key issues and priorities,

and setting goals and courses of action may be formed at all levels of government. In this chapter arts and cultural policy is examined through the policy formation process; links to economic, social and foreign policy; an analysis of *Creative Nation*, the Commonwealth government's 1994 cultural policy statement; and Asian cultural policies.

By definition a policy statement is a set of guidelines for action which are based on a range of inputs to ensure a particular outcome. Policy is informed by an ideology and particular consultation. Legislative, economic, financial and social factors impact on the development of policy. *Creative Nation* is described as owing much to the work of 'a panel of eminent Australians'[1] who were appointed in 1992 to advise the government on the formulation of this 'long overdue'[2] policy. The factors which informed this policy are economic statistics and multipliers for culture related industries, surveys and reports such as those on public and corporate attitudes to the arts and the status of artists produced by the Australia Council, the potential role of culture in achieving 'identity' for a republic, the impetus created by new technology, social justice issues including equity for Aboriginal and Islander people and ethnic groups, the need to review the role of the Australia Council, trade and economic links with Asia, diminishing government funds for the arts, promotion of private and corporate investment in the arts, and regular community consultation.

From such influences, policy makers, whether government bureaucrats, 'eminent citizens', board members or community leaders, determine goals and strategies to achieve the desired outcomes. Successful policy is owned by the community as well as by government. It requires a transitional period of application, particularly if the policy has been developed to correct a problem or change direction. As with all strategic plans, a policy statement should be monitored and evaluated according to its objectives, usually through performance indicators. These may be quantitative or qualitative, or as outputs and outcomes. Policy is always challenged and should therefore be designed with well-defined performance indicators to avoid compromise and withstand scrutiny. *Creative Nation* will be evaluated on the

achievement of its 67 objectives, but it will not be an evaluation of government performance: it will be an evaluation at the management level of arts and cultural organisations.

At the end of the four year funding period provided for in the policy statement, the policy's achievement will be measured in the community by qualitative and quantitative data on, for example, the number of schools using CD Rom technology or participating in Musica Viva tours; or the number of organisations sustaining the industry through partnerships with business, corporations and government departments; or the performance of those organisations gathered into the Major Organisations Board of the Australia Council; or the number of export and international exchange tours by cultural organisations; or the quality and employability of graduates from the National Institute for Indigenous Performing Arts and the National Academy of Music initiatives; or the number of Co-operative Multimedia Centres; or the increasing investment by private philanthropists in the arts.

All this implies that policy succeeds if those for whom it is intended take action and put the policy into practice. The government that defines the policy may reap the reward of attribution, particularly if the policy results in more effectively resourced strategies, but it is arts managers who facilitate delivery.

The inherent danger in the nexus between policy and funding is that government funding may become the means to an end. The arts manager may pursue funds at the expense of integrity; or to demonstrate support for a political ideology; or to cling to a budget in the hope of grant renewal; or to praise and practise government policy in order to survive declining subvention. Alternatively, the arts manager could act as lobbyist and advocate informing government of community needs and aim to balance leadership, entrepreneurship and vision with the pursuit of investment in and support for shared goals.

The arts and cultural industries are in dynamic mode: change is a part of everyday practice. The changes that occurred in the arts and cultural industry in Australia from 1990 to 1995 were momentous. Since 1968 when The Aus-

tralian Council for the Arts was established, artists, arts managers and arts bureaucrats have contented themselves with the demanding and fulfilling task of the development of excellence in Australian art from creation to presentation, and with the responsibility of ensuring access and participation for all. The arts manager in the 1990s practises in a highly competitive and complex environment in which there is a surge of trained talent from art schools and arts administration courses; the emergence of Aboriginal and Torres Strait Islander artists and companies; government-assisted regional touring and funding; communities craving cultural identity and development; cultural tourism where the arts expose the heritage and contemporary issues of our society; export of the arts and culture in initiatives like those of the Grin and Tonic Theatre Troupe taking Shakespeare to Singapore's secondary schools in an entrepreneurial small business venture; the import of major blockbuster musicals and art exhibitions; market-research-based artistic decision making; marketing consortia; sponsorship alliances; peer assessment; triennial funding; strategic planning; multi-government department support for the arts; and most particularly the elevation in status of arts and cultural development in government planning and policy in response to economic impact studies and statistics that creates a rationale for investment that is more than 'welfare' and the 'public good'.

This change has been captured in *Creative Nation*.

> There has probably never been a better time than the present to reassess our national cultural policy . . . At every level of society, Australians are engaged in cultural activities that are helping to reinvent the national identity, and most Australians would agree on the need to enhance and enrich our culture. To achieve this cultural policy must enter the mainstream of federal policy-making.[3]

The debate that followed the policy release created its advocacy. Diverse communities all over Australia in the arts, heritage, technology, education, business, government, tourism, industry, indigenous and ethnic groups moved rapidly to translate the policy into implications, action and funds.

Creative Nation clearly identified a shift in cultural policy from supply to demand, that is, a shift in emphasis from funding arts development to funding the creation of markets for the arts. It is a very outwardly focussed statement that expresses a concern for national identity, but also declares the need 'to deploy an increasing amount of . . . resources in areas of audience development, linkages with broadcasting technologies, marketing and sponsorship stimulation and international export development'.[4]

This policy may well be viewed as a political statement: the use of arts and cultural activity to create a national identity and an image for an Australian republic in 2001; or to create wealth and add value as an economic policy; or to promote trade and business for Australia in Asia.

Culture is explained in the policy as concerning 'identity—the identity of a nation, communities and individuals' and therefore also concerning 'self-expression and creativity'.[5] In this connotation the reader is shown how national identity will nurture culture. However, community artists and managers and cultural planners working in the community affirm that it is equally possible for cultural identity to be created at grassroots level. It does not have to be handed down as federal government policy. Through 'a sense of place' and 'cultural packages' a community can define itself: its heritage, achievements, symbols, language, attitudes, beliefs, rituals and relationships. Art may be the symbol; literature and song may be the language of communication; music and theatre may translate the ritual; architecture may display the heritage and achievements. This is so for a community, for a region, for a nation. The appeal for Australians to embrace a national identity may be cause for concern if the motivation rests on an economic and political base. International forays into global or regional encounters are easily politicised. There is a temptation to become competitive: to compare identities, cultural icons, cultural policies and practice, achievements in art, 'national treasures', and even nations themselves.

While internationalisation involves reaching out to other nations and exchanging ideas and content to deepen understanding, globalisation signifies seeing oneself and one's

nation as part of the global community, not separate, not individual, not representing an identity to be showcased for acceptance. The dangers of globalisation lie in homogeneity, of suppressing an identity for the good of the whole. The values of globalisation lie in the departure from egocentric practices and the vision and realisation of goals that are accepted in all regions. Every nation on the globe contains culturally diverse communities. As populations move, internationalism develops. As populations settle, nations address multiculturalism.

Cultural policy in Asia

Social, cultural and economic factors influence policy making. Since Australians have recognised and valued their demographic and cultural diversity, a policy for multiculturalism has developed. *Creative Nation* recognised this, and placed emphasis on promoting the great diversity of cultures, particularly to Asia. This represents a shift away from historical European cultural traditions to a dramatically diverse social and cultural relationship deepened by the inevitable economic dependencies in the Asian region. Australia's largest markets are in Asia. The Asia Pacific Economic Cooperation (APEC) leaders have openly supported social, educational and cultural links as crucial to the development of a genuine Asia Pacific community. Australian arts managers are being encouraged to follow the government's trade and economic links with the Asia Pacific region. The government minister responsible for this area told a conference of arts administrators in 1994 that 'it is our responsibility to make sure that our neighbours understand what it means to be an Australian and that we are a competitive, energetic and diverse nation'.[6]

Arts policy has always been influenced by other government activities and the elevation of cultural policy on Australia's political agenda clearly relates to economic strategies in Asia. Trade, business, tourism and education are key issues in Australia's growing Asian market. Cultural activity is at the core of everyday life and business practice in Asian countries. Entrepreneurial Australian arts managers now include cul-

tural links with countries in the Asian region as a priority in their strategic planning for the next three years.

In order to facilitate this cultural exchange, arts managers must develop greater understanding of the cultural infrastructure in Asian countries. Media policy, marketing and promotion strategies, public funding, legislation, community lifestyle, arts education and government priorities for development and internationalisation vary greatly from the western model in Europe and the United States of America, and from one country to another in Asia. The particular government ministry responsible for culture exercises considerable influence. For example, in Indonesia, Thailand and the Philippines where culture is incorporated with education, funding priorities always focus on education. Culture is minimised in funding, staffing and development. Indonesia has no national gallery, and although architectural plans have existed for some years, the establishment of a national gallery with all the necessary building or renovation, air-conditioning, design of display and studio space, staffing, collection, preservation, exhibition and promotion, will continue to be the dream of a small group of committed staff until the government or a particularly wealthy patron invests in the project. Most visual art in Indonesia is produced for sale and galleries exhibit solely for this purpose. Touring exhibitions are uncommon. The National Museum in Jakarta contains an un-airconditioned exhibition space, unsuitable for touring international exhibitions. Interestingly school children are the major audience for this National Museum, and a national gallery would similarly develop objectives for education and appreciation, but the dual ministry of education and culture does not enhance the cultural portfolio's funding status.

In Singapore and Vietnam, the cultural portfolio is in a Ministry of Culture and Information. The effect on cultural policy is that of tight control, as through the media, government policy is decreed. The Singapore government believes that having achieved the material benefits of economic development, its role is to provide cultural products for the cultural enrichment and education of the population. Millions of dollars are being spent on physical infrastructure for

both imported entertainment and presentation of local product of 'excellence', but little subsidy is available for artists. Cultural policy is entrepreneurial and directorial, aimed at audience development and establishing Singaporeans as a highly cultured people. The policy is stated as 'to promote widespread interest and excellence in the pursuit of arts in our multicultural society, and to encourage cross-cultural understanding and appreciation'.[7]

Without a great deal of information on this heavily regulated society and the administrative structure of the Department of Information and the Arts, the Grin and Tonic Theatre Troupe based in Queensland but performing nationally, decided to expand its market and tour Shakespearian productions to Singapore secondary schools in 1994. The non-profit, non-subsidised company operates on a simple mission of making Shakespeare more accessible to a wider public. The director recruits young actors and trains them to perform Shakespeare's plays and programs of Australian literature with passion and honesty to students in secondary schools. For many years the company performed from a commune lifestyle base in the north Queensland rainforests. Now they operate from Brisbane and have two small groups performing throughout Australia. Singapore was chosen because the English language is spoken by most of the population, secondary students face examinations designed in England, and because the economic relationship which exists between Singapore and Australia could provide support for the venture. The entire project was conducted through the independent establishment of a network of schools and through the Australian High Commission in Singapore, twelve months prior to the production tour.

Asian cultural policies distinguish clearly between commercial and non-commercial cultural product. For Australia, the role of government in cultural activity is to invest through subsidy in a possible commercial return and in the promotion of Australia abroad. Most Asian governments do not subsidise individual artists and organisations. Rather, artists are chosen for awards or employed as civil servants or teachers. Wealthy patrons, including the new patrons of business, newspapers, hotels and some government departments may

commission performances. Cultural exchanges are generally not expected to generate income for the foreign country, unless the product is 'entertainment' and commercially presented. The Ministry of Art, Culture and Tourism in Malaysia does not differentiate between non-profit cultural activity of foreign governments and commercial entrepreneurs. Both are presumed fully supported by their government because that is the principle under which the Malaysian government operates in its goal of preserving the national heritage and identity of the Malay society.

In the case of the Grin and Tonic Theatre Troupe tour, the Australian High Commission in Singapore acted as agent and provided a guarantee against loss. A formal sponsor is required by visiting arts organisations, and despite unsuccessful approaches to government authorities in Australia, the company received significant support from the High Commission in arranging visas, the formal entertainment licence and taxation liabilities. The company's director reflects that the process is no different from that which occurs in Australian cities, where an audience is perceived and the means are found to present to that audience. In two weeks the company of three actors presented twenty performances to fourteen schools. Income was sufficient to recoup expenses and because the actors were overwhelmed by both the students' response and the deeply respectful treatment at all government and educational levels in Singapore, they returned again the following year. For a company whose theatrical activity is closely linked to philosophy, they achieved, without subsidy and corporate sponsorship, a significant small-business success of the kind promoted in Australia's cultural policy, *Creative Nation*.

While arts managers in Australia are being asked to be more demand oriented and to heighten their marketing strategies, the arts in Asia generally retain their ceremonial base and ticket sales are anathema to measures of success. Jennifer Lindsay, who worked as Cultural Counsellor at the Australian Embassy in Jakarta, Indonesia, from 1989 to 1992 and lived for over thirteen years in Indonesia, sums up the arts manager's role in Asian cultural exchanges:

The point [is] . . . to plea for better understanding by our planners, funding bodies, artists and other cultural workers about the context in which this exchange is taking place. It is not that we should scale down our cultural programs because it is all too different and difficult, but rather that we should, through a better understanding of the context of cultural administration in the countries of Southeast Asia, find creative ways to work within this context rather than against it.[8]

Foreign policy, international marketing strategies and cultural tourism

The international projection of Australian culture is funded through specific initiatives by the Australia Council, the federal Department of Foreign Affairs and Trade (DFAT), state governments and corporate sponsors. All believe that the artists, companies and institutions benefit from this presentation to new audiences, with 'the principal reason for sending arts overseas under DFAT's auspices [being] to enhance our national image at critical times or to support particular goals'.[9] These 'critical times' include national and international festivals, celebrations or events marking a historical achievement and are closely linked to trade and investment efforts.

While the Australian government is actively encouraging cultural links with Asia, artists and arts managers do continue to maintain close ties with Europe and North America. The overseas studio residencies sponsored by the Australia Council in New York, Paris, London, Barcelona, Berlin, Besozzo(Italy) and Los Angeles host creative fellows all year round; Australian craft and visual arts are available in the shopfronts of cultural missions around the world; and the Australian Ballet performs as cultural ambassador for Australia almost every year (as it has done since its formation in 1963), most recently in Japan for Celebrate Australia in 1993, Australia Week in Washington in 1994, and the UNited we Dance celebration for Unesco in San Francisco in 1995. European gallery owners and art collectors welcome Aborig-

inal art exhibitions for interest and investment purposes. The cultural policies of these governments embrace support for arts practice within similar infrastructures and principles to those in Australia. For example, in the Netherlands, cultural policy promotes the principles of freedom of expression, pluralism, quality and education. It has three objectives: the conservation, development and dissemination of cultural values.

The quest for a new audience in a similar infrastructure took the non-profit independent entrepreneur ExportOz to South America in 1988. Justin Macdonnell, director of ExportOz, describes himself as a facilitator. He believed that South America with its similar post-colonial history of transported European society cohabiting uneasily with an indigenous culture comparable to that of Australia, would provide cultural exchange opportunities. In fact he found Ministries of Culture, state institutions such as theatre, ballet and opera, a developed commercial sector and a middle-class patronage of the arts. Most importantly, South America's cultural development faced problems similar to those in Australia: vast distances between capital cities and towns, a scattered population and a historical belief that culture from Europe must be transported to this new world.

The solutions to these problems paralleled what happened in Australia. For example, the Mozarteum was formed, a fine music non-profit organisation presenting ensembles to Argentinians through subscription, not unlike Musica Viva in Australia. In that first visit in 1988, Justin Macdonnell arranged for the Australian Chamber Orchestra to tour with the Mozarteum. Since then, ExportOz spends three months each year in South America: in Argentina, Brazil, Colombia, Venezuela and Mexico, facilitating cultural exchanges through partnerships with commercial promoters, municipal theatres, festivals or the Mozarteum. The protocols involve working very closely through the cultural missions in South America. The International Cultural Relations Branch of DFAT and the Performing Arts Board of the Australia Council provided strong support to ExportOz for these projects. ExportOz's mission is to take Australian artists to the world. The initiative which began on the instinct of the arts man-

ager is now firmly entrenched as a valuable 'international projection of Australian culture'.

The new direction for ExportOz is 'cultural packages' prepared as government commissions for events overseas, for example, Australia's National Day in Seville, Spain (1992), Australia Today '94 in Indonesia, Australia Alive! mini festival in Singapore in 1995, and a similar festival in Thailand in January 1996. This cultural activity is presented as 'stand alone' or partner to a trade link, and delivers maximum impact and media exposure to the critical mass when the activity is 'packaged', that is, an event or festival including performance of dance, theatre, song or music together with visual art and craft exhibitions.

Government funding is being channelled in this direction as the best vehicle for promoting understanding and recognition of Australia. By presenting a range of cultural forms, the foreign investor can visualise contemporary Australia in a high-impact environment. The arts motivate and captivate interest, resulting in tangible economic returns for the government.

This process occurs within the nation, as well as from the export and international marketing of arts and culture. Internally, cultural tourism generates a significant contribution to the export earnings from tourism. While cultural tourism embraces all forms of travel undertaken for essentially cultural motivation such as study tours, travel to festivals and visits to sites and monuments, it is becoming increasingly important for communities and regions to assess their heritage and find the means to present their culture in a memorable and intense fashion. Cultural tourism strategies have moved away from taking international and domestic tourists to showpiece resorts and performances, but rather to local environmental, cultural, heritage, ethnic and Aboriginal features. The arts bring style, culture, beauty, a sense of the continuity of living to tourism. They revitalise the tourism product, sharpen its market appeal and give a new meaning to national identity, permitting strong promotional efforts. Tourism brings new audiences to the arts, new partners with promotional funds and skills and a new distribution system.[10]

International visitors to Australia are attracted to its

uniqueness, in particular the Aboriginal and Torres Strait Islander culture. While statistics and survey summaries confirm the number of international tourists visiting galleries, museums, or performances to see and learn about Aboriginal and Torres Strait Islander culture or purchase works of art to the estimated value of well over $50 million, the issue of management of this cultural asset is of great concern.[11]

In the five years 1990 to 1995 the number of Aboriginal and Torres Strait Islander artists and arts organisations across all art forms increased dramatically. These include poets, writers, publishers, visual artists, craftworkers, museums, dance companies, theatre companies and teaching institutions. Unfortunately, the number of Aboriginal and Islander arts managers has not matched the arts growth. Some companies operate effectively with white Australian arts managers. Training in arts management in Australia is based exclusively on a European or Western management model with hierarchical staffing structures, boards of management, strategic plans and aggressive marketing. These are outlined in this text. But this model is inappropriate in the management of Aboriginal and Torres Strait Islander arts. Aboriginal people feel more comfortable in a model that embraces flexibility and process above outcomes. The organisational structure must be flat and decentralised allowing a collaborative approach to decision making. The consultation process must be exhaustive. Arts management trainers need to know 'Aboriginality': the vocabulary, the customs, the cultures, the history, the protocols and the people. An Aboriginal person brings to the job or role the 'whole person'. For example, it is impossible to separate the actor and the role from the culture, the family and the history.

In an era where global encounters are presented as the challenge for individual arts managers, there is still much for non-Aboriginals to learn about the culture of Australia's original inhabitants.

Packaged art

Packaging art into a digestible and accessible product has been the concern of many twentieth-century arts managers

and entrepreneurs who compete for product recognition amongst the myriad leisure activities available to the populace. The 'cultural packages' of ExportOz referred to earlier in the chapter aim at showcasing a culture through a program of varied artforms. Packaged art can also have a broader definition, being art which is delivered in a social context.

Most art is packaged or augmented in some form. A painter presents work framed or unframed, hung on a stark white wall or amidst other similar or dissimilar colours or works. This presentation of the raw product in some sort of setting is packaging in its most rudimentary form.

Observing the awesome beauty of a mountain may be an individual artistic experience for the viewer. The same scene described in the poetry of Wordsworth or Betjeman is packaged by the strictures of definition and interpretation which those poets provide. Similarly, insights represented through Shakespeare's characters convert the knowledge into a packaged artistic experience, shared collectively in the social context of the theatre, or in the more personal context of a communication between author and reader.

Galleries, museums and theatres all provide a context for the representation of art. The context is partly provided by the physical building or space in which the art takes place, which influences the audience's perception of comfort, understanding and genre through its architecture and facilities. Beyond the physical strictures of the building or space lies the social context of how individuals experience the event at a particular time and this is influenced by their preconceptions of it gained through publicity, the mood they are in at the time, the accompanying people, and their prior knowledge of the works on display.

Providing a context for art has become a subtle and sophisticated tool of postwar arts managers and marketers, and goes beyond the rudimentary concerns of place and space. Increased world population and population density have exacerbated the loss of individual community identity in many cultures and combined with increased international trade, communication and tourism, have promoted cultural interchange and a taste for internationalism in art.

The experience offered to patrons of art must be con-
venient, pleasant and meaningful in order to compete with
other leisure experiences. Preferably the experience should
encourage loyalty or continued use.

Buildings

Art museums, once the property of the royal family in many
countries, have in the last two hundred years become
democratised institutions open to the public. Predominantly
art museums retain the atmosphere of a hallowed space for
treasures wherein one can view the achievements of mankind
and share in them through a recognition of the progress of
civilisation. Rendering such treasures public instead of royal
property promotes the social experience of sharing in the
artistic event. But the dynamics of great institutions of art,
science or culture are more complex than those illustrated
by the shift from the private to the public domain. Works
displayed within these hallowed spaces automatically acquire
an aura of holiness and importance. For some, entering the
Hermitage or the Louvre is akin to the experience of a
devout worshipper visiting the Taj Mahal or St Peter's.

The residual sacredness of such places allows for exper-
imentation and avant-gardism with content. Art which may
not have the same impact or importance in another setting
can be endowed with extra dimensions of meaning and
importance when displayed in the shrine. McDonald, a Brit-
ish arts commentator, describes museums as 'essentially show-
cases for institutionalised subversion. Within their walls, art
works can be as politically extreme or morally reprehensible
as possible, but because of the magic designation of "Art",
all is permitted. The more sensational (or bewildering) an
artwork, the more desirable it will be for such institu-
tions . . .'[12]

Buildings which house art also sometimes pander to the
psychology of monumentalism. They are often designed to
represent the wealth and cultural sophistication of a nation.
They become important symbols in their own right, and as
such can either enhance, trivialise or dominate the art which
they were designed to display. An accepted language of

predominantly classical forms became the desired architectural style of many art museums around the world in the nineteenth and twentieth centuries, an architecture which paid less attention to regionalism than to an internationally recognisable form. The style of architecture has become a point of recognition for visitors, who use it to anticipate content.

Jencks, an architectural semioticist, notes that the more a message is expected, the less illuminating its content will be. A cliché, for example, will convey fewer insights than a great poem.[13] National art galleries traditionally address political and ideological issues by presenting art to outsiders as a sample of the talent engendered in the nation, and by presenting art to the people of their own nation as a sign of cultural cohesion. To be properly conveyed, such messages need a stage set of monumental proportions. Entrance halls, stairs which sweep dramatically into high spaces, wide galleries and extensive halls are common design elements.

Some of the great art museums may indeed have become clichéd in their style. It has become apparent in the latter half of the twentieth century that the spaces they offer do not always suit the contents they are to display or the number of visitors they are to accommodate, and there is a marked tendency to renovate, extend or convert these buildings. Extensions to the entrance of the Louvre are a notable example of how a modern and comfortable area can be incorporated without dominating the original architectural style, although the glass pyramid in the forecourt which symbolises a fusion of ancient and modern design has caused dissent amongst commentators.

Another trend has been the renovation of buildings constructed originally for other purposes into gallery spaces. The Musée d'Orsay in Paris successfully displays traditional and contemporary work in a converted railway station. The Tate Gallery in Liverpool is a dockside warehouse converted into a gallery. The Casa de la Caritat in Barcelona, the Manchester Museum of Science and Industry, and the Bicocca and Museopolis in Milan have all used converted spaces. Numerous small galleries use warehouse spaces in an exciting way to house art. A new aesthetic is in operation here, that of

renovation/warehouse format as another decipherable code for interpreting and anticipating content. The grand ornate style with its connotations of significant collection, history and edification is replaced by a less formal architecture and a more flexible and experimental approach to content. In the case of Liverpool and many others, the conversion also raises consciousness about the heritage of the location and gives elliptical recognition to the role of the local industries and history in the formation of culture.

Activities which take place within museums have also changed during the twentieth century. Social gatherings and educational talks, workshops, seminars and conferences align the newest cultural centres more closely with the original classical libraries and gymnasia in ancient Alexandria and Greece. Large cultural complexes today tend to be devoted more to leisure than to academia, but because of the diversity of activities they incorporate, flexible spaces are required in the design. The permanent and the ephemeral will both be suitably housed in their spaces.

The establishment of museums of contemporary art has been another worldwide trend in the twentieth century, partly in response to the dominance of historicism and classification in earlier museums. Japan particularly has experienced a rapid increase in contemporary art museums with institutes at Gumma, Saitama, Nagoya and Kyoto. The contemporary art museum has its own message to the visitor which is based on artistic style rather than nationalism or iconic monumentalism.

Blockbusters

The blockbuster art exhibition further illustrates the packaging concept. The blockbuster is a unique experience. Never before, and probably never again, will the art in a blockbuster exhibition be collected in the one place and at the one time. Art only forms part of the whole experience which is marketed and sold with the blockbuster. Guided tours, gift items, catalogues, interstate, international and inter-city tours are offered. Group discount bookings, bookings including lunches, morning teas or cocktail parties are

devised to seduce large numbers of visitors and to allow regular patrons or inhabitants of the 'host' city to experience a sense of ownership in the events.

Art is presented in a readable or digestible form, wherein the viewer is guided and directed along certain paths to view and judge it. Often a chronological path is devised for the observers, recording the formative influences of the artist or movement exhibited, and putting them into a social or historical context. The curatorship is thus also a part of the packaging, making the art accessible by presenting guidelines for interpretation. The inherent didacticism of this process offers patrons the illusion of a cohesive view of the whole and an educational and memorable experience. Patrons leave the blockbuster with the feeling of taking with them a small package of categorised knowledge.

The blockbuster also panders to the 'edge mentality', or the issue of regionalism, or of those who feel isolated from culture because of geography or demography. The edge mentality induces the need to travel a great distance to experience art, or to confine the experience into a contracted period of time. The convenience of being able to enjoy the work in one 'sitting' is seductive to people who are otherwise pressed for time.

The blockbuster is centralised, so that many people can enjoy the same work simultaneously. The 'host' gallery or venue will assume an extra degree of importance by virtue of the fact that it has curated and displayed something magnificent.

Endless opportunities exist for marketing the blockbuster. Besides the discounts and augmentations already mentioned are the opportunities to appeal to different segments of the market through different offers. Extravagant prices for extravagant promotions can be offered alongside highly discounted student and pensioner packages. A variety of offers or packages in fact emphasises the broad appeal and accessibility of the event.

Festivals

Arts festivals perform some of the same functions as block-

busters. Festivals package art into an event which can include disparate experiences and a range of choices. Festivals encourage group patronage and cultist following. Marketing opportunities encompass the tourist dollar, encouraging consumers to believe they can experience the essence of a culture in an abbreviated time frame. Unlike the blockbuster, it is difficult to judge the qualitative success of a festival as a whole experience. Festivals exist in fragmented form, and are enjoyed in a more varied way by their patrons than are blockbusters. The established formula of chronological didacticism which is so entrenched in the presentation of blockbuster art exhibitions is absent in festivals.

Whether or not their content is nationalistic, festivals tend to have an international appeal. Their content is often representative of the local or national culture, or provides a local or national context for the artform being presented. As events both in time and in space, festivals tend to be vibrant and exciting and can change the life of their particular environment for a short time into something different. They can cause a transformation of city or town life and provide a communal experience.

Packaging a festival usually involves a theme, as opposed to the venue or content base on which other art and theatre blockbusters are built. Folk music, classical music, comedy, history/heritage, innovative film, multiculturalism and gay rights form background themes for some festivals.

Many festivals have become important events on the tourist calendar. International culture is readily available in contemporary society through television, media and foreign travel, but festivals offer what none of these facilities can—a communal and participatory experience. The progressive theatre festival in Polvirigi (Italy) and the Tuscan music festival in Montepulciano are significant community events at which the artists and audience merge at feasts and dancing after performances. Gavin Henderson, artistic director of the Brighton Festival in Britain, comments on the liberating forces of festivals:

> Far away from the specialised art form assessment and practice of European life—a 'wholeness of being'

pervades, where the individual rejoices in a comprehensive desire to be poet, dancer, drummer and painter; where costume and make-up join with food and drink in a sensual feast that really lives up to the meaning of festivity.[14]

The collective experience of the festival and the fact that it revolves around live performances which can change and develop as a result of audience participation, differentiate it as an international artform that can only be truly experienced in situ. Performers may take advantage of this trait by touring the same act to numerous festivals in a particular continent or country. A negative result of this can be a homogeneity of festival programs. Arts managers can guard against repetition by careful selection and program planning under a theme.

In 1949 Denis de Rougemont established the European Cultural Centre in Geneva. His vision was to unite Europe in a cultural renaissance rather than emphasise national diversity. He envisioned traditional and new arts festivals promoting the vision of unity through the international exchange processes which must necessarily result. A similar movement came about in postwar Britain, where a spirit of regeneration and optimism encouraged the birth of many festivals, particularly away from the centre of London. The social role of peaceful unification continues to be a dominating theme of many festivals. Criteria for festival funding in some instances prioritises this societal function.[15]

Fringe festivals have become part of the make-up of a festival program. Arising from a need to cater for diverse tastes, the fringe complements the main event and often provides more affordable entertainment for some audience segments. Some fringe festivals have in fact become institutionalised adjuncts to the main event and are marketed or packaged with an appropriately professional degree of expertise.

Film, manifestos and cultural change

Film is an artform most suited to the rapid exchange of ideas and trends internationally, and devices for marketing or

packaging film tend to follow a universal pattern. Yet in its system of rewards and recognition the film industry is distinctly nation-based. Content is interpreted on a cultural-national basis, while technique benefits from international exchange. New films can be released immediately on the international cinema market, and can soon after penetrate the video and home television market.

Film tends to be one of the most risk-taking of all artforms. Repressive societies allow surprising liberties to filmmakers, surprising partly because the medium is so readily available to the outside observer. In China the film industry has burgeoned since the death of Chairman Mao in 1976 and the corresponding relaxation of Marxist policies espoused during the Cultural Revolution. Although propaganda films are still popular in the guise of heroic epics about past Communist leaders, these form the fodder for the Chinese domestic market and contrast to the very sophisticated product developed for international markets. Chinese filmmakers have the advantage of being able to produce works offshore in Hong Kong and Taiwan in a now independent market, and are thus not subject to the internal censorship of domestic video and television product.

Cheng Kaige's film *Farewell My Concubine* won the Palme d'Or at the Cannes film festival in 1993. The film documents the cruel training of two boys for the Peking Opera and deals with the Cultural Revolution and the taboo theme (in China) of homosexuality. It illustrates a difference between what the Chinese public views inside China and what China produces for outsiders. Films made specifically for the international rather than the domestic markets are trade commodities and agents of ambassadorship. *Farewell My Concubine* also formed part of the program of opening up China to the West and packaging the country as a more liberal destination for imports.

The *Mao goes Pop* art exhibition in 1993 also packaged China as a force to be reckoned with in the Modernist movement. It is interesting that the original title of this exhibition when it was curated in Hong Kong was the less cynical and less Western-oriented *China's New Art Post 1989: with a retrospective from 1979–1989. Mao goes Pop* has meaning

to the Western art observer with a knowledge of the twentieth-century movements from which Chinese artists were severed during the Cultural Revolution.

The connection between art and politics is always most evident when artists or those controlling art are concerned with the social role of their work. Mao's manifestos went as far as delineating a politically acceptable style of art (Maoist Revolutionary Realism) and subject matter (portraits of Mao himself predominated). In 1933 Hitler ordered the closure of the famous Bauhaus, a centre of learning for architecture and crafts, because of its powerful socialist philosophy. Walter Gropius, founder of the Bauhaus, had blamed capitalism and power-politics for the philistinism and lack of support for culture he perceived in Germany. Gropius's manifesto expressed his desire to create a total artists' community wherein a group of craftsmen could combine their talents in co-operative projects. The status of crafts would be elevated to that enjoyed by fine arts. 'There is no essential difference between the artist and the crafstman . . . Let us then create a new guild of craftsmen without the class-distinctions that raise an arrogant barrier between crafstman and artist.'[16]

Gropius wanted to reform art teaching while creating a new society. Hans Meyer became director of the Bauhaus after Gropius in 1929. As a Marxist, Meyer regarded art and architecture as of measurable social benefit. The Nazis accused the Bauhaus movement of decadence and Bolshevism as a result of Gropius's and Meyer's expressed desires to change society and the fact that some Bauhaus teachers were aligned with the group *Working Soviet for Art*.

Mao and Hitler recognised the power of art as a tool for social reform, and as a consequence took control of it. Lobby groups in more democratic regimes can also wield a great deal of power over artistic product and presentation, as the debate about the curatorial hijacking of Modernism referred to in chapter 3 suggests. Today the easy exchange of ideas internationally allows for representation of movements across national barriers. Arts managers should retain a balanced viewpoint of their role in packaging art, and act as facilitators rather than promulgators of popularist movements.

Heritage

In many countries including Australia, heritage policy forms a part of arts policy. The links between heritage and art come about because much of a country's heritage will be evidenced in great works of art, literature, music and architecture. Heritage issues are important to countries wishing to document, preserve and cultivate specific images of nationhood. The heritage and preservation movement illustrates the jealous guarding of national cultural identity as a reaction to dominant internationalism. Conversely, eradication of cultural heritage has been perceived as an essential ingredient to cultural change and was enforced in China during the Cultural Revolution, in Hitler's Germany, in Oliver Cromwell's England, in enemy-occupied countries such as the Netherlands (by the French in the nineteenth century and the Germans during World War II) and during the formation of the United Soviet Socialist Republic. Eradication of past identity, of past cultural achievements and systems of thought, was considered essential in creating a new order. The denunciation of writers, burning of books, destruction of buildings of learning, industry or government, censorship of live theatre, dictation of painting styles and subject matter, and banning of dances, games and other customs and light entertainments have been features of these regimes.

The heritage movement aims to preserve cultural identity through the conservation of tangible and intangible heritage. Tangible cultural heritage encompasses buildings, places, records in libraries and other information centres, and artworks. Intangible cultural heritage encompasses the ideas, values and language of a nation.

Management of heritage involves establishing stringent guidelines for selection of items of significance, and workable infrastructures such as the Australian Heritage Commission. Controversy often arises between the forces of purism and pragmatism, or those who wish to conserve at all costs and those who conserve with reference to comfort, expenditure or social change. Items of significance once again become packaged art through this process, representing important ingredients to the formation of the artistic/social/historical

present. Although this kind of packaging represents a less commercial process than others already referred to, its results are permanent and significant and perhaps subject to more widespread reference than other artform packaging.

Inherent in the heritage debate in Australia and indeed other countries with a colonial history, has been the development of an understanding of spiritual place and its significance to indigenous cultures. The building is not a dominant feature of place-making in Australian culture, partly because buildings have only existed here for two hundred years. Significant places tend to be connected to myth and history. Preserving and recognising important places has become part of the heritage brief. Place-making recognises local and national culture and counters internationalism which is represented by large cities of similar design throughout the world. Kenneth Frampton, an architectural theorist who propounds the theory of Critical Regionalism, claims that the investigation of the local is the condition for reaching the concrete and the real, and for re-humanising architecture.[17] As such, place-making tends to form another reaction to the hegemony of International Modern style, just as Post-Modernism had in art.

In Australia the scope of heritage issues has broadened to include urban design. Urban design forms the 'heritage of the future', influencing the choices people make in job and business location, retirement and travel, which in turn influence our culture.[18] The 1970s witnessed the rise of union involvement and resident action groups in town planning issues as well as the increased strength of the conservation movement. In Britain the recent call for the establishment of architecture centres based on the European model also exposes community interest in the quality of urban renewal and design. Robert Cowan, a British arts lobbyist, promotes the building of architecture centres to help retain the distinct identities of cities which are threatened by globalisation.[19] Cowan criticises the brand of conservation which panders to tourism. 'Old buildings and streets should be allowed to communicate honestly about the past, instead of being processed into whimsical, pseudo-

historical imitations, dulling visitors' senses with a cosy sentimental sense of familiarity.'[20]

Through heritage policies, landscapes, monuments, buildings, artefacts and sites are selected to present images of a culture. The way in which the images are presented or packaged can be offensive, as Cowan points out, and is of concern to arts managers.

Another issue in the ethics of heritage is the control of movable cultural products. Recent Australian legislation controls the import and export of movable items of cultural heritage, ensuring that items imported illegally from other countries are returned, and that other exhibition imports and exports are treated properly. Such legislation shows concern for ownership rights.

The debasing of art and significant cultural artefacts is an issue for general arts management as well as heritage management. Popularisation of Aboriginal art through commercialisation, for example, can be accommodated with a concurrent development and promotion of a product which will continue to retain value on the international market rather than be part of a passing trend in consumer taste.

The heritage sector contributes to employment and industry and is influential to tourism revenue. As arts policy comes more and more under the aegis of broader cultural policy, issues like heritage, architecture, and urban renewal are brought into the field of arts management. As cultural policy addresses international influences, arts management practices will further expand into the global arena.

Endnotes

1 Arts management and national identity

1 Australia Council, *The Artist in Australia Today* 1983; *Occupational and Employment Characteristics of Artists* 1986; *When are you going to get a real Job?: an economic study of Australian artists* 1989; *But what do you do for a living?: a new economic study of Australian artists* 1984; *The Arts: some Australian data* 1990 (based on the Australian cultural industry statistics of 1988).

2 'Music and Drama', *Sydney Morning Herald*, 19 February 1944, p. 6.

3 Tim Rowse, 'The Great Arts Funding Debate', *Meanjin* vol. 40 no. 4, University of Melbourne, 1981, p. 451. Glenn Withers and Susan Ryan are also contributors to this article. Rowse's ideas are echoed his book *Arguing the Arts*, Penguin, Victoria, 1985.

4 *Arts for Australians by Australians*, Australia Council, Sydney, 1993.

5 *National Library of Australia News*, March 1994, Canberra, p. 8.

6 'Australian Content: Review of the program standard for commercial television', Australian Broadcasting Authority Working Paper, November 1994.

7 *Creative Nation*, Commonwealth of Australia, October 1994, p. 5. This document is the Australian government's cultural policy statement released in October 1994 by the then prime minister, Paul Keating. It is referred to throughout this book, particularly in chapters 1 and 7.

8 *Creative Nation*, pp. 5–6.

9 Vegemite is a uniquely Australian condiment made from yeast

extract. The Eureka Stockade was a battle fought between gold miners and the military in Ballarat. Uluru, previously named Ayer's Rock, is a mountainous rock in central Australia and an international tourist destination. Phar Lap was an exceptional racehorse. Rod Radford in 'Alice Springs: Ayer's Rock, Aborigines and Art', *Australian Art Review* 2, Leon Paroissien (ed.), Oxford University Press, Melbourne, 1983, p. 57, claimed that '[Ayer's Rock [sic]] is very much a vital part of our national imagery and identity, even for those who have never actually viewed it. In a country with few internationally significant buildings, structures or memorable public sculptures, we have come to regard this natural phenomenon as our central core and as our national image'.

10 Robert Hughes, *The Art of Australia*, Penguin, Harmondsworth, rev. edn, 1970, p. 90.

11 Donald Horne, *Arts Funding and Public Culture*, Institute of Cultural Policy Studies discussion paper, Griffith University, p. 3. Horne's earlier publication *The Public Culture The Triumph of Industrialism*, Pluto Press, Sydney, 1986, elaborates on these theories.

12 *Creative Nation*, p. 5.

13 *The Shorter Oxford English Dictionary*, Clarendon Press, Oxford, 1972.

14 This term was coined by the literary critic A. A. Phillips and published in the University of Melbourne publication *Meanjin* in 1950. See *Australian National Dictionary*, Oxford University Press, Melbourne, 1988.

15 Joseph Lycett, *Views in Australia or New South Wales and Van Diemen's Land, Delineated, In Fifty Views, With Descriptive Letter Prefs.*, J. Souter, London, 1824–25.

16 Robert Hughes, *The Fatal Shore*, Collins Harvill, London, 1987, p. 341. Hughes suggests that Greenway's recognisable style was influenced by available materials.

17 Robert Hughes, *The Art of Australia*, p. 59.

18 Donald Horne, *Arts Funding and Public Culture*, p. 1.

19 Donald Horne, in *Arts Funding and Public Culture*, p. 1, uses the adjectives 'rare' and self-conscious'.

20 Dennis Carroll, 'Introduction', *Australian Contemporary Drama*, rev. edn, Currency Press, Sydney, 1995.

21 T. L. Suttor, *Hierarchy and Democracy in Australia 1788–1870: The Foundation of Australian Catholicism*, Cambridge University Press, London, 1965, p. 10.

22 A. Métin, 'Le Socialisme sans Doctrines', Paris, 1901, in

C. M. H. Clark, *Select Documents in Australian History, 1850–1900*, Angus and Robertson, Sydney, 1950, p. 678.

23 *Industrial Issues Cultural Tools: Papers and Proceedings of the Second National Art and Working Life Conference*, Melbourne, October 1990.

24 Donald Horne, *Artforce*, no. 48, Australia Council publication, 1985, p. 8.

25 C. M. H. Clark, *Select Documents in Australian History*, p. 677.

26 H. C. Coombs, cited in J. Radbourne, Commonwealth Arts Administration: An Historical Perspective 1945–90, unpublished thesis, University of Queensland, 1992.

27 Viola Tait, *A Family of Brothers*, Heinemann, Melbourne, 1971, p. 209.

28 Draft document of the Trust, March 1954, Australian National Library MS 5908 Box 94.

29 Clem Gorman, 'Do the Arts Need Massive Subsidy?', *Quadrant*, No. 309 vol. xxxviii no. 9, Media Press, Melbourne, 1994, p. 52.

30 Tim Rowse, *Arguing the Arts: the Funding of the Arts in Australia*, Penguin, Victoria, 1985, p. 56.

31 'The Performing Arts—Problems and Prospects', Rockefeller Panel Report, McGraw-Hill, New York, 1965.

32 C. D. Throsby and G. A. Withers, 'Measuring the Demand for the Arts as a Public Good: theory and empirical results', in School of Economic and Financial Studies Research Paper Number 254, Macquarie University, Melbourne, 1982.

33 'Patronage, power and the muse', House of Representatives Standing Committee on Expenditure Report (L. B. McLeay, Chairman), Parliamentary Paper 237, Canberra, 1985.

34 Tim Rowse cited in the McLeay Report, p. 86.

35 Di Yerbury, 'Abiding principles of Australian arts administration: arm's length funding and peer-group assessment', *Artforce*, Number 48, Australia Council, Sydney, 1985, pp. 6–7.

36 Nicanor Tiongson, 'Cultural Engineering: the Philippine Case' in *Dialogue in Diversity—Arts Administration in the Asia Pacific Region*, Conference proceedings, Australian Institute of Arts Administration, Sydney, 1994, p. 72. Conference held during Adelaide Festival of the Arts 6–9 March 1994.

37 Rajah Fuziah and Azizan Baharuddin, 'Tradition and the arts: recent trends in Malaysia' in *Dialogue in Diversity*, Sydney, 1994, p. 22.

38 Michihiro Watanabe, 'The Future role of arts managers' in *Dialogue in Diversity*, Sydney, 1994, p. 50.

39 Tiongson, *Dialogue in Diversity*, p. 76.

40 Georgina Carnegie, 'The Arts Industry—1994 to 2000' in *Dialogue in Diversity*, Sydney, 1994, p. 88.

Case study 1: Arts on fire

This case study results from Jennifer Radbourne's participation in the project as senior researcher and is used with the permission of Access Arts.

1 'Art in the Park', *The Bugle*, 13 July 1994, p. 3.

2 Marketing

1 Arts Research Training and Support Ltd (ed. Timothy Pascoe), *Marketing the Arts*, ARTS Ltd, Sydney, 1980. This booklet is no longer available, although the Australia Council and some state arts departments still have copies in their libraries. It is still a valuable resource for beginning arts marketers.
2 A. H. Reiss, *The Arts Management Reader*, Marcel Dekker, New York, 1979.
3 M. P. Mokwa, V. M. Dawson and E. A. Prieve, *Marketing the Arts*, Praeger, New York, 1980.
4 J. V. Melillo, *Market the Arts*, Foundation for the Extension and Development of the American Professional Theatre (FEDAPT), New York, 1983.
5 K. Diggles, *Guide to Arts Marketing: The Principles and Practice of Marketing as They Apply to the Arts*, Rhinegold, London, 1986.
6 *Australian Financial Review*, 27 August 1993.
7 *The Australian*, 30 August 1993, p. 3.
8 Further reading in survey questionnaire design, delivery and analysis can be found in Francois Colbert, *Marketing Culture and the Arts*, Morin, Montreal, 1993, pp. 215–21 and Kotler et al, *Marketing—Australia & New Zealand 3*, Prentice Hall, Sydney, 1994, pp. 101–7.
9 Simon McCall, 'Researching Event Audiences', *Australian Journal of Arts Administration*, vol. 2 no. 4, Spring 1990 and vol. 3 no. 1 Summer 1991 (double issue), Deakin University, Victoria, pp. 12–13.
10 Judy Simpson, 'The Museum Shop—A Marketing Review', Queensland Museum, February 1994.
11 David Throsby and Beverley Thompson, *But what do you do for a living?*, Australia Council, Sydney, December 1994, p. 27.
12 ibid, p. 25.
13 Heidi Waleson, 'Marriages made in Heaven', *International Arts*

Manager, vol. 2 no. 3, Arts Publishing International Ltd, London, May 1989, p. 59.

14 Waleson, p. 59.

15 Waleson, p. 61.

16 Tim Homfray, 'Sound Business Sense', *International Arts Manager,* vol. 2 no. 3, Arts Publishing International Ltd, London, May 1989, p. 29.

17 This example, 'The unholy alliance', was developed by postgraduate arts administration students, Shannon Woollett, Roberta Henry, Brett Dionysius and Katherine Crawford-Gray in September 1994 as part of the assessment process of their course at the Queensland University of Technology. The section shown here is used with permission.

3 Public relations and the media

1 Candy Tymson and Bill Sherman, *The Australian Public Relations Manual,* Millennium, Sydney, 1987, p. 3.

2 Noel Frankham, 'Introduction' to *You Are Here,* catalogues and essays from the Aglassofwater project curated by Luke Roberts and Scott Redford and initiated by the Institute of Modern Art, Brisbane. The exhibition was held in Brisbane in November 1992 then began touring to Sydney, Melbourne and Adelaide in February 1993.

3 Martin Terry, 'Not seeing straight', in *Art and Australia,* vol. 34 no. 1, Spring 1994, pp. 40–1.

4 Bill Bonney, 'The Media and the People' (1988), in *The Media in Australia: Industries, Texts, Audiences,* S. Cunningham and G. Turner (eds), Allen & Unwin, Sydney, 1993, p. 253 (originally published in *Constructing a Culture,* V. Burgmann and J. Lee (eds), Penguin, Melbourne, 1988, pp. 136–45). Bonney discusses the rise of the national newspaper as a capitalist-driven force, stating that the Labor press made sharp distinctions between news and comment sections. The capitalist popular press, on the other hand, depoliticised news and built up a middle class readership of broad appeal through a concentration on sport, entertainment and the family.

5 T. Miller, 'Radio', in *The Media in Australia*: *Industries, Texts, Audiences,* p. 44.

6 *Australian Content: review of the program standard for commercial television,* Australian Broadcasting Authority Working Paper, November 1994.

7 Australian Broadcasting Authority Discussion Paper, July 1994, p. 1.

8 Giles Auty, *The Spectator*, 1 January 1994, pp. 28–9; 8 January 1994, p. 29; 22 January 1994, pp. 35–6; 29 January 1994, pp. 50–1. Auty now writes for *The Australian.*

4 An ethical and legal framework for the arts

1 Australia Council, *The Arts in the Australian Corporate Environment—A practical guide to the legal obligations of officers of arts organisations*, Australia Council, Sydney, 1993.
2 J. Radbourne, Arts Administration Research Project—Board Member Survey, QUT, Brisbane, September 1993.
3 J. Radbourne, 'Recruitment and Training of Board Members for the 90's and Beyond', *The Journal of Arts Management, Law and Society*, vol. 23 no. 3, Heldref Publications, Washington, Fall 1993, pp. 222–3.
4 Jennifer Sexten, 'Artists win legislation to protect integrity', *The Weekend Australian*, 11–12 March 1995, p. 13.
5 Samela Harris, 'Arts uproar over defaced painting', *Adelaide Advertiser*, 27 September 1991, p. 2.
6 Michael Steele, 'Driller Jet Armstrong, The Bannon Case, and Moral Rights', *Bulletin, The Law Society of South Australia*, vol. 14 no. 6, July 1992, p. 8.
7 Damien Murphy, 'Writs for the Crits', *The Bulletin*, 2 November 1993, pp. 36–9.
8 *The Sunday Sun*, 16 May 1976.
9 *The Courier Mail*, 29 October 1969, p. 8.
10 J. Radbourne, Little Theatre: its development since World War II, in Australia, with particular reference to Queensland, Masters Thesis, University of Queensland, 1978.
11 Steven C. Dubin, 'Arresting Images: Impolitic Art and Uncivil Actions', *The Journal of Arts Management, Law and Society*, vol. 23 no. 3, Heldorf Publications, Washington, Fall 1993, p. 260.

Case study 2: Arts and crafts industry development

1 This case study is published with the permission of the Cooloola Regional Development Bureau. The feasibility study was conducted by Jennifer Radbourne and Bill Collyer in 1994.

5 Management of people and place

1 Rockefeller Panel Report, *The Performing Arts—Problems and Prospects*, McGraw-Hill, New York, 1965, p. 161.
2 Thomas J. C. Raymond and Stephen A. Greyser, 'The business

of managing the arts', *Harvard Business Review*, July–August 1978, p. 132.

3 Elizabeth Sweeting, 'Administration—Inspiration or Encumbrance?', *Theatre Australia*, January 1980, p. 52. Sweeting, from the United Kingdom, was responsible for the formation of the first graduate arts administration program in Australia at Adelaide in 1978.

4 John Pick, *Arts Administration*, E. & F. N. Spon, London, 1980, pp. 11–13. Pick was the first director of Arts Administration studies at City University London in 1974.

5 Kevin Radbourne, Deputy Executive Director of Arts Queensland, What is an Arts Manager?, paper delivered to graduate arts administration students, QUT, Brisbane, 16 March 1995.

6 Libby Quinn, Co-ordinator Museums Australia Inc. Qld, What is an Arts Manager?, paper delivered to graduate arts administration students, QUT, Brisbane, 16 March 1995.

7 Canadian Association of Arts Administration Educators, *Final Report of the Study of Management Development needs of publicly funded, not-for-profit arts and heritage organisations in Canada*, February 1987, p. 12.

8 Arts Training Queensland, *Training Plans for the Queensland Arts and Cultural Industry—1995/6*, 1st edn, April 1994, p. 174.

9 These mission statements from organisations in Australia, the United Kingdom and the United States of America were taken from the public documents of the organisation and given freely to the authors.

10 For further information on competency standards, contact Culture Recreation Education and Training Australia (CREAT Australia), the competency standards body for the arts, heritage, entertainment and media industries.

11 R. M. Stodgill, *Handbook of Leadership: A Survey of Theory and Research*, Macmillan, New York, London, 1974.

12 T. McCarthy and R. Stone, *Personnel Management in Australia*, Wiley & Sons, Brisbane, 1988.

13 J. Schermerhorn, *Management for Productivity*, Wiley & Sons, New York, 1986.

14 A. Maslow, *Motivation and Personality*, Harper & Row, New York, 1954.

15 This section owes much to the experience and ideas from Gareth James, Chief Executive, Olympic Park Management in Melbourne, and Kelvin Cordell, General Manager, Gold Coast Arts Centre.

16 Arts Queensland Newsletter, Office of Arts and Cultural Devel-

opment, Queensland Government, September/October 1993, vol. 3 no. 5, p. 5.
17 Michihiro Watanabe, 'The Future Role of Arts Manager', in *Dialogue in Diversity—Arts Administration in the Asia Pacific Region,* Australian Institute of Arts Administration Conference Proceedings, Sydney, pp. 52–3.

6 Financial management

1 *The Arts in the Australian corporate environment: a practical guide to the legal obligations of officers of arts organisations,* Australia Council, Sydney, 1993.
2 Report to Australia Council on Open Doors Consortium, compiled by Anne Craven, Rock'n'Roll Circus, Brisbane, June 1995. This scheme also had members from the Queensland organisations: Fractal Theatre, Expressions Dance Company, La Boite Theatre, Street Arts Community Theatre.
3 Cathy Hunt, Models of Arts Funding, Conference Paper, Affording the Arts in Australia and New Zealand, Sydney, March 1993, p. 6.

Case study 3: The Arts 2000 initiative

This case study was developed by Cathy Hunt of Positive Solutions in Liverpool, United Kingdom.

1 This third initiative involves a scheme whereby builders are required by the local government authority to contribute a percentage of costs to the inclusion of artworks and/or spaces in the construction. This applies to capital works, public building and, in some instances, public sector buildings.

7 Arts management and international influences

1 Commonwealth of Australia, *Creative Nation,* Commonwealth Cultural Policy, October 1994, p. 12.
2 *Creative Nation,* p. 7.
3 *Creative Nation,* p. 1.
4 *Creative Nation,* p. 15.
5 *Creative Nation,* p. 5.
6 Gordon Bilney, Opening Address, *Dialogue in Diversity—Arts Administration in the Asia Pacific Region,* Conference proceedings, Australian Institute of Arts Administration, Adelaide, 1994, p. 3. Gordon Bilney was Minister for Development Co-operation and Pacific Island Affairs in 1994. The conference, held in Adelaide,

was described by John Odgers, president of the Australian Institute of Arts Administration, as a 'watershed' bringing 'together speakers from Australia and other nations in the Asia Pacific region to address the notion of diversity in this region and the role of the arts as a catalyst for regional interaction and co-operation, and to attempt to understand the role of cultural administration in the future of the region'.

7 Jennifer Lindsay, *Cultural Organisations in South East Asia*, Australia Council, Department of Foreign Affairs and Trade, Myer Foundation, Sydney, 1994, p. 57.

8 Lindsay, p. v.

9 *Creative Nation*, p. 93.

10 Heather Zeppel and C. Michael Hall, 'Selling Art and History: Cultural Heritage and Tourism', *The Journal of Tourism Studies*, vol. 2 no. 1, May 1991, p. 29. Cultural tourism is a new area of policy and research with early works by Christopher Wood and Jennifer Craik still dominating the literature in this field. *Creative Nation* contains a section on cultural tourism on pages 99–100 with the objective to 'further develop links between the Department of Tourism, the Australia Council and the Department for Communications and the Arts to initiate programs to provide further opportunities for cultural tourism'. An annual fund of $250,000 has been provided to develop cultural tourism initiatives.

11 In 1991 the value of purchases of Aboriginal and Torres Strait Islander arts and souvenirs by international visitors was estimated at $46 million a year, an increase of $30 million from 1990.

12 John McDonald, 'Death of a Blockbuster', *Marketing the Arts*, ICOM, 1992, p. 175.

13 C. Jencks and G. Baird (eds), *Meaning in Architecture*, London, Barrie and Jenkins, 1969, p. 21.

14 Gavin Henderson, 'Festivals', discussion document on large-scale festivals from the National Arts and Media Strategy Unit, Arts Council, London, p. 17.

15 Criteria for festival funding specified by the Brisbane City Council prioritises the creation of opportunities for a community (city, suburb or special interest group) to unite in a common purpose, Brisbane City Council document, 10 December 1993.

16 Walter Gropius, Manifesto, cited in Frank Whitford, *Bauhaus*, Thames and Hudson, London, 1984.

17 Kenneth Frampton, 'Modern Architecture and Critical Region-

alism', *Transactions*, Issue 3, Royal Institute of British Architecture, London, 1983, p. 16.

18 *Creative Nation*, p. 74.

19 Robert Cowan, *The Cities Design Forgot: a manifesto*, London, Urban Initiatives, 1995, p. 1.

20 Robert Cowan, *The Cities Design Forgot*, p. 13.

Select bibliography

Armstrong, M. et al. *Media law in Australia*, Oxford University Press, Australia, 1995

Arts 21, The Victorian Government's Strategy for the Arts, into the Twenty-First Century, State Government of Victoria, 1994

Australia Council, *The Arts in the Australian Corporate Environment*, Australia Council, Sydney, 1993

Australia Council, *Corporate Support for the Arts 1993*, Australia Council, 1993

Brokensha, Peter and Guildberg, Hans, *Cultural Tourism in Australia*, AGPS, Canberra, 1992

Building Local—Going Global, Queensland Government Cultural Statement, June 1995

Byrnes, William, *Management and the Arts*, Focal Press, Boston, 1993

Colbert, Francois, *Marketing Culture and the Arts*, Morin, Montreal, 1993

Coombs, H. C., *Trial Balance*, Macmillan, Melbourne, 1981

Creative Nation, Commonwealth Cultural Policy, October 1994

Cunningham, S. & Turner, G. eds, *The Media in Australia: Industries, Texts, Audiences*, Allen & Unwin, Sydney, 1993

Fishel, David, *The Arts Sponsorship Handbook*, Directory of Social Change, London, 1993

Golvan, Colin ed., *Arts and Entertainment Law Review*, The Law Book Company Limited, Sydney, journal issues from 1992 to the present

Grogan, David and Mercer, Colin, *The Cultural Planning Handbook*, Allen & Unwin, Sydney, 1995

Horne, D., *The Public Culture The Triumph of Industrialism*, Pluto Press, Sydney, 1986

Hughes, R., *The Fatal Shore: A History of the Transportation of Convicts to Australia, 1787–1868*, Collins Harvill, London, 1987

Industries Assistance Commission Report 1976

Jeffri, J., *Artsmoney: Raising It, Saving It and Earning It*, University of Minnesota Press, Minneapolis, 1983

Kotler, Philip, Chandler, Peter, Brown, Linden and Adam, Stewart, *Marketing—Australia & New Zealand Edition 3*, Prentice Hall, Australia, 1994

Lindsay, Jennifer, *Cultural Organisation in Southeast Asia*, Australia Council, Sydney, 1994

Lumley, Robert ed., *The Museum Time Machine*, Comedia-Routledge, London, 1988

Macdonnell, J., *Arts, Minister?*, Currency Press, Sydney, 1992

McLeay, L., *Patronage Power and the Muse—House of Representatives Standing Committee on Expenditure Report*, Parl Paper 237, Canberra 1986

Marketing the Arts, International Council of Museums, 1992

Parsons, P ed., *Shooting the Pianist*, Currency Press, Sydney, 1987

Pick, John, *Arts Administration*, E.&F.N. Spon, London, 1980

Radbourne, J., Commonwealth Arts Administration: An Historical Perspective 1945–1990, unpublished thesis, University of Queensland, 1992

Reiss, Alvin, *Cash in! Funding and Promoting the Arts*, Theatre Communications Group, New York, 1986

Rosso, Henry A., *Achieving Excellence in Fund Raising*, Jossey-Bass, San Francisco, 1991

Rowse, T., *Arguing the Arts, The Funding of the Arts in Australia*, Penguin, Victoria, 1985

Sharpe, Diana, *The Performing Artist and the Law*, The Law Book Company Limited, Sydney, 1985. (Note that this book is out of print and an updated version is in preparation.)

Simpson, Shane, *Museums and Galleries—a practical legal guide*, Redfern Legal Centre Publishing, 1989

Simpson, Shane, *The Visual Artist and the Law*, The Law Book Company Limited, Sydney, 1989

Smith, Bucklin & Associates, *The Complete Guide to Nonprofit Management*, John Wiley & Sons, New York, 1994

Tait, V., *A Family of Brothers: the Taits and J.C. Williamson, a theatre history*, Heinemann, Melbourne, 1971

Throsby, David and Thompson, Beverly, *But what do you do for a living?*, Australia Council, Sydney, 1994

Throsby, D. and Withers, G. A., *The Economics of the Performing Arts*, Edward Arnold, Melbourne, 1979

Throsby, C.D. & Withers, G., 'Measuring the Demand for the Arts as a Public Good: Theory and Empirical Results', School of Economic and Financial Studies Research Paper No. 254, Macquarie University, Sydney, 1982

Vergo, Peter ed., *The New Museology*, Reaktion Books, London, 1989

Withers, G., 'The Great Arts Funding Debate', *Meanjin*, vol. 40 no. 4, University of Melbourne, 1981

Index